MUSEUM VISITOR SERVICES MANUAL

Roxana Adams, Series Editor

2001

AMERICAN ASSOCIATION OF MUSEUMS

PROFESSIONAL PRACTICE SERIES

MUSEUM VISITOR SERVICES MANUAL

Museum Visitor Services Manual
 Roxana Adams, Series Editor

 ISBN 0-931201-77-2

TABLE OF CONTENTS

INTRODUCTION

So what else do museums do? Doesn't it all boil down to serving the visitor? If that's the case, why aren't there more visitor services departments or programs in museums? After all, for visitors to enjoy and learn from the exhibitions and programs, they need to be motivated, comfortable, and secure, knowing that there are friendly and knowledgeable staff available when they need them. For museums to reap the fruits of their efforts in the form of return visits, contributions and public support, they need to sensitize their operations to these needs.

As director (from 1985-1992) of a small museum in Alaska that received 90% of its visitors (about 90,000) in three hectic summer months, I realized that our education staff was overwhelmed with guide training, motorcoach chaos, and conducting tours. Our summer audiences were, for the most part, from luxurious cruise ships and expected nothing less from their on-shore excursion. We were starting to get complaints from visitors and tour companies about service: overcrowding, not enough restrooms, feeling hurried, etc. We knew that the cruise lines monitored their customers' experiences closely and would delete sites from the tour that did not provide a quality experience.

Not wanting to lose the business, I went into high gear. I researched the hospitality and visitor industry for service models, went through a Public Dimension Assessment (MAP III) for an assessment of our own services and spent time observing museum operations as I traveled to my regional association meeting. After a year of evaluation and reorganization, I established a visitor services program. From there, the story is very similar to that of other institutions that have accomplished the same changes.

When casting about for models and literature from the museum profession, I found very little at that time addressing visitor services. I took my cues from our local convention and visitors bureau training, the Public Dimension Assessment report, an outstanding mentor, and the writing about commercial attraction development. Since then, a small but growing contingent of visitor services consul-

tants and professionals in museums have contributed to the literature. There is a Visitor Services Professional Interest Committee of the American Association of Museums and usually some visitor services sessions at the AAM annual meeting.

To help sustain this positive trend, I have compiled a book entitled *Museum Visitor Services Manual*. Peer reviewers Andrea Leonard, Head of Visitor Services at the The J. Paul Getty Museum and Mercedes Speigel, Director of Volunteer Services at the Cincinnati Museum Center, helped improve the book with their comments. Greg Harris, Manager of Visitor Services at the St. Louis Art Museum, provided information from the Visitor Services Professional Interest Committee of the American Association of Museums for this publication. Rebecca Helvey, intern from the Brigham Young University's Washington Seminar, conducted extensive research in visitor services that made this manual possible.

This book provides an introduction for any museum seeking to start or renew visitor services, communicate to the board and other staff about the need for a focus on visitor services, or organize a program, train staff, and evaluate services. The articles can help museum staff make informed decisions and create policies to manage visitor service issues specific to their individual museum. I wish I had had this book when I was starting out!

Roxana Adams,
Series Editor, Professional Practice Series

Assistant Director,
Museum Advancement & Excellence

American Association of Museums

HOW TO USE THE MUSEUM VISITOR SERVICES MANUAL

The articles and materials in the *Museum Visitor Services Manual* were reproduced with the kind permission of individuals and institutions. Users are encouraged to consult these materials in the context of their own institution's needs; however, the materials should not substitute for, nor substantially be used as the basis for, similar documents produced by their own institution. Each museum has its own unique circumstances that warrant thoughtful planning and discussion before drafting customized forms, guidelines, and policies to meet its particular requirements.

NAVIGATING THE MANUAL

The materials are organized into the following chapters:
- Why Visitor Services
- What Visitors Want and Need
- Organizing Visitor Services in the Museum
- Training Visitor Services Staff
- Evaluating Your Services

HOW TO MAKE THE RESOURCE PACK WORK FOR YOU

You are not expected to be an expert in visitor services or related issues in order to use this publication. The Manual is designed for a variety of users, regardless of experience in this subject—educators, directors, docents, volunteers, board members, etc.— in all sizes and types of museums. Although many of the materials are from larger museums, the basic principles of visitor services management apply to all types and sizes of institutions. They can help museum staff make informed decisions and create policies to manage visitor service issues specific to an individual museum.

The following steps are useful in developing visitor service policies for your museum.

STEP ONE: DEFINE THE ISSUE OR PROBLEM

The process of policy development begins with recognizing the need for written policy. Often a governing authority or director faces a decision that would be easier to make if a policy existed. The governing authority is not alone in identifying policy needs. Staff, advisory groups, audiences, and communities can surface issues and problems needing a policy.

STEP TWO: GATHER INFORMATION ON THE ISSUE

Suggestion: form a task force, committee, or working group to conduct an environmental scan of materials prepared by other institutions or organizations. You don't need to reinvent the wheel, but the policy needs to fit your museum's needs.

Sources of information for inclusion or comparison include:
- Sample documents from TIS (some are included in this Manual)
- Characteristics of an Accreditable Museum
- Experience from colleagues
- Research
- Local input (visitors' bureau, hospitality industry, chamber of commerce)
- Professional development and training on the subject

STEP THREE: SECURE RECOMMENDATIONS FROM THE DIRECTOR

Once information is available, the board seeks policy recommendations from the director, since the director is the staff member responsible for carrying out the policy.

STEP FOUR: DISCUSS AND DEBATE AT THE GOVERNING AUTHORITY LEVEL

Involving the members of the governing authority helps build understanding and consensus and assists consistent and appropriate policy development. Approval at all levels of governance and affected staff is essential to effective policy.

Questions to ask and answer about the policy:
- Does it support the institution's mission?
- Is the content within the scope of the board's authority? [Reiterate the responsibility of the governing authority.]
- Is it best practice?
- Is it reasonable? (Are any requirements or prohibitions arbitrary, discriminatory or capricious?)

- Does it adequately cover the subject?
- Is it limited to one policy topic? [Will it solve more than just the problem before the group?]
- Is it consistent with board's existing policies?
- Can it be administered? Is it practical? How much will it cost?

STEP FIVE: DRAFT POLICY

After the board has reached consensus on policy content, the policy writer goes to work. This person must be able to write clearly, directly, and succinctly. Pomposity, verbosity, and jargon should be avoided unless necessary to meet legal requirements. Policy must be broadly stated with room for adjustment to fit special circumstances.

STEP SIX: FIRST REVIEW

Once in writing, the policy draft is placed on the governing authority's meeting agenda for a first review, giving notice to everyone interested that the governing authority has a specific policy under consideration.

STEP SEVEN: MAKE REVISIONS

Revise the policy based on the information gained from the questions, comments, and suggestions obtained after the first review.

STEP EIGHT: SECOND REVIEW

The period between the first and second reviews allows time for all concerned persons to ask questions, make comments, and offer suggestions for changes and improvements.

STEP NINE: ADOPT THE POLICY

The governing authority formally adopts the policy. Adoption is recorded in the minutes of the meeting.

STEP TEN: DISTRIBUTE THE POLICY

Distributing the policies as widely as possible is one way to ensure implementation. Consider holding an all-staff orientation on the new policy.

STEP ELEVEN: OVERSEE POLICY IMPLEMENTATION

Policy oversight is a dynamic process that includes an evaluative component. Oversight is intended to make sure that the policy accomplishes its goal. Policy oversight can provide guidance on whether to continue or modify the policy and to determine future courses of action.

STEP TWELVE: POLICY EVALUATION AND REVISION OR MODIFICATION

Policies should be reviewed on a regular basis as a part of the board's standard operating principles. They can become out-of-date, unclear, or even contrary to the way in which the institution is operating. When any of this occurs, the policy needs modification or elimination. The policy amendment process is the same as the policy adoption process.

(*Steps One through Twelve are adapted from the Washington State School Directors' Association's Passport to Leadership materials.*)

FINAL THOUGHTS

It takes time to manage visitor services — to develop and implement effective policies and programs. It is also important to realize that the field and practices continue to evolve. In your work, you will undoubtedly encounter new issues and as you do, TIS is available to provide additional assistance.

CHAPTER 1

Why Visitor Services

VISITOR SERVICES DEFINED

Andrea Leonard

Reprinted From *WestMuse* (Summer 2000), the newsletter of the Western Museums Association. ©Andrea Leonard

If you work in Visitor Services at a museum, chances are you are always busy and work closely with almost everyone in your institution. You are generally easy to get along with and have a strong commitment and sense of the visitor experience and psyche. Yet, when a group of us in this field met at the recent AAM conference in Baltimore, we were hard-pressed to define Visitor Services. How is it that something that is so central to the mission and core of our institutions can be so elusive?

Generally speaking, the goal of Visitor Services (whether we exist as a separate department or a combination of functions) is to make our institutions accessible to all visitors regardless of their background, education, income, age, or gender. When we narrow this interpretation we find that Visitor Services professionals interact with all operational and programming areas of our institutions. To make the collections and exhibitions more accessible, Visitor Services works with Education and Curatorial on lighting, case and label height, and visitor flow. Site access, including signage and facilities for visitors with disabilities, finds Visitor Services working closely with Design and Facilities. We work with Custodial and Food Service to address the visitors' basic and often most important needs. We often assist Marketing and Merchandising with communicating the information guests need to make informed visiting and purchasing decisions. In addition, we help Events ensure that visitors' programmatic needs are met.

All of this is fine, but how do Museums quantify something as elusive as the visitor experience? What does Visitor Services actually do? Our functions usually include at least some of these--admissions, signage, mapping and way-finding, information desks, coat check services, group sales, event sales, ushering and ticket-taking, accessibility for visitors with disabilities, hospitality volunteers, food service, custodial, and even security in some instances. Once we narrow down the definition, Visitor Services really is about welcoming the visitor and making the logistics of accessing our building, grounds and collections as smooth, seamless, and enjoyable as possible. We take the often difficult, foreign, and confusing aspects of a Museum visit and turn them into a fun, easy and worthwhile experience for everyone.

When I'm working with our frontline team during their initial training session I go around the room and ask everyone a revealing question: "What is the first thing you do when you buy a new computer and take it out of the box?" Inevitably the answers include, "play with it," "read the instructions from cover to cover and then install it," and finally, "get someone else in the household to show me how to use the darn thing!" This great exercise never fails to find at least someone using each of the above approaches. We talk about how these are the ways in which people learn. It is our job to provide every visitor the opportunity to experience the Museum in one or more of the above ways.

For those who learn by reading (the computer instruction readers), we provide maps, signage, brochures and other pamphlets. For those who want others to show them how to experience the Museum, we provide frontline staff and volunteers throughout the property. Lastly, for those who just want to forge ahead on their own (the "play with it" group), we try to make the experience as intuitive as possible. Are we always successful? No, of course not, and that is where we rely on our frontline team of staff and volunteers. We need them to feel empowered to observe and communicate to us the challenges and roadblocks that vis-

itors experience. It then becomes our responsibility to either follow through on their suggestions or explain sound reasons for not doing so.

We take the often difficult, foreign, and confusing aspects of a Museum visit and turn them into a fun, easy and worthwhile experience for everyone.

We also look to the visitors themselves to tell us about their biggest challenges. Comment opportunities are extremely important. While responding to visitor concerns is essential, just as important is communicating the visitor's impressions to the administration. Summarizing the comments monthly into our top five compliments and suggestions motivates us to improve the visitor experience.

Our visitors often comment on our friendly and approachable frontline team. Customer service training that includes working with all kinds of people is essential for all front line staff. Presenting an open, accessible appearance, the importance of eye contact, communicating with people who speak a different language, and working with visitors with disabilities are essential to the success of our program. During this training we also take a look at what the visitor may have experienced before reaching us. In our case, the answer is always traffic. We are nestled in the center of the Sepulveda Pass, one of Los Angeles' busiest stretches of freeways. By the time they reach our parking kiosks visitors are not exactly in the correct frame of mind for a museum experience. To reach our front entrance, our visitors must take a 4-minute ride on our tram. To help them "decompress" after their bout with traffic, the tram has no announcements or advertisements. It is strictly a quiet, beautiful ride up to the Museum. The frontline team often mentions how the visitor that they see at the end of the tram ride is very different from the one they find at the beginning!

Our team assists people on and off the tram so we are constantly engaged in direct encounters. Our visitors arrive from all over the world and bring their own belief systems and customs. Tools for creating a welcoming environment no matter where a visitor hails from are essential. To help us enhance our sensitivity, I ask two volunteers to stand at opposite ends of the room. I ask them to approach one another and stop when they are at a comfortable distance from each other. I then ask them to stretch out their right arms. They are always at arms length from one another if they both grew up in America. This is the comfortable and preferred distance for Americans to interact with one another. I remind them that there are people who grew up in this country, though their physical characteristics may have them "look" as though they are from another part of the world. If they grew up here, the appropriate distance for interaction is arms length. However, in some cultures the comfortable distance can be as far away as two arms lengths or as close as a mere hands-length away. The key point is that our team needs to take their cues from the visitor. If the visitor wants to stand very close, we need to grin and bear it and hope they didn't have garlic for lunch. We really can't back away if that level of closeness is what is appropriate for that visitor (unless the situation is threatening). If anyone on the team is uncomfortable at such a close range, they can move the position of their head laterally to the right or left of the visitor. This can often help us to feel more comfortable and able to give the visitor our undivided attention.

A big part of our training focuses on keeping things in perspective--not taking things visitors say personally. When 95 % of our visitors arrive happy and have a great time, this might seem silly, but our team's ability to handle the tough moments is key to the success of the whole institution. For many service related industries the solution to this is look, listen, apologize, solve the problem, and thank the visitor for bringing it to your attention. One of the biggest mistakes new team members make when they have their first unhappy visitor is to desperately look around for help. This is not a good first move, as visitors need to feel confident in what you are doing and your ability to help. If they don't, they will simply get angrier and feel you could care less about them. Listening carefully and repeating what you heard are crucial; most of the problems visitors encounter occur as a result of a communication breakdown. Apologizing without regard for "who's to blame" takes the fuel from the visitor's anger. Our team is taught to solve the problem, make things right and own the issue. If they can't solve the problem to the visitor's satisfaction, they need to provide an alternative. They tell the visitor that someone will call them, and provide the name and number of that individual and when he or she will call if possible. Follow-through in this area is essential. If it doesn't happen, the whole effort is for naught. Lastly, thank them for bringing the problem to your attention. Let them

know that you will follow-through so that this experience is not repeated for other visitors.

In order for them to be successful, the team needs to feel empowered to make a decision when a visitor is unhappy. We tell our team they will succeed as long as everything they do is in the best interest of the visitor. Unlike other areas of the museum, Visitor Services cannot always operate with clear-cut rules and procedures. Professionals in our line of work must be comfortable thinking "out of the box" whenever possible to make the visitor happy. Going above and beyond the call of duty for a visitor should be encouraged and noticed. On particularly chilly days (yes, it does get cold in LA) I've seen, on more than one occasion, someone who works with me give his or her coat to a visitor. On warm days (don't worry, lots of those) we supply outdoor workers with personal misters that help them to cool off. More often than not the misters are turned on little kids for their enjoyment.

If your group sells anything, be it an admission, or an audio guide, you have to deal with refunds and a refund policy. So far, this is easy for us since the items we vend are under $5.00. It is always simpler for us to issue the refund than it would be to give the visitor any kind of hassle. First, we make the visitor a little bit happier by not giving them a fight; second, the cost involved in issuing a refund after the fact is much more than offering it on the spot.

So, whether we can clearly define it or not, Visitor Services is an essential element of our institutions. The training, visitor feedback, and collaborations with other staff work towards creating seamless visits that encourage return trips to our institutions.

Andrea Leonard is Head of Visitor Services at The J. Paul Getty Museum and can be reached at aleonard@getty.edu.

BEYOND QUALITY SERVICE: A BLUEPRINT FOR IMPROVING VISITOR SERVICES

Eleanor Chin

From *Forum* (May/June 1993) © 1993 The Mid-Atlantic Association of Museums. All rights reserved.

THE MUSEUM'S NERVOUS SYSTEM

Imagine for a moment that your museum is a living, breathing organism. Depending on your particular museum, the metaphoric head could be administration or finance. Either education or collections might be called the heart. If you ask the staff who work directly with the public to describe their part of the organism, they would probably say that they are the museum's nervous system. The public service staff, in its broadest definition, can include the information desk, housekeeping, docents, security, switchboard, interpreters, maintenance, museum teachers, museum shop, public relations and visitor services areas. These staff members experience direct contact with the public. Hence, this museum system contains many of the major receptors for those messages from our curious, confused, elated, distressed, sated and fatigued visitors.

If we buy into the nervous system metaphor, it would follow that the healthy organism is one that listens to the messages it receives from its nerve endings. Private industry certainly does. In companies and corporations throughout the U.S. and Japan, customer service has become the subject of intense management scrutiny. Service improvement initiatives abound under many code names such as "voice of the customer" and "quality service." The concept is simple enough to make sense. Why then do these slogans often ring hollow for museums?

Museums are institutions for learning and preserving. For many of us, it is radical to suggest that our museums are in any way in the same arena with mega-malls, movies and Disney World. But in the public's minds, we are all too often lumped into the same large competitive arena called "leisure time choices." The decision of what people do with their limited leisure time and whether they ever make

that same choice again has something to do with the quality of the total experience. Enrichment, entertainment and comfort is a winning combination in the decision making process. Considering the pressures of the economy and museums' increasing dependence on earned revenues, we can no longer afford to assume that "if we built it, they will come." We must sensitize ourselves to issues of comfort if we are to compete for the leisure time dollar. If for no other reason, economics forces us into the quality service arena.

When museums need to reconcile the economic forces with their educational and collecting missions, one of the departments we can look to is our visitor services. What role then does a visitor services program play in fostering visitors' readiness to learn from our exhibits? If education is at the heart of their mission, museums will have to be sensitive to their visitors' needs just as the most effective classroom teacher must focus on supporting his students' basic needs. Unmet needs such as hunger, shelter, acknowledgment and family support distract students from learning. Museum visitors are also easily distracted from exhibits when the rest of the museum environment is difficult for them. For museums, those basic needs translate into services such as affordable food, accessible facilities and programs and a well trained, empathetic staff.

Even as the AAM's landmark publication, *Excellence and Equity: Education and the Public Dimension of Museums* urges us to focus on an "expanded notion of public service" some of us will ignore the potential in the most public dimension in seeking to carry out our missions. Attention to the service environment in the museum can even address some of our education and diversity agendas. Here are some examples:

- Multilingual signs and a diverse staff give out messages about the communities we see ourselves asserting.
- Power-assisted doors remind all visitors that people have varying degrees of mobility.
- Baby changing tables in the men's rooms signal new thinking about current life styles.

BEYOND SLOGANS

In the broadest terms, when we speak of visitor services we are referring to every aspect of the visitor environment:

the setting and the delivery of services. Philosophically speaking, a visitor-focused environment suggests that staff at all levels throughout the institution struggle to remain sensitive to the audience's physical, educational, and emotional needs in policy, program and systems planning. While museums in their mission and practice represent a wide spectrum between audience centered-ness to object centered-ness, the range can sometimes be found within one museum among its different departments. It is vital to engage those differing views in defining the providing of visitor services in your museum, as well as its role in your mission.

In sharpening our focus on the visitor environment at The Children's Museum in Boston, we wanted to get beyond the traditional thinking in quality service management, namely that of nearly mindless slogans and acronyms: Total Quality (TC), Quality Circles (QC), etc. We found instead that we could look to our educational framework for a good starting point. The obvious first step was to come up with a Visitor Service Mission that paralleled our Institutional Mission.

Whether the initiative begins with upper management, middle management or even front-line staff, it is critical at this stage to get the senior administrators on board so that your end product is a breathing document that moves naturally into the implementation stage, rather than getting filed in a drawer. In this sense, it helps to examine successful models of mission development processes before you begin. If your museum does not yet have an institutional mission statement, you can lobby to include service values in the initial thinking.

At The Children's Museum, with the support of the administration, we developed consensus among the public service staff about the service values we hold in common. In our case, the major players were the Visitor Services and Museum Shop managers. In retrospect, we should have included an even broader group, encompassing public relations, facilities management, security and switchboard from the beginning. Nevertheless, we ended up with a useful document called our Service Mission Statement. It begins with a one sentence statement of our primary goal, then articulates several objectives and finally summarizes the concepts into four key words that express the values inherent in the goals. Some key words one might imagine

are common among mission statements are courtesy, respect and teamwork. Ours are safety, empathy, presentation and knowledge.

Clarifying values and priorities empowers the front-line staff to resolve visitor problems within a framework of common goals. This empowerment of staff avoids those awkward moments of "waiting for the manager" to come. Staff who are entrusted with the solving of daily problems are motivated to grow and be creative in improving systems. This creates an intersecting circle between learning and service which further differentiates the museum application of quality service from the McDonald's "have a nice day" approach.

Other institutions use names other than "mission" for the same concept: service themes, strategies, values statements. Our approach fits our institution's mission. Yours will reflect your museum's unique values.

HOW TO DEVELOP AN EFFECTIVE VISITOR SERVICES PROGRAM

In summary, if your institution is interested in reviewing and revamping its visitor services program, we propose three words to help guide your efforts: Evaluate. Escalate. Empower.

Evaluate your offerings. Particularly if you think your museum may need to allocate or realign resources to accomplish your goals, bringing the voices of the visitors to the conference table is a good idea. Board members and directors are more easily swayed by data gleaned from visitor research than by staff opinions, however passionate and grounded they may be. In fact, you may be surprised by the success, as well as the shortcomings of what you already provide.

Escalate the conversation to the highest levels of your museum. Our second strategy suggests that in order to succeed, prioritizing visitor services must be an institutional mandate. Aside from the obvious financial support, the visitor services staff need to feel that their colleagues value their work. In our museum, the director and the entire senior management team encourages all staff to volunteer for front line positions during school vacation weeks. Many staff say that despite what seems at first like an interruption of their real tasks, the opportunity to focus on the visitor ultimately informs their work immensely and give them a new found respect for the visitor service security and interpreter staff.

Empower the public staff who make up the nerve endings of your organic museum system to assist visitors on the spot with informed solutions, suggestions or information. You can provide this by offering clear expectations in your mission statement and a comprehensive, well documented training program that includes visitor interaction techniques, as well as content training.

Finally, by developing an environment where staff treat each other as you would want them to treat visitors, you create a full circle of learning between staff and visitors. This is the lesson that enriches the meaning of quality service in museums in a manner that will most certainly be felt by your audiences.

Eleanor Chin is the former Director of Public Programs and has been weaned on visitor services for the past sixteen years at The Children's Museum of Boston. She didn't realize that she had a legitimate museum profession until she became a parent herself six years ago. Then she understood the importance of creature comforts in museums. She consults on visitor services in her spare time.

FROM THE TOP DOWN: VISITOR SERVICES FROM THE DIRECTOR'S PERSPECTIVE

Suzanne LeBlanc

Originally published in the Winter 1993 issue of *Hand to Hand*. Washington DC, Association of Youth Museums. Reprinted with the permission of the Association of Youth Museums.

On an assignment for a class at the Museum Management Institute in Berkeley six years ago, I visited a museum I had never been to before, with the task of evaluating every aspect of my visit — especially the visitor services aspects. I called ahead to get directions, asked for information at the admissions desk, used the bathrooms, joined a tour, looked for a public telephone and the elevator, evaluated access for visitors with physical disabilities, and observed visitor traffic flow. I then evaluated the museum on its ability to make me, a first-time visitor, feel comfortable, informed, assisted and welcomed. All of us as museum professionals, and especially directors, because we are the most removed from the front lines, need an awareness of what it feels like to enter our institutions for the first time.

In preparation for writing this article, I reviewed a mental checklist of needs I had targeted for improvement as a new director in a year-old institution two years ago. Areas related to visitor services included the lobby, the admissions and information desk operations, public relations, signage, exhibit repair, visitor brochure, training for public program staff, and emergency procedures. My previous experience had included a position of director of visitor and community services at The Children's Museum in Boston, which has an attendance of over 500,000 visitors a year, and which serves over 250,000 children and adults each year in outreach programs. I arrived as executive director of the Lied Discovery Children's Museum in Las Vegas with a well-developed philosophy of the importance and role of visitor services and with extensive experience in developing and managing systems in a large public institution.

As a director, I was concerned with both the quality of each visitor's experience for its own sake, as well as for its impact on the visitor's division to return, and to recommend the museum to others. With a much too small, but talented and willing staff in place, I began to thoughtfully consider ways in which a director could most appropriately and effectively affect the quality of the public visit. In my experience, the director's input seems most critical in the following areas: developing an institutional philosophy and setting policies that promote visitor services as integral to the institutional mission; designing the institution's organization structure to reflect a visitor emphasis; setting a premium on evaluation and process; including visitor services goals and objectives in the long-range planning process; and emphasizing staff training in a variety of formats at all levels of the institution.

PHILOSOPHY AND POLICY — THE DIRECTOR'S ROLE

The director of a museum has a powerful role in setting the one for the visitor experience. A director's philosophy and priorities are communicated to staff every day in a variety of ways -- by budget and staffing decisions, at staff meetings and training sessions, in written policies and by example. It is important for a director to have the visiting public uppermost in mind as a primary constituency.

For instance, are allocations for visitor amenities and for visitor service staff written into the budget? If so, this sends a message to staff that visitor satisfaction is a real priority for management. Does the director take a leadership role in ensuring that visitor concerns are discussed, addressed, and taken seriously? This prescribes the framework for creating an environment where the quality of service to the public is continually being improved upon. Is the director involved orienting new staff and in ongoing training sessions public service staff and volunteers? This provides a forum for the director to communicate institutional philosophy and policies to front-line staff, as well as to engage staff who work directly with the public in a discussion about the relevance of their work to the visitor's total experience of the museum.

It must also be said that a director communicates philosophy by example -- by day-to-day decisions, discussions, and behaviors and by management style. A director who is attuned to the needs and concerns of an institution's visitors will translate this to staff in ways large and small, direct and indirect, over the course of each day.

ORGANIZATIONAL STRUCTURE

Decisions about management and organization structure reveal quite a lot about institutional priorities. At the Lied Discovery Children's Museum a position title Director of Operations was recently changed to Director of Visitor and Support Services to reflect an increased visitor advocacy role for the position. The Director of Visitor and Support Services is one of four senior managers. The position sits in the organization structure at the same level as the directors of education and exhibits, development and finance. The institutionalizing of advocacy roles for certain staff positions (visitor services, school services, early childhood programs, special needs, etc.) is one way of assuring that the audience represented will have a voice when conflicting needs compete for attention, money and time.

PROCESS AND EVALUATION

A work environment that values and facilitates learning for staff, as well as for visitors, is likely to be one in which staff are constantly involved in the process of evaluating and improving the way things are done. The creation of the climate and framework for this environment is the responsibility of the director. An accepting climate for experimentation and an emphasis on process, as well as on product, helps foster an institutional culture open to self-assessment and visitor evaluation and one that is likely to be more aware of and responsive to visitor needs.

LONG RANGE PLANNING

The long range planning process at both the board and staff levels should include discussions about audience that go beyond setting goals to increase audience and developing marketing objectives and strategies. It is critical to explore how well an institution is serving its current audience. This is where visitor services concerns enter the picture.

The Lied Discovery Children's Museum's long range plan includes two visitor service oriented objectives:

1. Increase repeat visits through improvements in the quality of exhibits, education programs and visitor services; and

2. Increase the museum's knowledge and understanding of its audience through evaluation techniques and visitor surveys.

STAFF TRAINING

It perhaps seems obvious to state that staff training is a basic element of providing high quality service to the public. But what kind of training, and for staff who are not delivering programs or services, is sometimes less obvious. Providing more in-depth content training for non-program staff (e.g., switchboard operators, secretaries and guards), and including all staff to some degree in discussions of mission and philosophy represents another level of staff training that can benefit the institution in many ways.

For example, at The Brooklyn Children's Museum guards were included in training about new exhibits, and about the philosophy behind the Museum's commitment to neighborhood youth and decision to welcome unaccompanied children as young as seven years old into the Museum. As the programs for neighborhood young people grew, and the Museum received a Youth Alive! Leadership grant from the DeWitt Wallace Reader's Digest Fund, guards were included in more discussion and training sessions. If the guards had not been incorporated in some way into the program, a situation could easily have developed where they would have been working with this audience from only a security perspective and at cross purposes with the Museum's program intent and philosophy. Again, the director of an institution is instrumental in setting up a situation where staff training is inclusive.

THINGS THAT CAN GET IN THE WAY

As a director, I try to stay aware of the things that commonly impede making progress in improved service to visitors. For me, they include the following:

1. There are so many important things competing for attention, time, and money, it is easy to stop "seeing" certain things, to put some things on hold, or to think a problem is intractable. In my view, this is a survival instinct for directors, which can be valuable

if wisely used, but disastrous if carried too far. Priorities must be clear, problems put on hold must not be forgotten, and care must be taken that the visitor does not get the short end of the stick.

2. The larger an institution gets, the more common it is to see priorities and standards get altered as they pass from the director to senior managers, to middle managers, to front-line staff. The ability to create and sustain a vibrant institutional culture driven by a strong commitment to audience and mission is vital to counteract this tendency.

3. The upkeep in all areas that affect the public's visit is time consuming, and like housework is never done. It is easy to let things slide. It helps to have staff who won't let you fall into this habit.

4. Visitor Services include many areas not thought of as glamorous. It is, for the most part, an area of expertise only recently recognized as such. As a result, staff who are experts in the field often don't view what they know as important or unique. It is much easier to get credit, acclaim and publicity for new exhibits an programs, than for important but more subtle things like a well-run admissions desk, clear and friendly signage, adequate parking, and staff well-trained to handle emergencies. This necessitates a commitment on the part of the director to making sure staff who work in this area feel empowered.

The director of a museum has a powerful role in setting the visitor experience. A director's philosophy and priorities are communicated to staff every day in a variety of ways by budget and staffing decisions, at staff meetings and training sessions, in written policies, and by example.

5. Effectiveness can become diluted because Visitor Services concerns are the realm of more than one department. Public relations, education, maintenance and security and office staff all have contact with the public and the ability to affect the quality of the visitor's experience at the Museum. The head of Visitor Services must be able to clearly and passionately communicate a vision, and be able to work well cross-departmentally.

I would like to describe in a little detail a visitor services problem we are in various stages of addressing at my institution: the lobby and admissions desk operations. The Lied Discovery Children's Museum shares a building with the Las Vegas Library. The facility was funded by a bond issue which described both institutions and was designed with the needs of both in mind. However, the museum and library are separate entities, one private nonprofit and the other governmental. Many people visit the museum assuming it is part of the library and are confused or upset about having to pay admission.

To further complicate matters, the lobby design and signage does not clearly demarcate the two institutions. People bring books to our admissions desk and go to the library desk for information about the Museum. Both institutions use the lobby to extend programming space during special events, such as the museum's Native American Harvest Festival. Additional admissions desk/lobby problems include signage that is in the wrong place or not welcoming or clear enough, the lack of a consistent staff person at the admissions desk, and inadequate visitor information systems. Because of financial considerations, this operation is staffed completely by volunteers who work in half-day shifts. Although the quality of their work is excellent, the logistics of making sure that each volunteer knows all the information she needs to know is complicated.

Solving these problems involves working on a number of different levels and has been assigned as a top priority to the new director of Visitor and Support services. However, the Las Vegas Library administration must be involved in any change that affects both institutions. The design of the lobby can't be changed in any significant way, so funds must be earmarked for signage, stanchions, visitor information boards and other items. A top-notch communication and training system must be designed that works in three ways -- from staff to admissions desk volunteers, from volunteers to the public and from volunteers to staff.

The changes necessary to make the Museum's lobby and admissions desk function effectively are not in and of themselves insurmountable, but they do require a commitment from the director of staff, time and money, and a concerted advocacy effort by a skilled staff person charged with both the responsibility of coordinating the project and the authority to make changes.

As I review the Visitor Services checklist for my institution mentioned at the beginning of this article, it is clear that Visitor Services issues, concerns and underlying philosophy must be integrated into the fabric of the entire institution. Many areas that have not been touched on at all, or have only been mentioned in this article, require intensive staff effort. Visitor evaluation, audience diversity, and exhibit labels for example are related areas that have been topics of research, writing and conference panels, and are areas of expertise in and of themselves. But an unwavering institutional emphasis on the quality of the visitor experience can provide a shared vision with the potential to transform the way an institution is experienced and viewed by its audience.

Suzanne LeBlanc is currently Executive Director of the Lied Discovery Children's Museum in Las Vegas. She has worked for children's museums for over 20 years, including The Brooklyn Children's Museum and the Children's Museum in Boston. She has served in a variety of positions and visitor advocacy has always been a primary concern.

NOBODY'S BABY: THE HIDDEN POTENTIAL IN VISITOR SERVICES

Lilita Bergs

From *Forum* (May/June 1993) © 1993 The Mid-Atlantic Association of Museums. All rights reserved.

Following decades of attention to professionalizing many aspects of the museum field, the current trend toward assessing how we serve our audiences is welcome and timely. Much of this assessment however, is focused on responsibility toward more inclusive audiences, and implications for collecting, exhibitions, and programming. In addition to addressing the needs of potential new audiences, perhaps we need to go a bit further by assessing how we treat any visitor.

The delivery of a museum's product can occur in a variety of formats, from the highly structured experience of docent-guided tours and special events programming, to the least structured, the self-guided experience of the walk-in visitor. In many museums, the walk-in audience represents well over half the annual attendance total, and improvements in our service to this audience may be the most effective and cost efficient means to increase our attendance.

Once the walk-in visitor has paid admission, that visitor will view at least part of our exhibitions, no matter how the visitor was treated. But, not unlike the experience in a restaurant visited for the first time, how you treat that captive audience determines whether or not the customer will return and how they will relate their experience to countless relatives and friends. A bad experience in a restaurant won't lead anyone to give up on eating out; a negative experience in a museum, especially for those not used to patronizing museums, may incline them to be non-users in the future.

> . . . the current trend toward assessing how we serve our audiences is welcome and timely.

It is the experience of the walk-in visitor that is the most critically impacted by the sum total of functions that are lumped into the management rubric of visitor services. In small museums, limited resources often require staff and volunteers to perform multiple functions and to interact more frequently with visitors. Because management and front-line staff are often one and the same, the small museum may succeed in conveying a more consistent message in both philosophy and delivery of service. In mid-sized and larger museums, where specialization increasingly removes large segments of the staff from front-line interactions, the responsibility for visitor services is parceled out to a variety of museum departments that may include facility management, security, accounting, food services, museum shop, education, and public relations.

The assignment of such responsibilities may seem perfectly consistent with our internal, professional needs, but, it may not necessarily be in the best interests of the visitor. The visitor quite naturally perceives the museum as a seamless whole. Any and all live bodies encountered on museum premises are viewed as experts and legitimate sources of information, and all aspects of a museum are viewed as emanating from a single and philosophically unified source.

In order to assess our performance we must try to step into the shoes of the visitor. This is not an easy task. Until recently few museum professionals ever carried the formal title of "visitor services manager," and few have received any training in customer relations. To get an unbiased view of our performance, those assigned to the task will have to set aside much "insider" knowledge and some of their day-to-day concerns in order to see how our facilities, signs, exhibitions, and our staff interact with visitors.

It might be useful to compare a museum to a retail store, which customers enter with expectations of obtaining something, and which they leave when they have satisfied that perceived need. Customer expectations about museums are not as easy to ascertain as those for a retail store, for we have yet to invest in the kind of consumer research that is common in for-profit marketing. Barring such research, let us assume that the visitor is here to satisfy the urge to see our collections, or to have a worthwhile, leisure experience with their family.

Does our signage and front-desk behavior assist or impede the customers' progress toward his or her goal? Do policies governing security, conservation, and safety impede or assist access to the "product," and are we giving contradictory messages? Despite the best intentions, do some of our staff seem bent on preventing visitors from reaching their goal? Do front-line staff have the knowledge and authority to serve visitors well?

There are a variety of techniques for gathering such information. We can observe and chart visitors' behavior, field work of a sort, to analyze visitor encounters with staff and the physical plant. Another technique is to devise reporting mechanisms to obtain meaningful information from front-line staff and volunteers. Other techniques, which might require the assistance of professional researchers,

include the administration of visitor surveys through questionnaire, interview or focus group formats.

No retail store is successful if even a portion of the sales clerks encountered by customers show poor knowledge of the products, and fail to convey a positive philosophy of customer relations. We, too, have "sales clerks" on our floors, the front-line staff that is rarely involved in assessment and planning, a pool of experienced people that knows our customers well, even if that experience is limited to tightly focused areas of operation. If we do not require front-line staff to analyze visitor services, this knowledge remains intuitive, and not readily usable. Armed with appropriate training and the opportunity for meaningful participation in improving institutional performance, these front-line resources can effectively and economically improve a museum's service and, consequently, its attendance.

A most promising development in museum management is the application of total quality principles that are successfully transforming the for-profit sector. With quality teams composed of staff from various disciplines, broad issues that cross departmental lines of authority in museums might be addressed more consistently. But even total quality management will not address shortcomings in customer relations, if visitor services in its broadest interpretation is not viewed as a priority by the museum.

We spend enormous energy, dedication, and resources to create the best and most professional products for our public. If our policies, aspects of our physical facilities and the behavior of staff and volunteers signal caution, admonition, inattention to customer needs, and contradict the expectations of the visitor, our work will have been in vain. We will have failed to convey our own conviction in the value of the product and especially our acknowledgement of its intended consumer.

Lilita Bergs is public relations officer of The Rockwell Museum, Corning, NY.

BECAUSE IT JUST MAKES SENSE: SERVING THE MUSEUM VISITOR

Kathryn Hill

From *Forum* (May/June 1993) © 1993 The Mid-Atlantic Association of Museums. All rights reserved.

When the United States Holocaust Memorial Museum (USHMM) opens this spring, we will ask visitors to take a difficult journey through a horrifying and tragic chapter of modern history. Visitors to the National Mall in Washington face no dearth of options of how they might spend their leisure time, and USHMM staff recognize that. We recognize, too, our obligation to take special care of the visitors who choose to embark upon what may be a painful experience. The various functions that constitute the Museum's service environment æ special events, the shop, the food service and the front-line service/interpretive staff æ have been brought together under one administrative umbrella, the Department of Visitor Services, and our role in the Museum's mission is to provide a comforting and caring visitor environment. In this Museum, it just makes sense.

Attention to the service environment makes sense in any museum. Based on experience at the Field Museum in Chicago, I want to put before you three reasons for establishing service to visitors as an institutional priority.

The service environment encompasses a wide array of elements, outside of exhibitions and educational programs, that impact on the quality of the museum visit: the usefulness of your directional signage, the quality of your shop and food service; the attention paid to exhibit maintenance; and the friendliness of your staff, etc. All of these elements that do not have to deal directly with education comprise the service picture. Reason number one for paying attention to the quality of your service environment is because you limit your ability to educate if you don't.

Or, put another way, they won't learn much if they can't find the bathroom.

This is reminiscent of Maslow's hierarchy of needs which tells us that human beings are not likely to embark upon intellectual pursuits until they have satisfied their more fundamental needs. This is also common sense.

In their book, *The Museum Experience*, John H. Falk and Lynn D. Dierking explore the literature available on museum learning and argue that:

"The visitor's perception of the museum is functional because he is a user, not a planner or insider. His view is not limited to an intellectual discipline or to individual exhibits or objects; rather, the visitor's perception is highly contextual, including the personal, physical, and social contexts. The visitor's experience must be seen as a whole, or gestalt." [1]

Falk's and Dierking's research suggests that museum learning is influenced by myriad factors, including the visitor's own reasons for visiting, prior experiences with museums in general and yours in particular, his interaction with other museum visitors and staff and the physical setting in which exhibitions and programs are found. Even 'minor' amenities, such as parking, lighting, benches, wastepaper baskets, and noise levels, affect the visitor's experience and can either facilitate or hinder learning. If it is true, that a comprehensive approach to visitor services can actually enhance a museum's ability to educate, then attention to serving visitors moves from the realm of nice-to-do and into the realm of our mission demands it.

Secondly, museums cannot afford not to serve visitors well. Museum professionals define museums as educational institutions, but why do people come to museums? When we asked our visitors to the Field Museum that question, in a comprehensive audience analysis, 62% of respondents said they came to have a good time with family and friends or to show friends and relatives the sites of Chicago.[2] That's over half of the Field audience coming essentially for entertainment. Studies in other museums have produced similar results. If we are interested in healthy attendance, we cannot afford to interfere with a visitor's good time. And visitors do care about this stuff.

In that same Field Museum study, we asked visitors what they liked and didn't like about their visit. The preponderance of positive responses referenced specific exhibits, the quality of the exhibition program and the architecture. Of the 55% of respondents who had negative reactions, 44% complained about general building maintenance, acoustics, exhibit maintenance and poor amenities. Only 11% criticized the quality of exhibitions.

It may be that visitors hesitate to criticize our programs, assuming our expertise in that area. But they are not reticent to criticize those things about their visit that have to do with whether we are making the experience enjoyable or not. In this economic climate, museums have to acknowledge visitors' reasons for visiting and make sure that we are not giving visitors a single reason not to visit us.

The final reason I want to discuss has to do with our service providers æ the front-line staff who represent your museum to your public.

Of all those elements that comprise the service environment, the people who meet and greet the public may arguably represent the most important. The volumes and volumes of literature available on the topic of customer service are unanimous in espousing the tenet that, if you treat your service providers well, they will treat your customers well, and conversely, if you don't, they won't. A caring and responsive service program depends heavily upon a quality work environment in which information and training are accessible, expectations are clear and achievement is rewarded.

This all makes sense in any service-oriented environment. The reason this piece of business is critical in the museum setting is precisely because we describe ourselves as educational institutions and because we, in this profession, have spent countless hours in discourse on multi-culturalism and on serving underserved audiences. And once those audiences arrive, who is it that serves them? The fact is our front-line staff probably represents the most diverse of our employee groups and come from the very communities we are trying so hard to reach. If it's true that how we treat our staff will be reflected in how they treat visitors, and if we truly care about serving the underserved, then we must pay attention to our service people. But more importantly, unlike our visitors who are with us for a couple of hours once a year, our employees are with us forty hours per week, fifty weeks per year, and we, as educational institutions, are in an enviable position to serve them æ by crediting them with being intelligent individuals, equipping them with skills and information, empowering them to serve our visitors and listening to their ideas about how we might do that better. The payback to the institution is incalculable in new ideas, increased productivity and infinitely better service.

Our mission is to educate. We cannot do that if we are not serving visitors. We cannot survive if we are not assessing and satisfying the needs of our constituents. If the most important ingredient in the service environment is our people, and if we take ourselves seriously as institutions of learning, we must begin by educating our own in new and creative ways æ in the best interest of our employees and in the best interest of our visitors.

NOTES

1. John Falk and Lynn D. Dierking, The Museum Experience, (Washington, D.C.: Whalesback Books, 1992) p 83.

2. "People, Places & Design Research," Audience analysis Field Museum of Natural History, Chicago, IL, (unpublished)

Kathryn Hill is director of visitor services at the United States Holocaust Memorial Museum in Washington, D.C. Formerly, she was chairman of public services at the Field Museum of Natural History in Chicago.

CHAPTER 2

What Visitors Want and Need

VISITORS' BILL OF RIGHTS
An open letter to museums, parks, aquariums and zoos

Judy Rand

From *Visitor Behavior* (Fall 1996, vol. XI, No. 3.) Reprinted with permission of Judy Rand, Rand & Associates, Seattle, Washington

Visitors are real people, with real human needs. If you think that goes without saying, consider this: when's the last time you walked through your institution and saw it like a first-time visitor does? It's almost impossible; as an expert, you already know too much. But if you don't know what the first-timers need, how do you know they'll return?

Of course, your particular audience has some special needs you won't know about until you survey them, but many human needs cut across age, gender, ethnicity and interests. And the experts in human behavior tell us that unless you provide for basic needs, the visitors will be distracted, rather than open to learning.

Based on years of research into visitor behavior, environmental research and human psychology, the Visitor Studies Association has identified 11 needs common to all your visitors:
 Comfort
 Orientation
 Welcome
 Enjoyment
 Socializing
 Respect
 Communication
 Learning
 Choice and Control
 Challenge and Confidence
 Revitalization

1. **Comfort. "Meet my basic needs."** Visitors need fast, easy, obvious access to clean, safe, barrier-free restrooms, fountains, food, baby-changing tables and plenty of seating. They also need full access to exhibits.

2. **Orientation: "Make it easy for me to find my way around."** Visitors need to make sense of their surroundings. Clear signs and well-planned spaces help them know what to expect, where to go, how to get there and what it's about.

3. **Welcome/belonging. "Make me feel welcome."** Friendly staff help visitors feel more at ease. If visitors see themselves represented in exhibits and programs and on the staff, they'll feel more like they belong.

4. **Enjoyment. "I want to have fun."** Visitors want to have a good time. If they run into barriers (like broken exhibits, activities they can't relate to, intimidating labels), they can feel frustrated, bored or confused.

5. **Socializing. "I came to spend time with my family and friends."** Visitors come for a social outing with family or friends (or to connect with society at large). They expect to talk, interact and share the experience; exhibits can set the stage for this.

6. **Respect. "Accept me for who I am and what I know."** Visitors want to be accepted at their own level of knowledge and interest. They don't want exhibits, labels or staff to exclude them, patronize them or make them feel dumb.

7. **Communication. "Help me understand, and let me talk, too."** Visitors need accuracy, honesty and clear communication from labels, programs, and docents. They want to ask questions, and to hear and express differing points of view.

8. **Learning. "I want to learn something new."** Visitors come (and bring the kids) "to learn something new," but they learn in different ways. It's important to know how visitors learn, and assess their knowledge and interests. Controlling distractions (like crowds, noise and information overload) helps them, too.

9. **Choice and control. "Let me choose; give me some control."** Visitors need some autonomy: freedom to choose, and exert some control, touching and getting close to whatever they can. They need to use their bodies and move around freely.

10. **Challenge and confidence. "Give me a challenge I know I can handle."** Visitors want to succeed. A task that's too easy bores them; too hard makes them anxious. Providing a wide variety of experiences will match their wide range of skills.

11. **Revitalization. "Help me leave refreshed, restored."** When visitors are focused, fully engaged, and enjoying themselves, time flies and they feel refreshed: a "flow" experience that exhibits can aim to create.

WHAT VISITORS VALUE

Will Phillips

From *Newsletter on Institutional Transformation* (Vol.3, No.1) published by Qm2—Quality Management to a Higher Power, Poway, CA. Reprinted with permission of the author.

If a museum wants visitors to return frequently, it must understand how to delight, not simply satisfy them. If you don't address this challenge, you may create an unending stream of new visitors who never return.

Knowing what your visitors (and potential visitors) value provides an underlay for understanding how museum programs will be received. Visitors gain value in four basic areas of the museum experience.

1. Programs and exhibits initially attract visitors to the museum's core competencies. Quality counts, as does frequency. The movie changes every few weeks. The symphony has a new program every performance. How often does your museum open a new exhibit? Urgency leads to action.

2. Basic support services make the visitor's stay convenient, efficient and effective. Is the museum easy to find? Is parking convenient? When I enter the museum, am I easily oriented? Am I greeted warmly? Are there clean, well-stocked restrooms? Can I get a bite to eat? Can I sit comfortably in the galleries? Can I get an audio tour? Is the museum open when I have free time? Extraordinary programs and exhibitions will attract visitors but may not sufficiently delight them to return unless you take care of creature comfort needs; orientation, excellent food service, clean restrooms, quiet spaces, adequate parking, and accessible public transportation all play a role in engaging the visitor and setting him on a course for a return visit.

3. The museum's recovery process refers to the standard way employees recover when a visitor complains or when a failure occurs in the eyes of the customer. Our natural response to a complaint is to do the very opposite of what enables recovery. We tend to explain why the problem is not our fault or belongs in some other part of the organization. The cafeteria always closes at 3:00! At times we blame the visitor and point out why it's the visitor's fault. Good recovery is rare, but powerful. Many people have experienced its power at one of Nordstrom's department stores or at a Lexus auto dealership.

4. Customizing the experience is the final category available to you to delight the visitor. A customized experience can move away from speaking to the visitor, toward speaking with her. The museum monologue turns into a dialogue. The visitor begins to teach the museum more and more about his needs, his situation, what's important to him. The museum can better and better serve visitors with exactly what they want, when and how they want it. The customized experience is a continuous collaboration between museum and visitor, with the museum learning what programs, exhibits, and services to provide and how to tailor those programs to the needs of the visitor. Customization in museums currently occurs for very special visitors. The time has come for museums to begin learning how to provide mass customization to all their visitors. The corporate world is leading the way in this area and reaping the rewards of extraordinary success.

VISITOR SATISFACTION

The taxonomy of visitor needs discussed earlier, when evaluated via levels of satisfaction shown in the table below, can help you increase visitor satisfaction and loyalty.

The table shows levels of satisfaction gauged against the four ways of creating value. By using this evaluation system, you can begin to see when to improve and when to address other types of customers. Dramatic increases in satisfaction will come with small investments in low cost areas such as an improved recovery process. It is also important to consider whether the museum should even attempt to respond to the very dissatisfied customer. He may, in fact, have come to the wrong place or be inherently unsatisfiable.

Phillips has been a speaker and seminar leader for the American Association of Museums and its regional conferences. He was the

Satisfaction Score	Satisfaction Level	Levers
5	Very Satisfied	Right programs and exhibitions, basic support provided. Customed relationship, strong recovery process.
4	Satisfied	Right programs and exhibitions, lack of some basic supports. Lack of customized relationship.
3	Neutral	Right programs and exhibitions, lack of basic support and customizing. Poor recovery.
2	Dissatisfied	Programs and exhibitions not right for visitors' needs and values. Lack of basic support. Poor recovery.
1	Very Dissatisfied	Chronic complainers. Lack of basic support. Poor recovery.

A WELCOME IN A NEW PLACE

Eilean Hooper-Greenhill

Reprinted with permission of ITPS and Routledge Press first as "A Welcome to a New Place," by Eilean Hooper-Greenhill, from the book *Museums and Their Visitors*, 1994, pp.88-90.

For visitors to museums and galleries, it is the total experience that will be remembered (Hood, 1989: 168). The total experience includes the exhibitions and activities, and also the shop, whether there is food and drink, the cleanliness of the toilets, the friendliness of the staff and most importantly, the quality of the museum or gallery visit will depend to a large extent on how easy it is to manage, in practical terms, on an intellectual level and socially. Many first-time visitors find it difficult to feel comfortable when first trying out a museum. This is not unique to museums. It is always a little strange to arrive somewhere unfamiliar. Thinking about what we do then might help to empathize with the first-time visitor to a museum or gallery.

On first arriving at an unfamiliar place the immediate feeling is often one of not knowing what to do or where to go. For some people this is an exciting feeling, but for others it leads to a feeling of being out of control and confused. In some, the anxieties caused by feelings like these are such that unfamiliar places are avoided as far as possible. What helps us to cope at times like this?

First, we need some information. If we are in a new town, on holiday perhaps, we need to know what there is to do, where the landmarks are, perhaps where the train or bus station is. We also perhaps want to explore. The information that we need depends on what we want to do, and what our personal needs and abilities are. If we are accompanied by tired and hungry children, rest and food might be the first concern. At a basic level, what we need is a 'menu' that lays out the opportunities for physical comfort (food, drink, rest, cloakrooms) and for the highlights of the town (museum, library, police station, shopping facilities, parks, tourist information). From this information we can build a personal agenda for action, depending on our interests, resources and constraints (time, energy, money, abilities).

In an unfamiliar shopping-centre, the needs are much the same. On arrival we need to know what comfort facilities there are (parking, creche, cafe, toilets, seating areas) and where the various shops are (food, clothes, chemist, post office). Many of the new out-of-town shopping centres have become skilled at directing customers to the various facilities in the order in which they are required (parking, toilets, other comfort facilities, then a choice of shops, a cup of coffee half-way through, and back to the car-park). Some of the better motorway service stations deal with things in the same way, and so of course do theme-parks and well-managed leisure venues, such as country houses, countryside parks, castles and so on (Westwood, 1989).

But what of museums? It is still possible to fail to find a museum because of lack of directional signposting. It is not unusual to walk past a museum or gallery building because it has no name on the outside, and it is almost normal to go in to a museum and discover such a dearth of information about what the museum is about that, rather than make the effort to find out, it is easier to walk straight out again.

What do we need to know on entering an unfamiliar museum or art gallery? We need to know what comfort facilities there are and what there is to see or do. We need to have this clearly presented in such a way that it is easily accessible and easily comprehensible. We then need to be able to find our way to whatever we choose to do first. This is so basic that it would seem a waste of time writing it down, except for the fact that there are very few museums that offer information of this nature. Very few museums name the comfort facilities (cloakrooms, cafe, shop, creche) and direct visitors to them, and even fewer name the galleries or exhibitions that may be seen, or provide a list of 'top ten' objects that could be seen, or provide suggestions for how to visit the galleries according to particular interests. Sometimes this information can be found in a guidebook or leaflet, which is of course useful, but this

basic orientational information must also be made available through panels in the entrance to the museum. Plans of the galleries should be displayed, with key points indicated and rooms named.

Museums are often difficult places to visit. As well as the lack of general information, the expressions used to describe the potential highlights of the visit are not those used in everyday life.

Eilean Hooper-Greenhill is a Lecturer in Museum Studies at the University of Leicester. She is author of Museum and Gallery Education *and* Museums and the Shaping of Knowledge.

CUSTOMER PERCEPTION AUDITING
A Means of Monitoring the Service Provided by Museums and Galleries

Nick Johns and Sue L. Clark

Reprinted from *Museum Management and Curatorship*, Vol.12 No.4, by Nick Johns and Sue L. Clark, "Customer Perception Auditing," 1993, with permission from Elsevier Science.

INTRODUCTION

Quality auditing is now well established as a means of assessing and enhancing service quality in many industrial sectors, and this paper suggests that the time is ripe for museums and galleries to take up the quality audit approach as a positive response to the service quality challenge. A quality audit is a systematic appraisal of service quality. It offers a quick and effective means of assessing service quality from the viewpoint of the customer. In fact it is often the only practicable way to do this. Auditing is widely used today by hotel and restaurant chains, retailers, high street banks and many other organizations offering a commercial service to the general public. Early approaches to quality auditing saw service quality primarily from a provider's point of view.[1] Typically, a checklist was prepared of aspects which management felt were important to the service, and these were then examined one by one, with the service assessed accordingly. The last ten years have seen a movement towards what is termed the customer perception audit, i.e. a type of appraisal structured to reflect the customer's view of service quality.

Quality audits have often been conducted by in-house personnel, particularly in large organizations such as hotel chains.[2] However, in-house auditors quickly become over-familiar with the service standards of their organization. They may take some aspects of the service for granted and will also tend to emphasize the aspects of quality which management regard as important, rather than those which are significant to the customer. Guest perception audits,[3] on the other hand, are usually carried out by specialized consultants. External appraisers are able to see the service product in a fresher light, and at the same time they can communicate their findings to management in a professionally oriented way.

WHY AUDIT?

British museums and galleries are currently undergoing a fundamental shift in outlook.[4] Rapid expansion, particularly in the numbers of independent museums, has led to a general fall in visitor numbers at most institutions, while at the same time there has been an increase in the numbers and diversity of attractions competing for the finite revenue from tourism and leisure. There is a growing need for museums to market themselves effectively, an important aspect of which is knowing the impact that their service product makes upon the visitor. However, public tastes are also changing, and competition from commercial tourist attractions may produce an 'enter-

tainment-orientated' mentality in some visitors, though market research indicates the growth of a suitable target market within what is termed the inner-directed attitude group. Individuals in this group tend to have well-developed spiritual and aesthetic values and may be involved on a voluntary basis with initiatives for the benefit of society, such as museums. Their behaviour reflects self-expression and self-realization, and when museum users, they are likely to be highly knowledgeable and discriminating about museum services. Quality auditing can contribute to a high degree in ensuring that the needs of such specific market segments are met.

Museums themselves are also becoming increasingly aware of the need to manage their service quality. This includes tangible aspects such as the buildings and exhibits, but it also applies to the helpfulness, enthusiasm and efficiency of staff. Museums and collections are increasingly turning to interpretive approaches, in which personnel demonstrate the dress and behaviour of the past, and here there may be conflict between the desire for accuracy and the need to maintain service standards. Quality audits provide an effective way of ensuring that these objectives are met.

The United Kingdom, like many other Western countries, is experiencing a demographic shift as the post war 'bulge' moves into middle age. This is likely to produce Increasing numbers of inner-directed individuals, but it will also bring a greater demand for disabled facilities, en-route seating, and services such as restaurants and toilets. Museums will do well to examine their facilities in the same way as inspectors from disability groups do, i.e. from the customer's perspective. Furthermore, museums are under a number of practical pressures which may affect the quality of their service. Security precautions may cause congestion at the entrance. Access and flow patterns may need to be controlled. Queuing is another potential problem which may be reduced or avoided by careful management. The behaviour of service personnel is also affected by crowding and by under-utilization. These problems can be detected by a visitor perception audit and may subsequently be addressed.

THE AUDIT PROCESS

Customer perception audits are usually based on the customer journey concept, i.e. the service experience is regarded as a 'journey' through the series of events shown in Figure 1.[5] Museums represent a very specialized type of 'service', with a number of specialist features, including:

extensive movement of people at all stages of the 'journey';

unpredictable flow and demand patterns;

a need to help customers make decisions about what they want to see and in what detail they wish to see it;

a comparatively long 'journey time', during which services such as food, drink and toilet facilities will probably be needed; and

commercial opportunities often limited to the gate, the restaurant and the shop.

Figure 1.

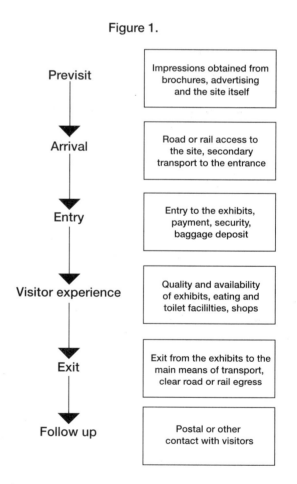

Previsit	Impressions obtained from brochures, advertising and the site itself
Arrival	Road or rail access to the site, secondary transport to the entrance
Entry	Entry to the exhibits, payment, security, baggage deposit
Visitor experience	Quality and availability of exhibits, eating and toilet facililties, shops
Exit	Exit from the exhibits to the main means of transport, clear road or rail egress
Follow up	Postal or other contact with visitors

Despite these specialist features the customer journey is the most appropriate way to break down the visitor's experience of a museum. It is common to all segments of the market, and yet provides a starting point from which to consider the needs of different groups in different museum environments. It is thus worth considering the stages separately in detail.

The pre-visit stage is that which forms visitors' initial expectations of the venue and makes them want to come. Individuals may obtain their information in a number of ways: from publicity material such as guide books, brochures and advertisements, and from notice boards located at the site. It is essential that these provide adequate, accurate information. For example, they should make clear any peculiarities of opening times (e.g. Sundays reserved for members of a particular association) or of pricing structure (e.g. students half price, except during vacation periods and bank holidays). It is equally important that promotional literature and notices project an attractive image, and the same applies to the site itself. Pre-visits also give the potential visitor an impression of the accessibility of a venue. For example, an area that is always crowded or congested on a Sunday is likely to be avoided, at least on Sundays. Pre-visits also transmit market positioning signals, and potential visitors may be put off by a perception that the experience will be uncomfortably down-market, excessively 'educational', or over-frivolous.

Arrival is the stage at which visitors begin to collect experiences to compare with their preconceived expectations. Important aspects include signposts, maps and location instructions. Approach roads may be inadequate for the type or volume of vehicle traffic, and the car parks may not be able to handle the volume of vehicles to be expected on particular days. Public transport may leave visitors, particularly the elderly or disabled, stranded beyond reach of the gate, while the weather may pose problems if there is a lack of covered walk-ways or complimentary umbrellas are not provided.

Entry is the first stage at which the visitor encounters the actual service offered by the museum. This may be the moment of truth when irritating aspects of the entry regulations or the pricing structure manifest themselves. Visitors may be required to queue for security checks or to deposit bags and clothing, and it is important that this first encounter with museum personnel is courteous and friendly. Entry is often the stage at which the needs of disabled visitors are first noticed. Wheelchair hire may be necessary, as well as arrangements for dealing with walking sticks and guide dogs. If entry to the museum precludes certain types of shoes (stiletto heels for example) there should be arrangements to borrow or hire alternative footwear.

An individual visitor's experience of the museum 'product' is very personal in nature. Nevertheless several aspects are common to different groups of individuals and therefore of general concern. Visitors generally wish to experience exhibits, particularly popular or famous exhibits, in one of two ways. They may wish to have a 'guided tour' which points out interesting details. Or, if they are already familiar with a display, they may wish to experience it again in its entirety, picking out for themselves aspects which they may have missed at previous encounters. Guided tours may be accomplished by an actual guide, by a guide book, or by electronic techniques such as interactive multi-media software or closed-circuit TV. Individual appreciation of an exhibit is affected by flow patterns and carrying capacity. Visitor experience is often enhanced by establishing pathways through the exhibits. Pre-programmed routes assist decision-making in the face of a bewildering array. They may also help to reduce congestion at particular exhibits. They do however depend upon good internal signposting, a logical layout, clear orientation maps, and well trained, well coordinated personnel.

The overall time spent in a museum is an important feature of the visit. It may affect visitors' perception of the value they have received for their money, but it also affects their need for services, including seating, restaurants and toilets. The location of these facilities is critical, though attention should be paid to the balance between revenue-generating opportunities, such as restaurants, and non-revenue competition, such as free seating areas. The opening times of restaurants are also very important in terms of the visitor experience. So is the hygiene of toilets and washrooms. Shops are increasingly an essential feature of museum visits, and they should reflect as high a level of service quality as that provided in commercial outlets elsewhere. Retailed goods, clothing, carrier bags and packaging are all marketing opportunities and should make clear statements about the museum, its exhibits and its value to society.

Exit from the museum is as important as entry, and visitors should leave the premises gratified, though with a feeling that the museum holds many additional interesting items, as yet unseen. Creative control of queues is crucial. Enjoyment of the visit must be maintained throughout the exit process, even though bags may have to be reclaimed and hired items returned. The walk back to the car park or to public transport may have pitfalls which were not encountered on arrival, and the signposts indicating the way out may be as critical to visitor satisfaction as those encountered on arrival. Follow-up may consist of mail order catalogues and purchases. Alternatively there may be newsletter or membership opportunities for local residents and enthusiasts. Follow-up may be important in terms of maintaining interest in the museum and encouraging repeat visits, and it is an opportunity all too frequently overlooked by museums in the United Kingdom.

LESSONS FROM THE QUALITY AUDIT

A properly managed customer perception audit gives management an overview of the whole museum product from the visitor's point of view. It will usually consist of a flow-chart of the 'visitor journey' together with an analysis of the strengths, weaknesses and issues at each stage. It should permit a better understanding both of the service itself and of the needs of specific customer groups. Current theorists propose the model of service provision shown in Figure 2. The quality of a service is affected by five 'gaps' which occur in this delivery model and which are defined in Table 1 on page 21. Customer perception audits help management to close these gaps in the following ways.

1. The positioning gap is located between the customer's requirement and management's concept of the product. Quality auditing helps bridge this gap by indicating

Figure 2: A simplified model of service quality provision showing gaps.

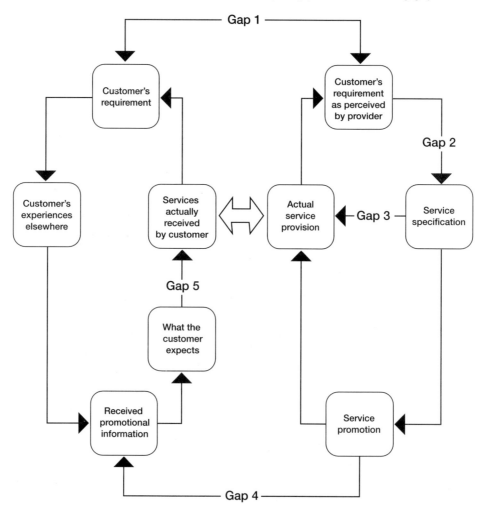

more clearly what the customer actually wants. It is then up to management to adjust organizational objectives accordingly. Marketing strategy may also need attention and the whole corporate climate should be communicated to employees through a suitable mission statement.

2. The specification gap is that which occurs between management's vision of the museum 'product' and the specifications or policies that are written for employees and others to follow. A quality audit can clarify the messages, which need to be sent both to staff, and to designers, architects or shopfitters. Tangible aspects of the museum (such as clean toilets) can be specified, but so can service-related ones, such as the way staff answer telephones or deal with visitor inquiries.

3. The delivery gap, between what is specified and what is actually delivered, is particularly critical in service oper-

ations. It may be controlled by staff training and by team-building, and it is important to encourage an ethos which clearly reflects the organizational objectives and mission of the museum. Many service organizations are currently working to change their employee culture to one of continuous quality improvement. Customer perception audits offer an excellent way to support such a programme by benchmarking progress and re-evaluating the function of quality systems.

4. The communication gap is that between the museum s external image and the service it is actually able to deliver. It is addressed by the previsit stage of the quality audit. Advertising, literature and press releases must be attractive, but at the same time must reflect the true nature of the product and the museum's organizational culture. Other promotional aspects may also be important, such as public relations exercises and information packs, for instance for schools.

Table 1: The 'five gap model' of service provision.

Gap no.	Name	Definition
1	Positioning	Between management perceptions of customer expectations and the expectations themselves
2	Specification	Between management perceptions of customer expectations and the actual service specified
3	Delivery	Between the service specified and that actually delivered
4	Communication	Between the service actually delivered and that externally communicated to customers (e.g. through advertising)
5	Perception	Between the service quality perceived and that expected by the customer

5. The perception gap, between what is perceived and expected by the customer, is the only one over which the museum has no direct control. Despite this, many studies have shown that perceived service quality is most likely to be guaranteed by closing the other four gaps. The perception gap is not directly assessed by quality auditing. It is best measured by visitor survey questionnaires, or by market research initiatives. However such activities tend to be time-consuming and expensive. The visitor perception audit does provide a quick and comparatively inexpensive glimpse of the factors contributing both to the perceptions and the expectations of museum visitors.

CONCLUSION

This article has attempted to describe the nature of customer perception audits and their value in the promotion and development of museums. This type of quality audit has gained rapid ground in recent years, as organizations have recognized the importance of high-quality service. The fruits of such techniques may be seen in many diverse service industries, including supermarkets and banks. Their use is also acknowledged in the public sector, particularly in highly competitive areas. Museums clearly come into this category and must make use of modern quality enhancement techniques such as quality audits if they are to ensure their proper place in the next century.

NOTES

1. Walter Willborn, 'Quality Assurance Auditors and Hotel Management', Service Industries' Journal, 6(3), 1986, pp. 293-308.

2. Peter Jones and Andrew Lockwood, The Management of Hotel Operations (Cassell, London, 1989).

3. Andrew Fay, 'Auditing Hotel Employee Performance'. Journal of Property Management. 56(6), 1991, pp. 26-28.

4. Victor Middleton, New Visions for Independent Museums in the UK (Association of Independent Museums, Chichester, 1990).

5. Susan Whittle and Morris Foster, 'Customer Profiling; Getting Into Your Customer's Shoes', International Journal of Bank Marketing, 9(1), 1991, pp. 17-24.

6. A. Parasuraman, Valarie A. Zeithami and Leonard L. Berry, 'A Conceptual Model of Service Quality and its Applications for Further Research', Journal of Marketing, 49(4), 1985, pp. 41-50. Andrew Brogowicz, Linda M. Delene and David M. Lyth, 'A Synthesised Service Quality Model with Managerial Implications', International Journal of Service Industries Management, 1(1), 1990, pp. 27-45.

Nick Johns obtained his PhD in Chemistry from the Loughborough University of Technology and has researched and taught a wide range of chemical and biochemical topics since then. Since 1990 he has undertaken research on Productivity in Hospitality Management at the Hotel School of the City College Norwich (UK) where he is Reader and Director of Research.

Sue Clark received her Postgraduate Diploma in Tourism from the University of Surrey and gained extensive experience in the tourist industry, both in the United Kingdom and overseas, before joining the Hotel School of the City College Norwich where she is Course Leader for Higher Education Tourism Courses.

TIPS ON SERVING VISITORS' NEEDS

Mary Kay Ingenthron

Reprinted from News Brief (vol.7, no.1), the newsletter of the Association of Midwest Museums. © Mary Kay Ingenthron

Studies show that upwards of sixty-five percent of museum visitors attend museums with family and friends to be entertained, to learn, and to have fun. How the public feels about a particular museum visit determines whether or not they return, and how they relate their experience to countless relatives, friends, and acquaintances.

All museums, large and small, need to pay attention to their quality of visitor services, for without a positive experience a museum limits its ability not only to attract future visitation, but the ability to educate and inform.

Behaviorists believe that people embark on intellectual pursuits only after they have satisfied fundamental needs. Translated to the museum environment, visitors can be easily distracted from the entertainment and educational value of exhibits when the rest of their museum experience is unsatisfactory, when even minor service and amenities are not provided.

If the behaviorists are correct, then museums need to approach visitor services as a means of enhancing, their ability to educate, inform, and entertain. Attention to visitors fundamental needs moves from the "nice-thing-to-do" and into the realm of the "museum's mission demands it."

Visitor services touch every aspect of the visitors experience — friendly and well-trained staff and volunteers, accessible and readable exhibit labels, adequate lighting, benches, clean and adequately supplied restrooms, affordable food service, available parking, directional signage, trash containers, etc.

To access your museum's visitors experience, step into their shoes, see your museum as they see it. Visit your museum on a weekend when staff and volunteers may not recognize you and experience the museum as others do, not as an "insider" but as a tourist.

- Look for information on the museum at places tourist frequent — information centers, hotels, motor inns, chain restaurants. Is it available?
- Reach the museum via highway and city directional signage.
- Once at the museum, park in the visitors' parking lot. Is parking ample and accessible?
- Enter the museum through the visitor entrance, and pay the regular admission price.
- Is the admissions staff welcoming, friendly, helpful?
- Do you receive a visitor guide and/or gallery map to help orient you to the museum?
- Are membership, calendar of events, and other informative brochures available at the admissions desk?
- Is signage to exhibits, restrooms, museum store, and food service prominently displayed?
- Are restrooms clean, fully supplied, and equipped for small children?
- Are exhibit labels easy to read, even for those with poor eyesight?
- Are hands-on exhibits working? Are exhibits clean and well-maintained?
- Does directional signage give visitors choices on how to proceed through the galleries or on how to leave?
- If you were inclined to purchase from the museum store, is the merchandise reasonable priced?
- Is the food service food of high quality and reasonably priced?
- Are the guards friendly? Do they respond to your questions in a helpful manner?
- When leaving the museum are your thanked for coming and encouraged to return?

Considering the pressures of the economy and increasing dependence on earned income, museums can no longer assume that "if we display it, they will come." In order to compete for the public's leisure time dollar, it is crucial that museums become sensitive to issues of visitor comfort. As an "outsider," as a tourist, how was your experience at your museum?

Mary Kay Ingenthron is Principal, MK Communications in Shawnee Mission, Oklahoma.

CHAPTER 3

Organizing Visitor Services in the Museum

VISITOR SERVICES PAY OFF

Steven M. Pulinka and Deborah N. Buckson

From *Forum* (May/June 1993) © 1993 The Mid-Atlantic Association of Museums. All rights reserved.

At the 1992 MAAM/NEMA Annual Meeting, the staff of the Historic Houses of Odessa chaired a seminar on visitor services. Halfway through the panel presentations, we were talking as much about marketing was anything else. We just happened to mention that since focusing on visitor services, we increased our attendance by 33 % in three years. Better yet, we increased our group visitation by 90 % in the same period. Suddenly, questions were flying from every corner of the room. Needless to say, we spent the balance of our time talking about the interplay between visitor services and successful marketing.

Our story began in 1990 when the staff of Historic Houses of Odessa sat down and faced some hard, honest facts. Our attendance was slightly over 7,000 people a year and reflecting a slow but steady decline. We responded by increasing special events, a band-aid which assisted the healing process, but was not a cure for the disease. Our location in rural Delaware did not make our site a natural attraction, and though we are a part of the well-known Winterthur Museum we existed on a separate endowment which barely covered our needs.

Being two, no-nonsense, professionals we soon got down to basics. Having limited resources forced us to focus and define our mission. Once a mission statement was devised, we frankly admitted that increasing attendance was a major goal. The great thing about writing goals and objectives is it often puts hidden assumptions on the table. It turned out our board was on the same wavelength and was delighted with our approach.

Next we defined who our audience was and how we wanted to approach them. Of course, we had the usual breakdown æ walk-in visitation, special events, groups and school tours. But, which promised the greatest gain with our limited resources? Our answer was large groups. The dollars and cents of large groups argue persuasively on their behalf. They are the most efficient use of staff, who can be scheduled and paid for specific times, rather than waiting around for walk-in visitors to appear. They earn money for the institution in admissions, the gift shop and lunches so that it would not be unusual for a large group to contribute $1,000 a visit to our earned income line.

Having accepted this as a goal, we had to tackle the negative image large groups had with our own staff. We decided to have a very close look at how we traditionally dealt with large groups and found this negative image was because we were not considering their special concerns and needs. We found that our staff needed specific training about how to handle large groups and we needed to rethink our whole process.

The Delaware Tourism Office proved invaluable to our efforts. We had worked with the excellent staff of this small but professional office and found their advice to be right on the mark. After going to several seminars given by them, it was a short walk to asking their advice about how to attract our target audience. We researched the market and talked to the suppliers. We developed a five year plan which aimed at increasing our group attendance to 5,000 people in a year by 1993 and 10,000 people a year by the year 2000. Our overall attendance goal was 20,000 visitors a year by 2000.

Visitor Services was an integral part of our plan. Being a small site, we knew we had to fight hard to attract more visitors and to keep those we had. Hospitality has always

been a strong suit and we decided to capitalize on it. In the training programs offered by the state it became apparent that not only could we sharpen our "people skills" generally, but also we could apply them to specific marketing goals. Our experiences with groups gave us a picture of what their needs were. They were not complicated: restrooms, a place to eat, a chance to shop and the feeling that they were welcome and that we were providing a personalized service. You may ask, where do the educational goals sited come in amongst market considerations, visitor services and financial goals? The answer is that they are the same for large groups as for the individual walking in the door. Large groups are groupings of individuals in terms of our education objectives.

We moved on all fronts to supply these demands. We immediately started a "box lunch program." We supplied a location, the atmosphere and staff; and a nearby restaurant delivered the lunches. Within a year most of our groups were taking advantage of this service, on which we make a modest profit. Next, we centralized reception, ticketing, orientation and offices in one building so that services were easy to get to. We moved our gift shop to make it more accessible and expanded its floor space. Luckily, new restrooms were available in our reception center. Lastly, we introduced an orientation video which started everyone on the same footing.

At the same time, we reorganized our staff so Deborah Buckson, Curator of Education and Public Programs, directed efforts and we added a half-time Tourism Coordinator position, held by Linda Danko. This was crucial in making any headway, since this market requires coordination by mail, telephone and a great deal of personal contact with tour organizers. In analyzing the large group programs of other institutions we noticed a lack of commitment to this market. That is, the institution might say that it wants large groups but does not provide the staff and other resources necessary to accomplish the task. In our case we sacrificed a secretarial position in order to have a Tourism Coordinator position.

The group market requires inside knowledge that cannot be learned from literature. To that end we made it our business to woo tour organizers by treating them to a fireside lunch. We have also made it a point to attend and make contacts at regional market places, like the Pennsylvania

Bus Association and National Tourism Association. These can be whirlwinds of six-minute interviews with tour organizers and well worth the number of contacts that are made. The Delaware Tourism Office cautioned us not to expect immediate results because the group tour market works 18 months to 2 years in advance.

The group market requires inside knowledge that cannot be learned from literature.

In house, we continue to provide visitor service training, but more specifically, how to conduct tours for groups. Interpreters are vital to the whole effort. It is important that staff convey the sense that large groups are valued customers and that we are making a special effort to attract them. This goes hand-in- hand with the idea that people are at least as important as the collection and the information one imparts. We all know the story of the "great" guide who has vast amounts of knowledge about the history of the site and little idea of how to transmit that information in an entertaining and "people-wise" way.

Group Tourism can be a real logistical challenge for a small historic site and we have continued to improve ways to handle numbers of people. To this end, we redesigned the tour structure. But before they even arrive the visit starts with our Tourism Coordinator, when she takes the first telephone call. We unified the format so all information flows through this staff position. Terms are agreed upon in advance, in writing, and last minute changes are documented with follow-up correspondence.

When the group arrives, we are very careful that their first impression is one of hospitality. A designated staff member greets the group while they are still on the bus with general information. The group is immediately escorted to the orientation area where they see a seven minute video and are free to use restrooms nearby. Clear communication is one of the keys to a successful tour and the group is informed about exactly what to expect of their tour, when to meet back at the bus, when lunch starts, etc. At this point, they are split into several smaller touring groups and are introduced to their guide who stays with them throughout the tour, creating a sense of continuity.

What happens with the group's experience once they are on tour is our current focus of training. We want our visi-

tors to leave the site with an emotional imprint æ of a pleasant, educational outing æ where they were treated as individuals and had their curiosity aroused.

Practical concerns have to be considered first, although they should remain invisible to the visitor. For instance, security on tour is our number one concern but several things can be done to insure the best odds in favor of the collection. Small objects are placed far behind the stanchions, groups are kept strictly together and are not taken in areas where crowding would be a concern.

Timing is also a major concern since the group must leave on a deadline. A frequent problem is that the group is late and must still leave at the original departure time. It happens so frequently that it is not a problem, because we expect it! Our contingency plans usually involve dropping some areas from the tour rather than trying to whisk them through the same number of rooms at a higher rate of speed.

How does a guide treat a group as individuals? Our guides tell us of many tricks. One way is to involve a single individual out of the group and address questions to him or her about how comfortable they would find that couch, or where do you suppose the servants slept, etc. The others in the group will often participate vicariously through this individual. When someone asks a question, it is imperative that the guide repeats the question for the group's benefit and then answers it, addressing the whole group. Also, we don't forget to ask each group about their particular interests ahead of time so that tours can be slanted toward an interest in decorative arts, local history, architecture, etc. We try to customize each tour and large groups are no exception.

When we think of visitor services we cannot help thinking of the marketing aspects. Museums are in the position to provide personalized services to the public. We are in direct competition with many other "attractions." We have to try harder, confident that if customers needs are met, the natural allure of the "museum experience" will shine forth.

Steven M. Pulinka is director and Deborah N. Buckson is associate curator, education and public programs at the Historic Houses of Odessa, Odessa, Delaware.

INSIDE AND OUT: VISITOR SERVICES AND COMMUNICATIONS IN THE U.S. HOLOCAUST MEMORIAL MUSEUM

Naomi Paiss

Originally published in the Spring 1994 issue of *Hand to Hand*. Washington DC, Association of Youth Museums. Reprinted with the permission of the Association of Youth Museums.

When I joined the staff of the U.S. Holocaust Memorial Museum in 1990, we designed a public relations program for an institution that only existed in its staff's imagination. In those days, the international search for appropriate artifacts, film footage, photographs, documents and survivor testimony to fulfill the design of the Museum's permanent exhibition dominated the time of the Museum's senior staff and curators. Meanwhile, a small staff of fundraisers was trying to stimulate the imagination of various individuals, corporations, and foundations to contribute to the $168 million capital campaign needed to build and equip the Museum.

The Communications Department, in these circumstances, had the same task as other public relations professionals who promote an unknown product or political candidate: to create an dentification and understanding of the Museum's mandate, purpose and programs for the American public and promote enough enthusiastic support for the Museum among its key constituencies to support the needs of the fundraising campaign. Within the first year, the department had sponsored several events and programs to begin the communications process, including the commissioning and publication of a national survey about American's knowledge of and attitudes toward the Holocaust and an ambitious program of media

tours to 20 large American cities. Slowly, the Museum began to develop a public profile and define itself as a unique and critically needed addition to the roster of American cultural institutions.

By 1992 it occurred to me that, having come to a museum environment with absolutely no museum experience, I knew a lot about attracting the public to a new concept and nothing at all about what to do with them once they got there. I had spent two years applying my experience as a Washington public affairs professional to this new Museum as if it were an idea or a program -- health care reform, say, or national service. As we drew closer to opening, however, I had the uneasy sense that something or someone was missing in an area I couldn't define, but that somehow commented on our public relations program.

At that same time, the leadership of the Museum began to look past the completion of the Museum's exhibitions and buildings to the need to operate a complex, federal, public museum. Elaine Heumann Gurian, a seasoned museum professional, joined the staff as Deputy Director and immediately began looking at operational issues: managing the gallery floors; developing and running a bookstores and café; orienting and helping visitors, particularly parents with children, in a difficult, emotionally demanding environment. In the spring of 1992, less than a year before the Museum was to open, Ms. Gurian recruited Kathryn Hill from Chicago's Field Museum to run our fledgling Visitor Service department.

Before Kathryn even had a chance to pack up her belongings in Chicago, I sent her results of focus group discussions conducted in Philadelphia, Raleigh, N.C., and the National Mall in Washington to discover who would want to visit our museum, and why — and who would not and why not. Fortunately, she joined the Museum just as we were putting the final touches on a survey of 1200 visitors to the National Mall, and the results were extraordinarily useful to both of us, as communicators plotted to entice every possible visitor to this new Museum and Visitor Services planned their experience once they got there.

Within a month of Kathryn's arrival, we discovered that there were few activities we could plan that would not affect each other's programs. One example may suffice:

A Holocaust Museum, by its very nature, is a difficult and demanding place. Our focus group studies showed that a significant number of potential visitors were somewhat afraid of what they would see in our Museum, and unsure if they could handle the sorrow and the horror of our topic. As Communications Director, it was my job to answer questions from the press and the public about the explicit nature of our displays and their potential effect on our visitors. As Visitor Services Director, it was Kathryn's job to train a floor staff in both the history of the Holocaust — to answer factual questions — and in what can only be described as the psychological impact of the experience which would be necessary to help visitors feel comfortable enough to absorb the material. It was not possible then, for the marketing effort to develop a falsely reassuring message to attract more visitors, or to soft-pedal the harsh and explicit nature of some exhibition elements. If visitors did not have a realistic sense of what to expect when they entered our portals, the front line staff would be dealing with some angry, upset, and discomfited visitors who had been led to expect an easier experience.

If a visitor asks why we are a federal museum, or why we tell the story of all the victim groups, or what the museum's position is on modern-day Germany, he will get the same answer from a gallery representative as he will hear from me during an interview on talk radio.

Over and over again, we discovered that the external messages proffered by my department had to closely coincide with the actual experience handled by hers. When we discovered, for example, that the design of the permanent exhibition contained some unavoidable bottlenecks, it was a visitor service's job to figure out how to pulse visitors through in an efficient manner that would not diminish the experience. One answer, only six weeks before opening date, turned out to be timed tickets for the permanent exhibition, administered by Ticketmaster. It was then up to the Communications staff to publicize the policy through free media, as quickly and as prominently as possible. To a certain extent, we succeeded — but both the gallery and PR staff felt the sting of visitor comments in our early months when the ticketing policy was not completely communicated to an eager public.

Similar questions, some common to every museum and some peculiar to ours, kept arising, and busy as we were the Communications and Visitor Services staff made sure to check in with each other before even a de facto decision on any sensitive issue was reached. This is not to say that we did not sometimes find ourselves at cross-purposes. The Communications staff, early on, dedicated itself to the proposition that the Museum would have one enormous opportunity to position itself as a Museum that every American should visit — at the opening. We planned the opening for the maximum amount of positive publicity consonant with the Museum's innate dignity and somber subject. By March of 1993, our efforts had paid off, and our small staff was working twelve hours a day, seven days a week to accommodate the surge of press requests for interviews, previews and tours — all for a building that was still decorated by scaffolding and reverberating to the noise of jackhammers. By April, when we had credentialled more than 300 journalists from around the world to attend the dedication ceremony keynoted by President Clinton, we knew that we had stimulated an unprecedented amount of public interest and curiosity in this new cultural institution.

Concurrently, the Visitor Services staff was facing a potential disaster. The public, must-have areas of the Museum building were literally not finished until twelve hours before the staff preview opening on April 18; the last artifacts in the permanent exhibition were not installed until April 16. With the delays in artifact installation, Visitor Services had been unable to train staff on-site, on the Museum floor, until a scant two weeks before the opening week of previews. Signage consisted of a few hand-made directional signs, the timed-ticketing system had not yet been tested, we had no VIP tour policy and various crowd-handling issues were not resolved. In the midst of resolving these issues, Visitor Services staff would look up to see yet another network TV crew filming in the Hall of Witness, or the Newsweek correspondent coming through for a tour, and know that each new article and broadcast would further stimulate visitor demand.

And so we opened to more than 10,000 phone calls a day demanding reservations and information — calls that crashed the phone system in our first week. We opened to lines that stretched the length of the building and around the block, to hundreds of requests from political, enter-tainment, academic and media celebrities for one-on-one tours, to groups of holocaust survivors literally grasping the stones of the building that had fulfilled their memories . . . a recent survey indicates that 94% of visitors polled rate their experience high or very favorable.

The lessons that we have learned from 18 months of shared experience are simple, and we believe applicable to museums facing similar challenges.

First, test, test and then test again. If we made a mistake it was in not putting full credence in the results of our Washington visitor survey in the summer of 1992, when more than half the respondents indicated that they would be very interested in visiting the Museum. Despite this error of pessimism, we learned much from our focus groups and visitor survey — information that fueled message development for public relations and program development for visitor service, public information and marketing objectives. Testing, incidentally, does not mean that a cultural institution should let what the public thinks dictate its agenda. What it does do is give museum planners a roadmap to the ideas, expectations and misconceptions the public may have about a particular program or exhibition, so that a comprehensive public relations and marketing effort can be carefully put into place to promote the museum's efforts.

Second, every public relations professional working for a museum must find out what promises can explicitly or tacitly be made to the public, so that those promises can be kept. If there is someone with the responsibility for the overall management of museum operation, so much the better — but if not, data collection from the curators, educators, gallery managers and other hands-on professionals who are actually putting the program together must be current, consistent, and immediately accessible to the public relations staff. It is self-defeating to sell what isn't here, or promotes what can't be accomplished. Public relations and marketing are two sides of the same coin.

Finally, close coordination between Communications and Visitor Services provides consistency of purpose for the two groups on whom the visiting public most directly relies. It took six months and nine drafts to develop a briefing book about the Museum's most important objectives and messages that satisfied our disputatious senior staff. The book

was used to assist everyone working in the Museum who could conceivably be interviewed by the media, by framing our major messages and suggesting answers to frequently-asked questions about the Museum. Surprise — with very few adjustments, the book was adapted by Visitor Services gallery managers as a training manual for the forty-five gallery representatives brought on just six weeks before we opened. Now, if a visitor asks why we are a federal Museum, or why we tell the story of all the victim groups, or what the Museum's position is on modern-day Germany, he will get the same answer from a gallery representative as he will hear from me during an interview on talk radio. Our floor staff, our information brochures, our newspaper clippings, our informational video, our educational materials — all reflect a consistency of tone and purpose and meaning that summarize the essence of the United States Holocaust Memorial Museum.

Museums are educational institutions that cannot require matriculation, mid-terms, or graduation. The utilization by museums of the modern techniques of public relations, though still suspect in some quarters, is necessary in an environment where museums are competing for visitors, funding and attention in a very crowded marketplace. By coordinating every facet of its public relations program with the people on the front lines who fulfill the promises, the U.S. Holocaust Memorial Museum may be considered a useful model of an integrated, dynamic, and thoughtfully organized institution.

Naomi Paiss joined the staff of the United States Holocaust Memorial Council in 1990 as Director of Campaign Communications. Prior to her affiliation with the Council, Ms. Paiss directed public relations programs for corporate and non-profit accounts at the Washington office of Ogilvy & Mather. She is currently the Director of Communications for the U.S. Holocaust Memorial Council.

ACCESSIBLE FACILITIES AND EXHIBITS

John P.S. Salmen

From *Everyone's Welcome: The Americans with Disabilities Act and Museums*, John P.S. Salmen, Ted Benson, Illustrator. © American Association of Museums, 1998. All rights reserved.

I. OVERVIEW

Museums broaden their appeal when they create environments in which all members of society may gain valued experiences. The Americans with Disabilities Act is a key influence in this expansion. Our era's recognition and celebration of society's pluralism also leads to an emphasis on providing widened opportunities for all.

Today's audience ranges from young children to the elderly. The ADA requires museums to provide equal access for visitors with disabilities to public programs and spaces, including exhibits.

Museums display and teach, for example, science, art, and history, and range from children's museums to historic house museums to zoos, botanical gardens, living history museums, and galleries. Their activities include permanent and temporary exhibits, public programs, special events, demonstrations, performances, lectures, and research. Today, a trip to a museum can fully engage the visitor—who is no longer thought of as a passive observer—in a variety of participatory activities. This philosophy shapes how exhibits are designed and presented.

The ADA Standards for Accessible Design (Standards) provide design requirements for newly constructed buildings, facilities, elements and spaces to make them accessible. Exhibit design, as described in this workbook, is based on requirements and concepts taken from the ADA Standards, the Smithsonian Guidelines for Accessible Exhibition Design, data derived from disability-related human factors studies, and experience in making museums and their collections accessible since the passage of the Rehabilitation Act of 1973. This book sometimes goes beyond the minimum requirements of the law and presents "universal design" examples that can make museums usable by all people.

"Museums are changing from being static store houses for artifacts into active learning environments for people. It is now no longer enough to collect as an end in itself; collecting has become the means to an end, that of making connections with people and making links with their experience."

Eileen Hooper Greenhill
Museums and Their Visitors (1994)

All new construction and alterations that affect usability must be designed in compliance with the requirements of the ADA Standards. This chapter elaborates on key topics museum administrators and personnel should consider as they make existing facilities and programs accessible and plan for future modifications. Some actions may be required and others are recommended. It also identifies the minimum requirements of the ADA Standards and provides recommendations on how to improve usability for all visitors.

II. GETTING INFORMATION ON THE MUSEUM BEFORE THE VISIT

Typically, people find out about a museum and its special exhibits and events from radio, newspapers, seasonal mailings, posters, newsletters, and community cable television stations. These usual and customary methods of dissemination also can reach people with disabilities. But, refinements and alternative media make them more effective.

A. USE OF ACCESSIBILITY SYMBOLS AND STATEMENTS OF ACCESSIBILITY

Many people with disabilities do not assume that museum facilities and programs are accessible. Thus, it is important to provide statements regarding accessibility in all publicity and broadcast announcements. Declarative, low-key affirmations of a policy of nondiscrimination indicate a museum is committed to providing accessibility. A sample statement might read: "This facility and its exhibits are accessible to all people," which is preferable to the stigmatizing phrase, "The exhibit is accessible to the handicapped."

Publicity can contain symbols that indicate what type of accessibility the museum offers. The most recognized logo is the International Symbol of Accessibility, a stylized wheelchair. If a museum fails to provide full access to people with mobility and/or sensory disabilities, then it should alert potential visitors of the limited level of access provided.

A Sample Low-Key Statement:
"This meeting is accessible to all people."
(Never use the phrase accessible to the handicapped.)

For example, when lack of financial resources compels a museum to make a sign-language interpreter available only with advance notice, a statement to that effect should be included in brochures and informational materials. If, however, a docent is a qualified interpreter and is available during normal museum hours, then the Sign Language Interpreted symbol (see Chapter 2, Accessibility Symbols, page 47) can appear with no additional explanation. Depending on the level of accessibility the museum provides and how obvious the accessibility is, it may be vital that all publicity includes information on how and where users can find accessible parking, entrances, exits, and information in alternative formats, such as audio tape, large print, or computer disk.

B. PRINT MEDIA

The design of flyers, brochures, and newspaper or magazine advertisements should avoid overlapping type and

Like other museum visitors, visitors with disabilities should be able to:

Obtain information on and directions to the museum prior to the visit.

Find and use accessible parking and/or drop-off areas.

Get from an accessible arrival point to an accessible entrance via the shortest route possible.

Obtain additional information and directions about the museum on site.

Move around the site as needed to attend all offered activities, performances, and functions.

Experience and enjoy exhibits.

Select and purchase merchandise in the gift shops and restaurants.

Use public rest rooms, telephones, water fountains, and other typical public amenities.

images, and use typefaces that are large, high contrast, and easy to read (simple serif or sans serif, see page 115). This increases legibility for people with limited vision and for others, especially people with hearing disabilities who get the majority of their information through sight. (See Labels, page 114.) As much printed publicity as possible should be in large enough type to work both for people with corrected or low vision. (See Large Print, page 123.)

While space limitations may not allow all information to be in large print, key concepts, dates, and telephone numbers should use the recommended general type characteristics. Additionally, keying important statements with the appropriate accessibility symbol (e.g., interpreter symbol for a lecture) will highlight them for people who have difficulty reading.

While Braille is very useful to those who can read it, not all people who are blind read Braille. If financial resources are limited, other formats (e.g. audio tapes or diskettes) might reach a larger audience.

C. BROADCAST MEDIA

Television and radio can reach people with disabilities in a way print media cannot, particularly people with visual or cognitive disabilities. The audible portion reinforces graphic images. These programs are often easier to understand than printed text. Due to the brief nature of broadcast media, allow for sufficient follow-up to inquiries on the museum's accessibility features. Use of broadcast media may go beyond the scope and budget of many museums; however, there still may be opportunities to provide audio information with public service announcements, public-access cable television channels, or donated air time.

Although radio can reach large numbers of people, it is not effective for people with hearing disabilities. Television, however, can be an ideal way to publicize because it has both audio and visual features. Captioning makes the audio portion of the message visually comprehensible. In addition, similar to some televised news reports, a sign-language interpreter can appear in the corner of the screen. Captioning and interpreters, however, increase the risk of visual clutter and cost of production.

D. THE INTERNET AND COMPUTER BULLETIN BOARDS

While not as pervasive as print or broadcast media, the World Wide Web on the Internet and computer bulletin boards have gained popularity among many people with disabilities. Web sites are used to provide information about the museum, its programs, special events, and contact points. For the information to be accessible, it must be available using text-based browsers as well as conventional graphical browsers. It also is now possible to add audio to the visual information and to provide a text-only version that can be read by special Internet browsers intended for people with visual impairments.

E. ORGANIZATIONS THAT SERVE PEOPLE WITH DISABILITIES

Museums can contact local disability groups and organizations to publicize accessible activities, programs, or services. They can get the word out to members of their community whom traditional media do not reach. Notify these organizations as early as possible to allow them ample time to include information in their scheduled releases, newsletters, publications, and announcements.

F. RESPONDING TO INQUIRIES

Once interested, how does someone find additional details that the general media may not carry? Providing telephone responses to questions regarding accessibility is critical.

If the museum is large or if the methods to provide accessibility are complicated, it may be best to have an accessibility coordinator, described in Chapter 2 (page 36), who is thoroughly knowledgeable about all accessibility services. Museums can train staff to offer detailed information on matters such as accessible parking, entrances, and rest rooms, as well as the availability of TTYs, interpreters, and audio descriptions.

Being able to communicate over the telephone with people who have hearing or speaking disabilities is very important. Telecommunication devices for people with sensory disabilities, known as text telephones (TTYs), can be used with traditional telephone hand-sets to type messages back

Portable TTY

and forth between museum staff and hearing- or speech-impaired callers. Publicity material should indicate TTY numbers if information is provided via TTY. Software exists to allow some computers to function as a TTY.

Another option available to communicate with people who have a hearing disability is the Telecommunication Relay Service offered by local telephone companies in each state and required by the ADA. Operators at the relay service act as intermediaries between those who use a TTY and those who do not. This service is not as efficient or effective as TTY-to-TTY systems and may not be appropriate for large and/or high-profile museums. It can be used as an interim measure.

III. THE MUSEUM EXPERIENCE

A. ARRIVING

Visitors arrive at the museum singly or in groups, such as a class of school children or a university study group. They use personal cars or vans, public buses, taxis, or a subway system. All visitors, including people with disabilities, must be able to move about the site with safety and ease.

Providing an accessible route of travel is required for safe and independent use of a site and its buildings by all people, especially those who use wheelchairs, walking aids, or who walk with difficulty or have a visual impairment. This single continuous accessible pedestrian path should be at least 36 inches wide, firm, stable and slip resistant without low or overhanging hazards or obstructions, and not require the use of stairs. All circulation paths must be free of protruding objects for people with visual impairments. Snow, fallen wet leaves, ice, etc. are continuing challenges for outdoor facilities that have large numbers of outdoor accessible routes. The accessible route provides a direct path from parking, bus stops, drop-off areas, and sidewalks into a primary building entrance and links or joins all accessible exhibits, exhibition and program spaces, drinking fountains, and rest rooms.

It must connect all accessible buildings and areas designated for visitor use such as outdoor sculpture gardens, displays, gift shops, and restaurants.

B. ENTERING THE FACILITY

An accessible route to the entrance is free of steps or uses a ramp, elevator, or gently sloped walkway to change levels. Lifts may also be used for existing facilities. Faced with existing main entrances that are inaccessible and difficult to modify (or where modifications would threaten or destroy the historic significance of a qualified structure), a museum may convert another entrance at ground level into an accessible entrance. (See the historic home illustration on page 35 of this chapter.)

The ADA intends for people with disabilities to be able to use the same entrance as other visitors. If the museum has no accessible entry and it considers building one, it should be designed to serve as another primary entrance for all visitors. However, when the museum offers multiple visitor entrances and not all are accessible, it should install signage at the accessible entrance displaying the International Symbol of Accessibility and directing the visitor to the accessible entrance. Make sure the accessible entrance is open the same hours as the main entrance and during all special events. Signage directing the public to the accessible entrance should be high-contrast, low-glare, uncomplicated, and easy to read.

Accessible Parking

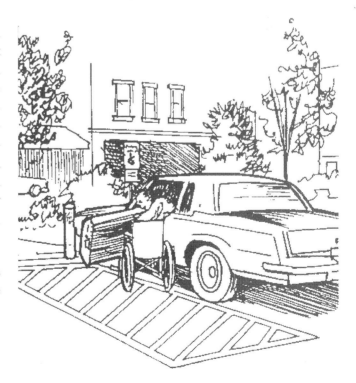

Getting to and Arriving at the Museum

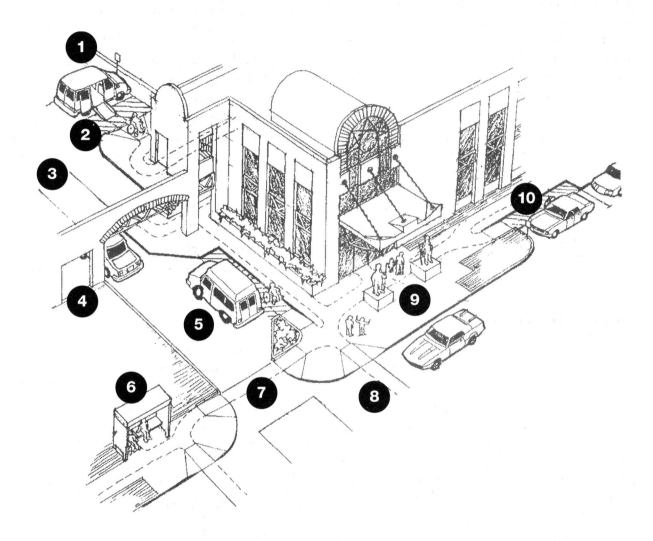

1. Accessible van parking (in multiple space lots, one van space for every eight accessible car spaces; if eight spaces or fewer, at least one must be a van accessible space). Accessible parking spaces should be located on every level of parking that has a direct route to an accessible entrance. If only off-site parking is available, accessible spaces must be provided in that location.

2. 96" wide van accessible access aisle.

3. Two-story garage.

4. Ground level entry of parking garage allows raised roof vans to enter.

5. Accessible passenger drop-off area.

6. Accessible bus shelter.

7. Accessible route to building entrance connected to nearest public transit stop.

8. Accessible route from site arrival points to accessible building entrances.

9. Accessible building entrance.

10. Accessible curb-side parking.

C. INFORMATION AND TICKETING

MAIN DESK AS KEY CONTACT POINT

The first place a museum visitor encounters is usually the ticket booth, which often serves as an information desk. It should be on the accessible route that connects the parking and the accessible entrance and exhibit spaces. The desk should have sufficient space allocated to circulation so that a person using a wheelchair can approach and maneuver into position to pay for a ticket and receive information about the museum.

Event Tickets Suggestion

Establish a policy for obtaining event tickets for people who are unable to wait on line for long periods of time due to fatigue, inability to stand, intolerance of heat and/or cold. This is often resolved by allowing people with disabilities to "cut the line," but a bench or other seating area and "placeholder" system might be more appropriate.

To be wheelchair accessible, a section of the counter or desk must be no higher than 36 inches. For a desk with a high surface, attach an auxiliary fold-up shelf to its front face. A table in close proximity to the main desk can serve the same purpose. The use of such an auxiliary surface should not be considered in new construction. See Section 7 of the ADA Standards.

Note: Although not required by the ADA to be fully accessible until needed by an employee or volunteer with a disability, the employee side of the desk may be required to permit a person using a wheelchair to approach, enter, and exit the work area. If the area is made accessible initially, it prevents costly modifications later and provides more opportunities for volunteers.

STAFF AWARENESS

Visitors often seek information when they enter a museum. Front-line staff and/or security guards who are there to welcome them should be trained in and knowl-

A New Accessible Entrance

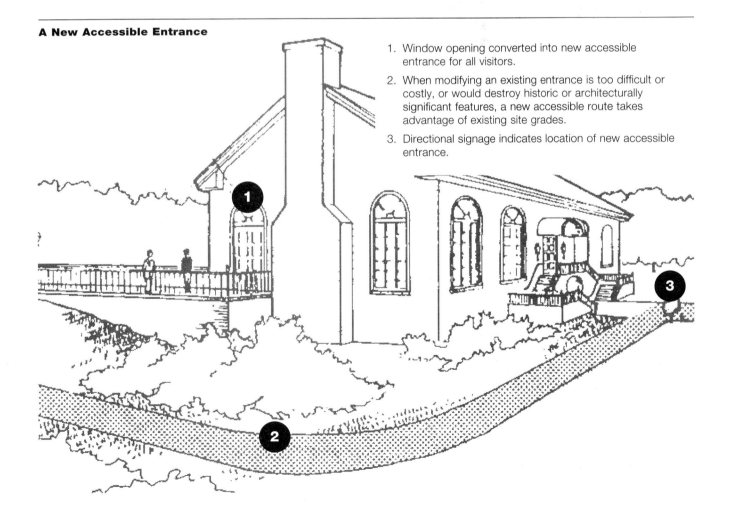

1. Window opening converted into new accessible entrance for all visitors.

2. When modifying an existing entrance is too difficult or costly, or would destroy historic or architecturally significant features, a new accessible route takes advantage of existing site grades.

3. Directional signage indicates location of new accessible entrance.

Information and Ticketing

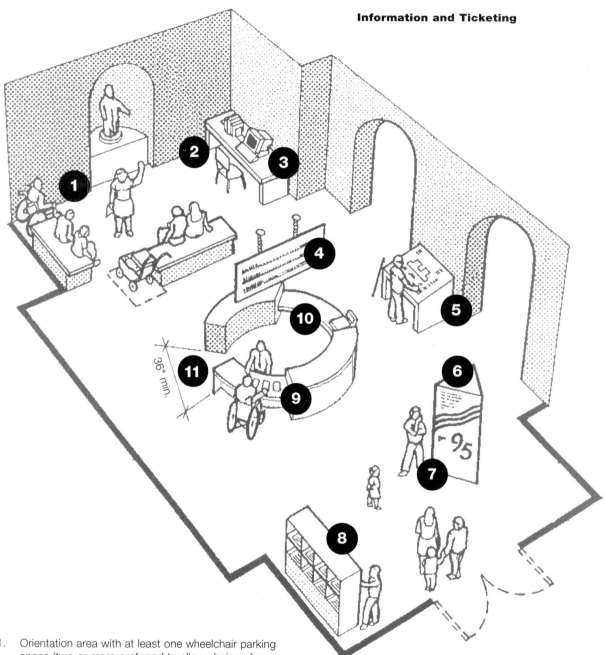

1. Orientation area with at least one wheelchair parking space (two or more preferred to allow choice of position).

2. Knee space and movable chair.

3. Computer with audio output gives overview of museum services.

4. Overhead sign with lettering size appropriate for viewing distance, at least 3" high.

5. Directory with raised-line map, tactile lettering, and knee space below.

6. Static information kiosk with speaker that presents audible version of text (See page 59 for interactive kiosk.)

7. Speaker button.

8. Self-serve, large-print brochures at heights reachable by all people.

9. Information/ticketing desk must be accessible to visitors and have a section of counter no higher than 36".

10. Although not required unless needed by an employee with a disability, it is recommended that information desks initially be designed with an accessible work/counter segment that has adequate knee space.

11. Adequate circulation around and within information/ticketing desk (See page 56.)

edgeable about the accessible features and services the museum provides.

A staff that knows disability issues and can respond quickly, accurately, and sensitively to requests for information, directions, or assistance conveys genuine welcome.

GATHERING INFORMATION

Directional information is a part of visitor orientation. The museum should provide a brochure at the information desk or near the entrance that explains an exhibit's overall structure. Because people assimilate information in different ways, the ADA requires directional information found in brochures to be available in alternative formats such as audible or tactile formats. In a small museum, the staff could read the brochure to a blind visitor.

Directional signage must be high contrast and have a nonglare finish. Additionally, directional signs higher than 80 inches (such as those suspended over gallery doors) must have a minimum letter height of 3 inches. Existing signs should meet these criteria, if possible. (See additional information in Signage, page 70.) Note: Within exhibition spaces of larger museums, heavy reliance on directional signs is discouraged because more subliminal techniques such as sight lines and color coding are often more effective and preferable. In smaller museums, docent training, special assistance, or audio tapes can be cost effective and universally usable.

TACTILE MAPS

A high-contrast, low-glare tactile map with raised lines and lettering is an excellent and universal way to provide directional information on the museum layout. Although three-dimensionality is a primary feature of a tactile map, by incorporating inked lines and text, it can be readable by sighted users. The museum perimeter, entrances, exhibit spaces, rest rooms, telephones (including TTY), restau-

Interactive Kiosk

1. Operating instructions provided in both visual and audio formats.

2. When alcove depth is less than 24", alcove width can be as narrow as 30"; however, 36" is preferred.

3. 40" recommended to center of speakers that require talking or listening at close range.

4. Interactive touch screen, see page 98. To accommodate people with visual impairments, it is recommended that instructions also be via tactile or audio cues, e.g. speakers or hand-sets.

5. Full knee space, required for forward approach.

6. When counter depth beneath controls is less than 20" the height to top of control can be as much as 48"; if counter depth is greater than 20", the maximum control height is 44".

7. 30" X 48" clear floor space for a forward approach.

8. Clear floor space must adjoin or overlap accessible route.

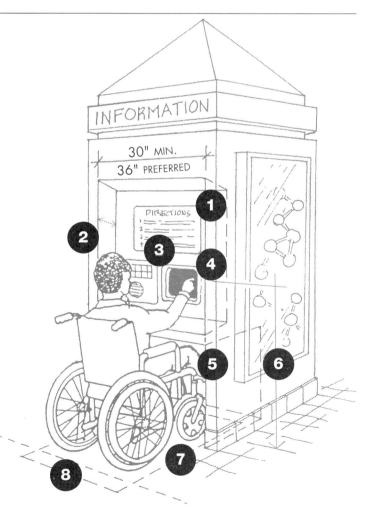

Lowered Folding Counter at Existing High Information/Ticketing Desk

36" max.

1. Lowered surface allows people who are seated or of short stature to sign documents or review brochures and publications.

2. The counter can be folded out of the way when not being used.

rants, gift shops, etc., should be clearly marked. The map could be augmented by an audio tape connected to a control at the map.

ON-SITE INFORMATION KIOSKS

Ideally, all kiosks, both interactive and static, should reflect universal design and communicate information in both audible and visual modes. Sound pollution can diminish the experience for everyone, so audible information must be carefully controlled. If designed with an interactive screen or keyboard, the kiosk should also have audible output. (See page 97 for a discussion of accessible interactive screens and keyboards.)

If large exhibition posters are placed on a static kiosk, then a user-activated tape stating the same information should be an integral part of the kiosk. Also, docents can convey the same information to a visitor who cannot access visual information.

John P.S. Salmen, AIA CAE, president of Universal Designers & Consultants, Inc., Takoma Park, Maryland, and publisher of Universal Design Newsletter, *is a licensed architect who has specialized in Barrier Free and Universal Design for over 20 years.*

ORIENTATION WITHIN THE MUSEUM

Ross J. Loomis

From *Museum Visitor Evaluation: New Tool for Management.* ©1987 American Association for State and Local History: Nashville TN. Reprinted with permission of AltaMira Press, a division of Rowman and Littlefield Publishers, Inc.

Orientation at the museum includes meeting needs for information at the point of entrance, a specific orientation center or exhibit, and coordination of a number of aids throughout the public areas of the museum. Orientation to specific exhibits and their content is also part of the intramuseum orientation.

Entrance orientation. Every museum, no matter the kind, location, or size, should provide orientation information at the visitor entrance. As Daniel Dailey and Roger Mandle note in their article "Welcome to the Museum:" The orientation center is a preamble for learning, preconditioning for the physical and psychological ambience of the entire

museum experience? Their advice applies equally well to entrance as well as orientation center areas." First impressions are formed as visitors pass through the doors and begin to organize their visit. Each setting, no matter how small or large, communicates its unique ambience to incoming visitors. Visitors, on entering any new setting, are at a critical point of needing information as they start a visit. Some kind of visit pattern is required, if nothing more than as an aid in deciding turn right or left. In large museums, wayfinding orientation may require planning a specific route that will include certain galleries and exclude others in order to keep a visit within a prescribed time limit. Evaluation of entrance orientation should

address topics of wayfinding, conceptual, and comfort needs. For example, the entrance to a local history museum can provide visitors with a number of alternatives (see fig. 5.1). Effective entrance orientation evaluation should provide information for answering the following specific questions:

- Where do visitors go on first entering the museum? What is the first stop they make in their visit?
- What questions do visitors have about the museum?
- How many visitor needs does the entrance area serve?
- What changes (experiments) can be made to improve entrance orientation?

The first question deals with wayfinding and can be answered with simple observation. One hundred visitors can be unobtrusively observed and their first stop recorded. It is important to observe unobtrusively so as to avoid influencing visitors to move in one direction or the other. Ideally, observations should be spread out over different time periods, to sample periods of both high use and low use and changes in circulation that occur on specific days or other time periods. In museums with slow rates of vis-

itation, it may take longer to get a sample of one hundred visitors, and it might be prudent to have an attendant or a volunteer keep a log over several days until the sample is completed.

Figure 5.2 displays a hypothetical outcome for one hundred observations at the entrance of a museum like the one pictured in the earlier figure. Note that both the direction of turn and the point of first stop were recorded in the observations. This simple procedure of collecting a set of observations can identify problems with orientation and can be refined by keeping notes on specific incidents that suggest people are having difficulty knowing where to go in the museum. For example, a summary of entrance circulation like that shown in figure 5.2 might reveal that people stop first in the middle of the entrance and look around or ask orientation questions of others in their group. Careful observation can also detect unintended circulation patterns suggesting that people are not looking at the museum but are trying to find their way. Quick movements in and out of an exhibit without stopping to look at objects displayed and/or facial expressions of puzzlement or uncertainty can indicate orientation problems. It is

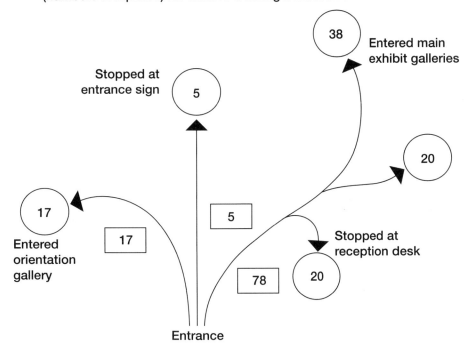

Figure. 5.2. Hypothetical outcome of one hundred observations of first stops (numbers in circles) and direction of first turns (numbers in squares) for visitors entering a museum.

important to note on the observation form when and where these specific types of behavior occur. Sometimes the observer must use a bit of intuition to anticipate or detect visitor-orientation problems.

Intuitive impressions can lead to a refined observation procedure. Qualitative observations can suggest new observation categories. For illustration, assume that while making first-stop and direction-of-entrance- movement evaluations, the observer notes that several visitors ask each other whether they are going in the right direction to find exhibits and that these inquiries always occur at the same location point in the entrance lobby. Visitors appear uncertain about their destination, and some transition-point information is needed at that location. An observation category for recording the number of visitors asking each other for information could be added to the observation form.

In large entrance areas, it may be useful to do a sequential analysis of stops — that is, note the number and sequence of stops visitors make before entering a gallery. Do they stop first at the cashier's desk (if the first step should involve paying for admission)? Do visitors ask for information from the volunteer host/hostess at the reception desk -- or from the museum guard, because the guard station is located nearest to the front door? Sequential-stop analyses can reveal any confusion that exists about where to go upon entering the museum and/or unnecessary movement in the entrance area that can add to confusion.

There is a distinction that grows out of research on entrance circulation patterns that is well to keep in mind. Ervin Zube, Joseph Crystal, and James Palmer studied a sample of National Park Service Visitor Centers and concluded that the design of the centers usually produced one of two basic circulation patterns: (1) open or radial circulation, in which visitors fan out in several different directions toward one or more exhibits -- signs often can provide orientation in such open situations; and (2) sequential circulation, which occurs in entrances with physical restrictions or barriers [19]. For instance, visitors can be funneled in controlled pathways to a reception area or cashier, if admission tickets must be purchased, and then moved to an orientation area that provides information about the museum. From that point of circulation, visitors would select the specific galleries they want to visit. Orientation aids, like maps or pamphlets, can be handed out

at the cashier's station or the reception desk. The guard station, coat room, and other amenities can also be included in a sequential circulation plan. Museums with large entrance areas, and/or heavy visitor circulation flow periods, may find a controlled circulation pattern useful in preventing confusion and unnecessary movement in the entrance lobby area.

Whether or not a museum has an open (radial) or sequential entrance, circulation pattern depends heavily on the architecture of the building. Architecture, however, can be modified with features like wall partitions, rope barriers, signs, lighting, and placement of desks and counters. Modification of features provides flexibility in preparing improved orientation for visitors. A major choice to consider is whether or not to guide visitors to some central conceptual orientation area. An orientation area might include special exhibits, an amphitheater and/or attendants who give an introduction to the museum and answer specific questions on wayfinding information.

Once circulation patterns are identified and it is known where visitors move and stop upon entering the museum, on-the-spot short interviews can identify various orientation needs and problems. Visitors can be asked why they stopped where they did and what specific orientation information they require. If visitors have difficulty suggesting orientation needs or problems, a checklist question may help. For example:

Check the following three items that describe features of the museum you are most interested in as you enter the building (other than the exhibits themselves):
- A place to hang your coat
- A drinking fountain
- An attendant who can answer questions
- Restrooms
- A map of the museum
- Snack bar (or vending machines)
- A place to rest
- Signs or pamphlets that explain how to visit the museum
- Information about the history and purpose of the museum

Examples of open-ended questions that could be asked include:

- What could the museum do to improve the quality of your visit?
- What questions do you have about the museum?
- How could we make your visit more enjoyable?
- Were you able to find exhibits you wanted to see?

Such questions work best near museum exits. People may mention the need for more signs or a guide pamphlet or the need for specific orientation information about the museum.

Interview questions can also inquire about specific problems identified in the observations. If visitors are observed to be wandering or appear lost, they can be interviewed at that point of observation and asked about information needs. This intervention style of interviewing can be effective at identifying orientation problems in the entrance area as well as at important transition points within the museum.

Augmenting observation with a few interviews should also include talking to volunteers, guards, attendants, and any other staff people stationed near the museum entrance. A good question for these people is to ask for a description of the questions most frequently asked by visitors entering the museum. People who regularly meet the museum's public often have very definite opinions about orientation needs, since they have to answer the same visitor questions over and over again. In fact, it could be argued that evaluation of entrance orientation should begin by systematically interviewing the staff people who work with the public. There is an advantage, however, to performing observations and interviews without too many preconceived ideas and then validate the outcomes of these measures against staff and/or volunteer observation.

Acquiring a set of observations, a sample of spot interviews, and reactions from staff and/or volunteers who interact with visitors will provide the basis for some working conclusions about strengths and weaknesses of entrance orientation. One more evaluation procedure can be of help at this point: a planned change can be introduced in the entrance area and assessments made before, during, and after the change. A change might be the moving of a reception desk to a more prominent entrance loca-

tion, or emphasizing its presence with additional lighting and installing more vivid signs to attract attention. Emphasizing the reception desk could be a desirable change if admissions must be purchased there and if newcomers receive major visitor orientation at the desk through distribution of pamphlets or spoken greetings and comments by attendants who deal with the public. Creating a mock-up for a new orientation lobby sign and museum map is another example of a temporary change that could be evaluated. The temporary sign and map could be tried in more than one location to determine which placement draws the most use. Frequently, the difference between an effective or an ineffective orientation sign depends on placement. Comparing sets of observations made at different placements can determine where an orientation sign works best.

Before, during, and after observations, provide tangible evidence that a change does (or does not) make a difference. So often, changes are planned and completed with no real knowledge of whether the modification really will be useful or effective. Suppose, for the sake of illustration, that a reception desk in a quiet corner of the entrance area was relocated to a place directly in front of the entrance doors. The desk would be prominently displayed as visitors come into the museum. Suppose further that the relocated desk had forty-three first stops and the rate of stops dropped back to twenty-one after the desk was returned to the original position. A change of twenty or greater in one hundred observations is not likely to be caused by chance, but suggests that the location change of the reception desk is influencing the choice of a first stop. Furthermore, a change back to the earlier rate of first stops provides additional evidence that the desk location does relate to the frequency of first stops.

The example of the relocated reception desk is hypothetical, and series of before, during, and after observations might have shown very little difference in the rate of first stops at that point in the entrance. In a real situation, it could be argued that it is too costly and/or too time consuming to make a change back and forth and complete the observations. For some permanent changes, a cost problem would be a limiting factor. Other changes could be made on a temporary basis or a low-cost mock-up or simulation of the change tried before the permanent modification is installed. Considering the length of time a given

arrangement of entrance lobby features may serve a museum and the number of people that will be served by that arrangement, spending some time and resources to make visitor entrance orientation the best possible is a wise investment.

Whether or not the third procedure of planned change is used, the basic evaluation strategy of combining observations with a few on-the-spot interviews and staff or volunteer reports of orientation questions frequently asked by visitors will yield useful information about visitor orientation. In fact, that basic strategy can be useful for evaluating orientation at other points in the museum. The strategy can be summarized in the following outline:

A THREE-STEP OUTLINE FOR EVALUATING ENTRANCE ORIENTATION

STEP ONE: SYSTEMATIC OBSERVATION

A. Observe one hundred visitors at random as they enter the museum and note (1) direction in which they move, the pathway they use, and (2) the point of their first stop.

B. If needed, note second and third stop locations (or however many sequential stops are of interest).

C. Make qualitative observational notes of any indications of visitors looking confused, lost, or disoriented. Note signs of unintended wandering or unnecessary movement because of disorientation.

D. Summarize the one hundred observations as percentages of routes taken and stops made. Determine whether the observations suggest any orientation problems.

STEP TWO: ON-THE-SPOT INTERVIEWS

A. Stop a small sample of visitors (twenty-five or so) in the entrance area and ask them about information they need for their visit. Observations from Step One might suggest ideas for specific interview questions.

B. Interviews can be taken as people either enter or leave the museum. It can also be useful to interview visitors briefly as they enter and then complete the interview at the time they leave.

C. Interview volunteers and/or staff for their perceptions of orientation problems and commonly asked information questions from visitors. Try to validate observation and interview findings against staff perceptions.

D. Summarize results of observations, interviews, and staff and volunteer reactions to see whether specific orientation problems can be identified.

STEP THREE: PLANNED CHANGES

A. Results from the first two steps may suggest specific changes that would improve orientation. For example:
 1. Relocating entrance furniture (reception desk, etc.)
 2. Adding signs for directing wayfinding.
 3. Relocating signs and/or maps.
 4. Adding an orientation exhibit.

B. Whenever possible. use mock-ups of temporary formats to test their effectiveness and control costs.

C. Collect one hundred observations and/or a small sample of interviews before, during, and after the change.

D. Look for different rates or outcomes in the evaluation measures across the three samples (before, during, after) to verify that change is having the intended impact.

E. If the results are positive, make permanent modification.

One conclusion that may be drawn from evaluation of the entrance area is that an orientation exhibit or center is needed. It may be desirable to include, at one location in the museum, signs and information on exhibit content providing conceptual information about the history, purpose, and nature of the museum and collections. Wayfinding information may also be included. Museum designers and planners have experimented with a wide variety of orientation centers. Evaluation can help improve the effectiveness of such centers and exhibits.

Ross J. Loomis is Professor in the Psychology Department of Colorado State University, Fort Collins, Colorado and current president of The Visitor Studies Association.

WORKING AT AN INFORMATION STATION

Sam H. Ham

From *Environmental Interpretation: A Practical Guide for People with Big Ideas and Small Budgets*. Reprinted with the permission of North American Press, 16100 Table Mountain Parkway, Ste. 3000, Golden, CO 80403-1672.

An information station or reception area can be elaborate or simple depending upon your needs and financial resources. For example, it could be a counter in a visitor center or simply a small building at the entrance to an area; it could be a booth near a feature such as a beach or viewpoint; it could be located in an office or alongside a road; or it could consist of nothing more than a table that's set up each day and taken away at night. Sometimes giving information to visitors is a full-time job, but often it's just one part of someone's job (e.g., an entrance station attendant, office receptionist, or clerk).

Information stations serve an important, yet often under-appreciated role in interpretation. Like any form of communication, they can be dynamic or they can be boring depending on the organization and skill of the people managing them. Some interpreters think that "desk duty" at the visitor center, office, or information station is less important or less exciting than other interpretive work. Quite naturally, this attitude has resulted in some unimaginative and even dysfunctional approaches to running information desks. The fact, however, is that the personal contact you have with people at an information desk is often the only contact they have with a representative of your agency or organization. Good information can be crucially important to any visitor, and if it's offered in a timely and positive way, it creates not only more enjoyable experiences but good will toward you and the organization you work for.

Following are some tips on offering more dynamic information services. Many good references on managing information desks exist. Some especially useful English-language sources are Sharpe and Hodgson (1982), Lewis (1980), Regnier et al. (1992), and Manucy (1968). Morales (1987) gives a good summary of considerations in Spanish.

1. Present a positive image both in behavior and appearance. Be well-groomed. If you've been in the field just prior to your shift at the information desk, try to shower or wash up before going on duty. Appear like you've gone out of your way to make a good first impression. While a soiled uniform or body odor may not be offensive to you or your workmates, many visitors may form a negative impression of you based solely on your grooming.

2. Actively greet people as they arrive. Stop whatever else you might be doing and focus attention on the visitors. Always smile and welcome them to the area. Immediate eye contact is important. Don't begin speaking to them while you're looking at something else; it sends the message that you're doing something more important and that they've interrupted you. If you happen to be on the telephone and can't greet them immediately, look up, smile, and let them know you see them and will be with them soon.

3. Arrange the information station in such a way that the people feel expected. Some-times visitors are reluctant to approach a person at an information desk because they're afraid they might be interrupting something. Besides actively greeting the people, you can counter-act this feeling with a conspicuously displayed welcome sign. Many information stations even display the name of the person on duty in order to personalize the contact from the beginning. It's always a good idea to wear a name tag on your shirt. At the Mount St. Helens visitor center, U.S. Forest Service staff put a potted plant or vase of freshly cut flowers on the counter to make visitors feel at home. They always use domesticated (often home-grown) flowers to avoid giving the impression that flowers are picked from around the visitor center.

Figure 6-6. Five functions of an information station.

Information Stations Serve Five Main Functions

An information station — whether it's an elaborate visitor center or simply a table in an office — should be designed and operated to serve people in five major ways.

Function	Example Applications
Welcoming visitors to the area	Make visitors feel expected and not merely tolerated. Wear a name tag, or display your name on a sign or placard that's conspicuously placed on the desk or counter. Display a welcome sign or poster saying "Hi, Can I Help You?" Let people know that they're the most important aspect of your job and that you're there to serve them. Playing soft background music may help to break the silence and encourage interaction.
Orienting visitors to the area	Let visitors know what kinds of things they can see and do in the area. Have available maps, brochures and other information not only about your area but about other areas nearby. Have on hand information about interpretive activities and other special events in the area. Display a large map of the area which shows the visitors where they are as well as the location of major features and points of interest. Include travel distances on the map if possible. Have a notebook or chart which shows travel distances and driving times between major locations, If pertinent, include biking and walking times, as well. Information on local weather is always appreciated.
Sensitizing visitors to the area's values	Give or display information which explains the reasons your area exists. Tell how the area benefits people and how visitors should conduct themselves in order to avoid damaging the site. Use positive statements: "Thanks for leaving the wildflowers for others" (not, "And remember, no flower picking!").
Responding to visitors' needs	Be prepared to answer questions on a wide range of topics including the locations of bathrooms, potable water, gas stations, restaurants, and camping and picnic areas. Have a notebook, organized by topic, which contains answers to common questions. Update the notebook regularly. When you don't know the answer to a question, say so, but find the answer as soon as possible and add it to the notebook. If it's feasible, give the answer to the person who originally asked the question.
Interpreting the site	Have brochures, exhibits, photographs, specimens, etc. of important objects or features. Be prepared to answer a wide range of questions about the natural and cultural significance of the site. Keep a notebook, organized by topic, which has answers to common questions. Keep the notebook updated. Be perceptive of interests that visitors have. When you think you've identified an interest, offer to provide additional information.

4. Make a habit of asking if this is the visitor's first tune in the area. You'll find that your approach will be different with first time visitors than with those who already know something about the area. For example, you might have a fairly standard list of things to tell first time visitors (such as where to go, what to do, safety information, etc.), whereas the information you give to repeat visitors might be more variable. Local residents who are very familiar with the area may bring friends and family members who are seeing the area for the first time. Often, the local residents will want to do the interpreting for the rest of their group. Be sensitive to this. Address the local residents as though they're the tour guides, and give them the option to tell the others about the area. Be sure to give them information on any changes they need to know about (a trail or road washed out, new programs, etc.).

5. Be prepared to answer all kinds of questions æ not only about the natural or historic significance of your area, but about other nearby areas and about the locations of bathrooms, potable water, restaurants, local shopping (especially arts, crafts and souvenirs), camping and picnic areas, and other services and facilities for visitors. Compile and regularly update notebooks that contain information about these topics. A list of some possible topics is shown in Figure 6-7.

6. When you don't know the answer to a question, say so. But make a concerted effort to find the answer. If you can't find it, a very good idea is to tell the visitors you'll try to get the answer before they leave that day and invite them to stop back later. Some interpreters go even further; they write down the visitor's mailing address, and when they finally get the answer they mail it either on a postcard or in a personal letter to the visitor's home. This is excellent service and excellent public relations. In either event, be sure to add the new information under the appropriate heading in one of your notebooks.

7. Have a map of the area mounted on the counter or wall. If it's on the counter, position it so that it's right-side-up for the visitors and oriented with north facing north. Practice reading the map upside down; with some time you'll get used to it. If a map will be given away or sold at the site, it's best that it be the same map you use to give directions. That way, the directions you've given will be more easily understood when visitors look at the carry-out map.

8. Keep sheets of paper and a pen or pencil at the desk. (Even scrap paper will do as long as it allows legible writing.) Use it as a visual aid when explaining something or giving directions. Encourage the visitors to take it with them for later reference.

9. Have a collection of interpretive aids (specimens, photos, etc.) that you can use in your discussions with visitors. These can be kept behind the desk or put on a table for visitors to see. Some interpreters create a "mystery table" containing several unlabeled specimens with a sign asking visitors to guess what the items are. Correct answers can be written on labels and attached to the bottom of the items, or they can be written on a list which is kept behind the desk.

10. Come out from behind the desk or counter whenever possible. This personalizes your contact with the visitors by eliminating a physical barrier between you. Perhaps you can go to the other side of the counter to view the map alongside the visitors, to point something out in an exhibit, or to demonstrate something using a visual aid.

11. Focus attention on the visitor. Except in real emergencies, allowing distractions to interrupt your contact with a visitor sends a clear message: "You're not as important as the thing that interrupted us." If that "thing" was your boss, a friend or co-worker you're making a very negative statement to the visitor. Never interrupt an employee or co-worker who's speaking with a visitor unless there's an emergency. Most visitors will tolerate being interrupted by a ringing telephone, but you should inform the caller that you're in the middle of something important and that you'll be available shortly or you're willing to return the call later. If possible, locate the telephone away from the information desk where someone else can answer it.

12. Be available to serve everyone equally. This is especially important in busy information centers where there are a lot of people who need information. Some

Figure 6-7. Possible topics for information notebooks.
Visitors Need All Kinds of Information

Information stations attract all kinds of people with all kinds of questions. To anticipate their need for good information you should consider compiling notebooks containing information on the topics most likely to be important in your area. Following are some ideas for main headings.

Emergency Services, Phone numbers and street addresses	• Police stations • Fire stations • Ambulance • Hospitals (Have simply drawn maps available for people needing to go directly to an emergency room.) • Veterinarians
Interpretive Opportunities	• Schedules and locations of conducted activities offered by your agency and others nearby • Locations of self-guided interpretation (signs, exhibits, trails, etc.) • Interpretive guidebooks available for purchase
Natural and Cultural History of the Area	• Information on important plants and animals • Information on important historic and cultural resources
Nearby Attractions	• Natural and cultural sites • Museums, art galleries, and theaters • Scenic drives and viewpoints • Unique features such as waterfalls, lakes, rock formations, etc. • Sightseeing tours • Recreational opportunities of the area (water and land-based) • Potential hazards such as poisonous plants or dangerous animals (snakes, bears, etc.)
Seasonal Weather	• Typical weather for that time of year • What visitors can do in the area even in inclement weather • What films work best under different weather conditions
Food and Lodging (get a list from the chamber of commerce to avoid the appearance of favoritism)	• Grocery stores, restaurants, and snack bars • Hotels, motels, and bed-and-breakfast establishments • Camping and picnic areas • Private resorts • Recreational vehicle parks and campgrounds with RV hook-ups
Vehicle Services	• Gas stations, car repair shops, and towing services • Motorcycle repair shops • Dump stations for recreational vehicles
Tourist Transportation Services	• Distances and driving and biking times between major points • Bus schedules • Phone numbers for taxis, car rentals, airlines, trains, travel agencies, etc. • Local charter flight services and bus companies offering charter tours • Local outfitters and guides
Other Important Services	• Banks and automatic teller machines • Camera stores that process film and repair cameras • Souvenir shops, and arts and crafts sales • Local churches (listed by faith and denomination)

people may have many questions and require a lot of help, and others may simply want to chat and pass the time. If you notice that you're spending an inordinate amount of time with one person while others are having to wait, politely inform the person that even though you're enjoying the conversation, you need to attend to some of the other people. Invite the person to wait until you have a little more time to spend, or suggest something for him or her to do while you wait on the other people.

13. Consider offering "after-hours" information for people who arrive when the station is closed. A bulletin board (located either outside or inside in a window) could contain basic information such as emergency phone numbers, an area map, and information on camping, safety, major attractions and recreation opportunities. Some "after-hours" bulletin boards also have a space where people can leave personal messages for other visitors. Be sure to include information on the station's normal operating hours.

14. Be a good listener. Listening to the same questions again and again creates lazy listeners. Don't make assumptions about what visitors are asking or about to ask. Really concentrate on hearing questions as they are put to you.

15. Be ready to suggest options. If poor weather or a road closure prevents visitors from doing what they planned to do, be able to give some good alternative suggestions.

16. Be prepared for emergencies. At a minimum, have a fully stocked first-aid kit on hand and make sure all employees know how to use it. Knowing at least basic first-aid and CPR procedures is a must.

A NOTE ON HANDLING ANGRY AND DIFFICULT VISITORS

Roving interpreters and information personnel sometimes encounter visitors who are angry, upset or irritated. This is normal. Flat tires, engine trouble, screaming babies and other pressures can be stressful. After a particularly difficult day or irritating incident, even the nicest people can become belligerent. Unfortunately, when you encounter these people in your work, you may become the target of their frustrations. When this happens, and it will, try to stay calm. Don't get emotionally involved if you can avoid it. A particularly angry person may even call you names or launch personal attacks on your co-workers or agency. Although a normal response is to resent this treatment, a defensive reaction won't do anything to help the situation you're faced with; in fact, it could easily worsen it.

Experts seem to agree that the best strategy for handling angry visitors is to listen. Really try to understand the people's situation and why they're irritated. Don't interrupt, even if they're being verbally abusive. Let them vent their frustration. Think how you'd feel in a similar situation. Above all, show concern for the person's well-being. Look them in the eye and let your face and eyes demonstrate your concern and understanding. Counter abuse with charm in equal proportion. That is, the more abusive they become, the more caring you become. In most cases you'll find that once the visitors have vented their "steam" they'll respond positively to your attempts to help. And even if you can't solve their problem, they'll appreciate your trying.

Sam H. Ham is Professor in the Department of Resource Recreation and Tourism, College of Forestry, Wildlife and Range Sciences, University of Idaho, Moscow, Idaho.

CHAPTER 4

Training visitor services staff

SERVING STAFF WHO SERVE VISITORS

Kathryn Hill

This article was originally published in the Winter 1993 issue of Hand to Hand and later reprinted with permission in *Collective Vision: Starting and Sustaining a Children's Museum,* 1997. Washington DC: Association of Youth Museums. Reprinted with the permission of the Association of Youth Museums.

The ways in which museums organize visitor services efforts vary by institution. In some museums, visitor services is a division within the education department, while in other museums, visitor services is a department in and of itself. Among the latter, some choose to consolidate within visitor services all of the various functions that contribute directly to the service environment -- the store, food service, special events program and the front-line service staff -- while other museums carve out a subset of these functions to call visitor services. Whatever the configuration, however, the visitor services manager likely finds herself somewhere in the middle of a museum's hierarchy. Now the middle of an organization, in any capacity, is often a confusing place to be, but as a visitor services professional, the middle may be particularly unsettling. One is asked to pay attention to, and serve as visitor advocate for, myriad issues relating to the visit experience over which one has no direct control. Even in a relatively small organization in which the director has given unequivocal support to the visitor services program, one may find oneself in conflict with colleagues over the priority given to solving maintenance problems, the size of the label type or the placement of benches. Or else one watches as one's most cherished plans for restroom renovation find no place in the budget even though one knows it would be important to visitors. Even the most patient diplomat and skillful negotiator may become discouraged by one's lack of ability just to get things done, for crying out loud.

However, when one finds oneself in a position of limited control, one is well advised to concentrate efforts on those things over which one does have control. While we can-

not usually dictate the service ethic which governs the institution, most visitor services professionals exert a certain amount of control over the recruitment, training and management of at least some part of the front-line staff. In the visitor services profession, staff management is perhaps the most important and most rewarding part of the job, and it is incumbent upon the visitor services professional to develop extraordinarily creative managerial skills in order to nurture and encourage an effective service staff.

THE FRONT-LINE STAFF

In museums, the front-line staff may include the housekeepers, security guards, the maintenance staff, the switchboard operator, store clerks, admissions cashiers, visitor services representatives and interpreters. Large museums may have staff in each of these categories: in small museums, front-line staff may fill multiple roles. The size of the institutions and the numbers of staff involved notwithstanding the front-line folks are generally the lowest paid and least involved members of your organization.

But of the hundreds of details that comprise a museum's service environment, can there be any doubt that the staff who meet and greet the public represent the most important? A visitor may forgive us a confusing directional sign or a burned out light bulb, but even the gentlest visitor may not excuse a rude employee. One unsatisfactory encounter with a member of your staff may convince that visitor never to return to your museum and the customer service literature tells us that, for every complaint you receive directly from a visitor, ten more visitors walked away angry without telling you. They will, however, tell their friends

about their bad experience, multiplying your loss geometrically. The customer services literature also tells us that management's treatment of employees is directly reflected in the way those employees treat customers.

The reason that quality management of staff is particularly critical in the museum setting is precisely because we describe ourselves as educational institutions and because we, in this profession, have spent countless hours in discourse on multi-culturalism and on serving underserved audiences. While not every museum has a visitor services program, nearly every museum does have an outreach effort. And once those audiences arrive, who is it that serves them? Chances are great that the front-line staff represents the most diverse group of our employees. They represent the very groups that we are trying so hard to reach. If it's true that how we treat our staff will be reflected in how they treat visitors, and if we truly care about serving the underserved, then we must pay attention to our service people. But more importantly, unlike our visitors who are with us for a couple of hours once a year, our employees are with us forty hours per week, fifty weeks per year, and we, as educational institutions, are in an enviable position to serve them.

SERVING EMPLOYEES THROUGH COMMUNICATION

The manager as service person is a rather radical concept, but the key to developing an effective service staff is to ensure that that staff is well-served. If your job is to craft the service environment, then you have no more important job than to serve your people, and what makes your front-line people happy is precisely what makes any of us happy in our jobs: acces to information, the skills and permission to reach potential, clear expectations and recognition of success.

If it has been awhile since you spent any time with your front-line people, then you might be surprised at what they do know — about your building, about what visitors like, what systems don't work, and why that one exhibit element breaks every other day. But what they may not know much about are things we on the management side take for granted. Your front-line may be only vaguely familiar with your mission statement. They may sense that attendance is down but have no knowledge of your attendance goals. And unless you have told them, they likely have no idea

that they figure into anybody's long-term plan. As managers, of course, we know for fact that the more we know, the better decisions we make. It is just as true for front-line staff, and at the departmental level, the only information that a visitor services manager should withhold from the front-line staff is confidential information about another employee or information that is safeguarded by law. Letting front-line in on the inside information only increases staff's sense of belonging and identification with the institution. The department can then, as a team, articulate its own mission statement, in support of the institution's mission, and set goals in support of institutional directions. With information, the front-line you trust to represent the museum to your public have begun to belong in a meaningful way to the museum.

An effective system of communication, of course, always involves two-way channels. It may be that you are extremely conscientious about bringing museum news to your staff and keeping them in touch with museum goals and plans. What may not exist, however, is an opportunity for some of the front-line to participate directly at the table when visitor services issues are raised. Too often, the front-line folks, if they have a voice at all, can only be heard through their manager, and we know that we would rarely be satisfied by communicating exclusively through intermediaries. If, however, you enable some of your people to sit on appropriate committees or attend problem-solving meetings, several wonderful things will happen. Your staff will begin to understand the problems you encounter on a daily basis and will begin to form reality-based expectations of you and the institution. Your colleagues and managers will begin to develop an appreciation for the talents and insights of your people, which will be helpful, not only to your staff in the advancement of their careers and to your own advancement as a manager, but to visitors who are, after all, what we're all about.

Communication with the front-line is not always easy. For one thing, if your museum is open most days each week for long hours, it may be extremely difficult to pull your folks together in one room during the workday. At the Field Museum, we experimented with potluck suppers once a month, but the overtime costs were prohibitive. At the United States Holocaust Memorial Museum, we repeat the same meeting numerous times with sections of

the staff, as that is the only we can get to everyone. Written communication is necessary, of course, but rarely replaces people-to-people interaction , and you may want to think carefully about the skill levels of your staff people. It may be that not everyone on the front line reads English with ease, and relying on the written word may inadvertently alienate numbers of your people.

EMPOWERING EMPLOYEES

At this point, the term "empower" likely makes us cringe, it has become such a cliché. We all know that we are supposed to empower our employees, but what does that mean? We do not empower people by simply leaving them alone to solve problems without guidance and without leadership, because standards by which we evaluate performance and judge behavior are critical to the establishment of a successful and consistent service program. There is a balance between maintaining service standards and structuring an environment in which employees are trusted to make independent decisions and granted some amount of control over their professional lives. If your museum has created a service-oriented organization at every level, then your job within your department is much easier, and you are lucky. The rest of us may be expected by an institution to create a service program without the benefit of an institutional paradigm, and that is a completely different kind of challenge.

Once your employees understand the museum's mission and have developed a sense of their role in the attainment of institutional goals, your department can begin to work together to create a vision of the way the visitor services program should work, and the vision that you begin to explore together will, implicitly or explicitly, reflect the values your group brings to its work. If articulated out loud and universally understood, these values can become extraordinarily powerful tools in shaping your department's service ethic and in structuring nearly every facet of your operation. You know, for example, that there is no way to develop rules to govern every single situation that may arise on the floor of a public institution predictable only in its lack of predictability. However, if your department has ascribed to values that have to do with service and with compassion, then everyone within your department now has the guidelines to handle encounters with visitors in ways that are consistent with your mission and goals. If one of your values involves cooperation or teamwork -- and all public operations rely on teamwork -- then you have a way to address chronic tardiness problems which impose a real hardship on those who show up on time. Violating a museum rule may be acceptable from time to time -- you let a mother and her children in for free because she left her wallet at home and here she is, at your door, looking so harassed -- but violating a value is never acceptable.

Values instead of rules may help you and your employees create not only visitor-sensitive service standards but an environment in which employees feel -- well -- empowered to solve problems on the spot and make decisions in the best interest of visitors. If you articulate values that have to do with a commitment to excellence and to continual improvement, you have now paved the way to creating an environment in which employees feel compelled to offer new ideas, experiment with different ways of handling old tasks and taking on new projects. At the Field Museum of Natural History, one of the Visitor Services staff put together a complete needs analysis and budget for a parking shuttle service -- and he did this largely on his own time. Another developed a computerized inventory system for floor equipment and information desk literature. The system told him where every piece of equipment and every brochure was, where we got it, how much it cost and when we would need to re-order. This employee did not let his lack of computer knowledge deter him for a minute: he simply sought help from the technical services people in the museum, who may have been surprised by his request but were also gracious. The visitor services representatives at the United State Holocaust Memorial Museum developed a complicated box office operation from soup to nuts, largely by themselves. When staff lay-off forced us to look at new scheduling options, it was the representatives who developed a plan that met the criteria and proved most palatable to those whose lives were affected.

It sounds a little like magic: out of the hat of values emerges a productive, motivated front-line staff. It doesn't quite work that way, of course. A set of values that is consistent with the museum's mission and meaningful to your staff may serve as the department's foundation. But values will apply to management, as well. If you have identified teamwork as a departmental value, then there is no job a manager won't take in the best interest of the team

when the floor is short-staffed. If compassion is a value, then each employee merits consideration and understanding, even during difficult times. And a commitment to compassion will mean that the first sign a visitor encounters in the museum does not contain a list of things one cannot do on the premises. Values may constitute the philosophical foundation for the department, but every product and every management decision must also be rooted in those values to legitimize expectations of staff.

RECOGNIZING ACHIEVEMENT

Open channels of communication and a departmental ethic that encourages initiative in providing quality service may go a long way toward motivating employees and improving all aspects of your service program. It is difficult to sustain the momentum, however, if employees are not rewarded for heroic effort. This is a piece of business that museums often neglect, in part because museum workers at all levels do tend to derive satisfaction just from working in museums, but mostly because museums assume that they cannot afford to recognize achievement. Indeed, salary increases, in those years in which they come at all, are generally too small, and the difference between the raises received by the superstar and the average achiever too negligible to represent meaningful recognition. Even in relatively large museums, career ladders are short and upward mobility is limited.

These real limitations notwithstanding, there are methods to recognize achievement that are not prohibitively expensive. A note from the museum director, a public announcement in the newsletter or at a staff meeting, a round of applause by the department are forms of recognition rarely experienced by the front-line, are often very valuable to them and cost nothing. Affordable alternatives might include a day off with pay, a free lunch in the museum café or movie tickets, and if one of the achievements you reward is accuracy at the cash register or number of memberships sold, the employee's success has probably more than paid for the reward. At the Field Museum, if an employee chose to spend time during his vacation at another museum and brought back an idea even if it was an idea we did not ultimately use, one day of that vacation was credited as a day worked.

Recognition can come in many, many forms, and the best place to find the ideas is from the employees themselves. After all, there is no point structuring an elaborate set of benefits if those benefits do not feel like rewards to employees. The development of a recognition program within prescribed guidelines may be a task that you turn over to a group of your employees so that the ultimate product is meaningful and satisfying to them.

At the end of the typical day, a visitor services manager may know that she was completely unsuccessful in lobbying for an increased training budget. The front door banner may still be faded, the benches may still need painting, and despite best efforts, there is no organized effort to get senior staff out of their offices and onto the floor of the museum. What a successful visitor services manager should remember, however, is that countless acts of kindness happened in the museum that day. She knows, too, that the front-line staff worked, not only to provide direct assistance to visitors, but also to improve the quality of the museum environment in a variety of small, but important ways. And perhaps at the end of that day, these staff people will leave with the satisfaction that a sense of accomplishment brings. Most importantly, both manager and front-line know that the many, many people who asked for help that day walked away well-served.

IF ONLY OUR MUSEUMS COULD BE SO PERFECT!

Susan M. Ward

From *Heritage Communique* (Feb/March 1997) private consultant newsletter. Reprinted with permission of Heritage Communications. Heritage Communications integrates business practices into museums.

The following (mythical) interview is with Arturo Santiago, a front desk supervisor at the (mythical) Mid-State Art and History Museum. He is the perfect employee! He is enthusiastic, interacts well with visitors, gets along with other employees, and is dedicated to the future of the museum. This interview is meant to illustrate how and why Arturo is such a good employee. How long have you been at the museum and what was the hiring process like?

I was hired three years ago after I responded to an ad in the local newspaper. The hiring process was very thorough, which was one of the things that appealed to me about working here. I sent in a resume and letter, was called for a phone interview, filled out a questionnaire, and came to two interviews. The first interview was with my current boss and the second one was with the hiring committee and included my boss, the public relations assistant, the personnel director, and one of the curators. From my perspective, that second interview gave me the opportunity to get to know others on the staff here, and because it was a mix of staff from various departments, I knew the museum was serious about teamwork and good internal communications. It was the kind of place I wanted to work!

TELL US ABOUT YOUR JOB RESPONSIBILITIES.

I hire, train, coach, and supervise a staff of six employees who answer phones, sell admissions tickets, and welcome and orient visitors to the museum. Our job is to set the tone for everyone who comes into the museum to have a great visit. That tone we set includes not just being friendly, but being sure everyone feels comfortable about being here — that they know what there is to do, and that they have the tools and the information to fit their interests, background, and previous experiences.

HOW DO YOU TRAIN YOUR NEW EMPLOYEES?

First off, at this museum, every new employee — whether it's the new executive director or the new technician —

goes through a two-day orientation program. Everyone gets the same basic information about the museum including what the museum is all about, what's in the collection, what kinds of programs and special events we do, who the typical visitor is, what the museum's customer satisfaction plan is, and who's who in the museum. During those two days, everyone is given a comprehensive tour of the museum, as well as an informational talk from one of the curators about the highlights of the collection from a behind-the-scenes perspective.

The training in my department builds upon the orientation program. Overall, we deal with the specifics of the job æ everything from how the phone system works, to the three questions you need to ask visitors in order to help them best utilize their time here. Our training includes a half day of classroom type instruction, a half day of "shadowing," a half day for reading, and a half day for walking through the museum. That half day for walking through the museum is mostly unstructured. We have some hand-outs that employees might want to look at, and we provide suggestions, but basically we want people to become familiar with the museum, and to spend time looking at the things they enjoy! How can we tell people what to see in the museum if we're not familiar with the collection!

WHAT IS YOUR DEPARTMENT'S CUSTOMER SERVICE PHILOSOPHY?

We take the lead from the museum as a whole. Two years ago, the museum spent eight months creating a customer satisfaction program that impacts every department in the museum. We created a customer satisfaction mission statement, integrated certain hiring qualifications that include an ability and/or experience in working with the public, added questions to our bi-annual employee evaluations that relate to visitor awareness, and basically redesigned our programs and exhibitions to bring visitors into all

aspects of planning. We don't do anything any more without getting some form of information from potential users of the program, exhibit, or whatever it is we're creating.

My department has an essential role to play within the overall ambiance that everyone in the museum is trying to create. We can't have a bad day in my department! Everyone knows that they have to leave their difficulties at home and be able to interact positively with everyone that comes through the door to the museum. We strive to always be friendly and approachable. Sometimes people are coming to the museum for the first time, or maybe it's their first museum visit of any kind, ever. We have maps and brochures about the exhibits, but last year we realized that visitors needed something more tangible. My department, in conjunction with the curatorial and exhibition departments, created a mini orientation exhibit. There are only 7 objects in the exhibit, a handful of photographs, and limited label copy. We all worked very hard to create the most succinct overview of the museum that we could. It's been very successful æ the visitors love it and we all had fun working together on it.

WHAT DO YOU LIKE BEST ABOUT WORKING AT THE ART AND HISTORY MUSEUM?

Changing people's lives! It may sound silly, but this museum can open people's eyes to a new artist, or intrigue them about how people traveled across this country in wagons, or give them the opportunity to try out a new skill or talent, or provide them with new topics of discussion when they visit with their family. . . . We're not a stuffy or high brow museum! At the same time, we have high standards about our collections, research, and exhibitions. Visitors seem to appreciate both aspects of who we are. Everyone who works in this museum knows that it's not just what we tell visitors, but it's what they tell us. The best part about working here is that each of us knows that we can have a profound impact on visitors. If each of us that works in the museum can excite, intrigue, or motivate one person a day to look at art or history in a new way... we just might change the world!

CUSTOMER SERVICE TRAINING IN MUSEUMS

Museums as Everything You Wanted, But Were Afraid to Ask: Are You Servicing Your Visitors?

D. Neil Bremer

Session Handout, Association of Midwest Museums 1992 Annual Meeting, Milwaukee Wisconsin. Reprinted with permission of D. Neil Bremer.

Why has it taken so long for museums to begin getting comfortable using the "T" word? Why train at all? The concept of Visitor Services in museums is not that old. Institutions across the nation have begun to realize the importance of the visitor. Which, in my opinion, is a classy, museum way to say, "We are competing with going to the Cineplex 12 and cruising supermalls! What do we do to get the people to come here?"

What will make visitors come back? They'll return because they learned, were challenged, reflected, were moved, discovered, and so on and so on. Curators can give you a thousand reasons why you should enjoy an exhibit, but the operative word is enjoy. It was a positive experience. The reality is this — a visitor can spend hours enjoying a wonderful exhibit put together by highly educated people, but if, upon leaving, it takes 40 minutes to get their coat and parcel, or they have a less than positive experience with a museum employee — that's what they will remember about your museum.

The training of front line employees is only part of the process of improving the visitor experience in your museum. It is difficult for me to discuss this separately from systems analysis, management training and enlightenment, or total visitor planning, but, nevertheless, let's talk about this one, important element.

TRAINING PREREQUISITES

You will never accomplish effective training if the communication with your front line is one-way. Karou Ishikawa, considered by many to be the father of quality control in Japan, put it this way; In quality control one cannot simply present a goal and shout "work hard, work hard." In one museum where I was involved with setting up training, we barely got to the actual training. Security guards held such a strong view of upper management being punitive and uncaring, we could never really get to the issues involving visitors. That particular front line staff was craving attention — their opinions. from their perspective, were being ignored. At another museum, as I was beginning a discussion of visitor needs with employees from different departments, it was immediately apparent the departments hadn't talked with one another. This sharing of observations and feelings is vital. It builds a feeling of team. It is also easier to institute ideas if they've been reached by consensus. Masao Nemoto, Managing Director of Toyota, is famous for a particular quote about communication.

One of the most important functions of a division manager is to improve coordination between his own division and other divisions. If you cannot handle this task, please go work for an American company.

Plan for these discussions when you design your training schedule. If you do not allow ample time, which could be hours, days, or even weeks, you will have problems. You will either cram the needs of the visitor down their throats while appearing to not care about the employees' needs or you will spend so much time talking that you never get to the training.

As you establish this open door — keep it open. You must accept the bad along with the good because in terms of morale and self esteem, it is all worth it. By letting staff know you want to hear their opinions and ideas, you set yourself up for having to listen to things you do not want to hear or subjects that might seem obvious or petty. Remember, it might be petty to you, but not to the person on the other side of your desk. Walk a mile in their moccasins, you might learn something.

Before you train, do the job. Do not waste an employee's time by discussing customer service attributes while checking coats if you have not spent some time hanging up some wet, dripping garments while 15 more people are waiting in line, watching you. Even if you don't learn anything you didn't already know, your staff will have a deeper respect for you. It's that moccasin thing again.

TYPES OF TRAINING

OUTSIDE PROFESSIONALS

If you have the budget, these consultants have been through it before. The experience is beneficial. They will typically conduct interviews to discuss needs and help them design a personalized course. Front line staff may feel more at ease discussing their operational problems with an outsider than with management. Think about this though. If they cannot talk to you — THAT'S the problem. I feel that outside trainers are best used for specific follow-ups after a good in-house program is established.

IN-HOUSE

Setting up the training yourself might be quite an experience. You may learn things about your own department you never knew. An advantage is enhancing the feeling that you are all on the same team. A disadvantage is adjusting priorities and making time for training along with your other responsibilities. In some places, training is provided by another department such as Personnel or Human Resources. Just remember, these are your front line people. Have a thorough understanding of the training materials and approve any content before someone else trains your people.

PEER TO PEER

You can certainly set up a program where experienced front line staff trains the new employees. Are you certain the new staff is being trained in a way consistent with your expectations? We encourage the front line to use their heads. Will this mean 10 different employees have 10 different ideas about how to train? This requires careful management. Make it clear when the training has ended. A new employee will reach a point when they do not want to be told what to do by someone at their level.

An important point to remember is that training must be continuous. There is virtually no project or system which cannot be attempted on a trial basis. The changing conditions in your museum will require constant updating of

the training materials and methods. This can be in the form of informal staff meetings over coffee. Everyone learns. Because we operate on a seven day-a-week schedule, we have two staff meetings a week every two weeks in order to catch everyone. Something always comes up where one employee's approach to a problem sparks an idea in another staff member.

TRAINING TOPICS AND TIPS

DISCUSSION

Training should always be a dialogue. Nothing is more boring than a lecture. A few years back I offered to tape security managers training their new employees and provide each manager with an individual video tape so they could learn how to improve their "performance". Some of them were so bad, the tapes were never discussed again. One manager, conducting a training session on general rules and regulations, merely paced back and forth reading from the manual — which every trainee was holding and could read for themselves. Stimulating stuff. If the staff is active in the training, they will feel a part of the training. Make them read aloud in class and take turns. Use lots of True/False questions at first. A feeling of success is easier to obtain than making them sweat over multiple choice questions.

HUMOR

There is a way to make training fun and keep the retention level very high. Use tasteful humor. Humor directed at yourself always is a way of humanizing a manager in the eyes of entry-level staff. I always discuss keeping a good sense of humor at work. It makes the day go faster. However, I always caution employees to avoid humor in front of the visitor. It could be a very funny line, but somewhere, sometime, it will backfire on you.

MAKE IT PERSONAL

The ratio of Temporary employees to Full-Time Regular employees has risen dramatically in the past few years. How do you provide training to someone who potentially feels very little loyalty to your museum? Try addressing the skills required for quality customer service as skills they can use in every day situations in their life. "The skills we will discuss can help you on your next interview." Introduce visitor needs as human needs with which anyone can identify.

★ Employees need to see value in learning.

★ Employees need learning goals.

★ Employees need feedback on how they're doing.

★ Employees need to have their improvements recognized and rewarded.

Regarding this last point: Reward leads to repetition of the new skill. And practice leads to learning. Without this practical application, much will be forgotten within a very short time. Set your training goals as small goals at first. Allow for lots of gratifying successes and a quick sense of accomplishment.

FIRST IMPRESSIONS

This establishes the tone of an encounter with a visitor. Make it an important part of your training. Talk about body language, posture, smiling. Remember — Customer Service isn't smiling. The biggest and most sincere smiles in the world cannot fix a bad or ill-managed system. Assuming, however, that your system works, then work on smiling. It never killed anyone. I've heard employees say when asked how they deal with a situation when they do not feel particularly happy, "I have a neutral face." My response is — Why pick neutral? Go all the way and smile. From a visitor's perspective, neutral is as bad as a scowl. Neutral looks like the employee does not care. Neutral looks like "I was having an OK time until you walked up to the counter." This reminds me of so many managers who say, "Leave your problems at home or at the door." This attitude is ridiculous. No one forgets their problems. Tell your staff that you understand worries about kids, money, day care, etc. You share some of the same concerns. Managers can tell employees how to dress, behave, smile, greet, and what to say, but never, ever, how to feel.

ACTIVE LISTENING

Talk about this early on and it will help the rest of your training. Explain that listening is a practiced skill and just hearing someone doesn't count. I relate this to listening to supervisors as well as visitors. The example that gets the response is a new employee following what they thought was the proper instruction from a supervisor only to find out there was a misunderstanding in the direction. Who "gets in trouble"? Every time, new employees know that a

supervisor can get away with bad direction because of an entry-level employee's "bad listening." It reinforces that good customer service skills are for all occasions, not just for customers.

ROLE PLAYING

I believe role playing is a good system but better used for advanced classes. Remember, you are up in front conducting the class; this stuff doesn't make you nervous. An entry-level employee may get so caught up in "acting" that the lesson is not learned. Being demonstrative in front of peers is very different from addressing a visitor. I like to warm up the employees with grab-bag questions. Write typical questions on slips of paper and have the trainee draw one out of a paper bag or box. You then take the question and read it aloud as if you were the visitor asking the question. The trainee can simply stand at their place at the table and respond. Remind them not to start with "Well, I'd probably say..." They should respond as if you are the visitor. This is a less stressful version of role playing and gets things going. The questions can get harder or more controversial as you go along. This builds easily into actual role play with employees acting out encounters with visitors.

SOME RESOURCES

Nilson, Carolyn. *Training for Non-Trainers: A Do-It-Yourself Guide for Managers.* American Management Association, 1990.

Donnelly Jr., James H. *Close to the Customer: 25 Management Tips from the Other Side of the Counter.* Business One Irwin, 1992.

Anderson, Kristin, & Zemke, Ron. *Delivering Knock Your Socks Off Service.* American Management Association, 1991.

Martin, Ph.D., William B. *Quality Customer Service.* Crisp Publications. 1989.

Gerson, Ph.D., Richard F. *Beyond Customer Service: Keeping Customers for Life* Crisp Publications, 1992.

Martin, Ph.D., William B. *Managing Quality Customer Service.* Crisp Publications. 1989.

D. Neil Bremer is Executive Director of the Elmhurst Art Museum, Elmhurst, Illinois, and one of the principals in Bremer Communications. He has been an established museum professional since 1981.

DISTINGUISHED SERVICE

Gaby Gollub

In July 1997, the Franklin Institute Science Museum's customer-service advisory committee realized visitors were dissatisfied with its front-line staff. Visitor comments about "rude" and "unapproachable" staff "didn't match our vision for customer service" in which "the visitor comes first," says Kim Neubauer, who chairs the committee. Comments written on "scorecards" described staff talking among themselves and leaning against the wall as if they didn't care about visitors. In response, top management decided to institute a mandatory customer-service training program to provide front-line staff with a philosophy of first-class customer service. Created by Neubauer, the training services director, the result was good enough for the Philadelphia museum to garner last year's training and development award from the local chapter of the American Society for Training and Development (ASTD).

Neubauer consulted her supervisor, the vice president of human resources; as well as the director of visitor services; front-line staff in membership, visitor services, and interpretive services; and members of the advisory committee, comprised of managers of the front-line staff. She designed case studies and role-play situations-based on problems that had actually happened and might recur-in four 2- to 3-hour sessions for permanent staff and long-term volunteers. Those working on a temporary or part-time basis,

such as students working during the school year and those participating in the museum's summer program, are required to take only the first session.

Introduction to Customer Service, the overview course, encourages participants in mixed groups-for example, a ticketseller, an exhibit interpreter, and a greeter-to examine how their particular roles support the philosophy of the museum by writing a customer-service mission statement. This session helps make staff aware of their attitudes and promotes conveying pride in the Franklin. When the training program began, "there was a lot of resistance," Neubauer says. "Some people felt they didn't need it . . . After the first session, people were basically sold on the fact that there was something they would be able to get out of the training that was useful to them in their jobs."

Listening Skills, the second session, teaches through role playing "effective, active listening skills that can be used in specific situations," Neubauer says. If a staff member has been asked the same question 50 times, and the answer is printed on the wall, she now knows to take a deep breath and respond non-judgmentally. The training session teaches her to be attentive to visitor needs and try to meet them proactively. In the Angry Visitors session, participants deal with "real issues that occur on the museum floor on a day-to-day basis" and learn how to diffuse anger, Neubauer says. A visitor who leaves the theater in the middle of a film may not realize that the doors will lock behind him. He might become irate when he realizes he cannot get back in. Staff learn how to convey compassion and cool down an angry visitor. Dynamics of Diversity has proven essential for the entire staff, helping to create an inclusive environment in which all visitors feel welcome. All museum staff now participate in this session. "If we want to be successful, everyone needs to participate," Neubauer says.

Managers participate in two additional sessions: Effective Feedback and Progressive Discipline. The first helps develop skills in giving constructive feedback. The second examines what to do when a staff member's negative behavior does not change, despite the constructive comments.

Several steps were involved in winning the award, open to organizations with at least one ASTD member. (At the Franklin, Neubauer belongs to the 70,000-plus member association.) Interviews were conducted over the phone and in person with Neubauer and the visitor services director. Then a dozen front-line staff members participated in a focus group. Finally, secret visitors (representatives of ASTD working "undercover") toured the museum and observed staff performance over a month-long period.

The museum received a crystal plaque and, in March, Neubauer demonstrated one of the training sessions at an ASTD meeting. The award shows that "everyone pulled together and is going beyond the call of duty to serve the visitors" and how hard the front-line staff and the customer-service advisory committee are working, Neubauer says. "A lot of people are proud of themselves and deserve to be."

PUBLIC SAFETY, INSTITUTIONAL SECURITY, AND THE WELCOME VISITOR

Tom Bresson

Session Handout, American Association of Museums 1996 Annual Meeting, Minneapolis, Minnesota. Reprinted with permission of the author.

This presentation will examine how the museum security department affects the visitors' museum experience, and what role it plays in meeting the wide range of visitor needs. There is no doubt that, like the museum with a visitor services staff, the security staff of a museum is the first line of contact with the visitor. He or she serves as the "ambassador" of the museum, and may be the only human interface the visitor experiences. It is obviously important therefore, that the contact is favorable, the visitor impressed, or at least, not disturbed as a result of the security presence.

SECURITY IMAGE — "BAD GUY" OR "GOOD GUY":

The nice things the museum tries to do for the visitor include providing the intellectual stimulation and personal enrichment. the ambiance, the high quality of the exhibit, the superb shop where the visitor can browse or spend, and of course a quiet cafe. But with all the niceties and welcoming...there are some rules you know!

No smoking! No food or drink! Do not touch! Sorry. No strollers allowed! You will have to check that large item! The museum is closed now! Do not enter-non public area! No parking in this area! The enforcer of these necessary, but perhaps annoying (to whom they are directed), regulations is...security, the bearer of bad news to the otherwise enthusiastic visitor.

For nearly every enforcement of building or other regulations though, there are reunions of lost children with parents, findings of lost items, assistance to sick visitors, and in more serious situations, safe evacuations under emergency circumstances.

Under this examination then, security responds to our visitors' experience under what might be described as "good guy" or "bad guy" scenarios. Where experience is needed, and training required, is how to best perform in each situation. We need to look at positive attitudes and practices that

bring together the security mission and responsibilities with the visitors' reasonable expectations. The following outline will be used for discussion, questions and answers:

A. Study Concerning Staffing Guidelines at the Museum of Natural History
 (1) What the study is showing with regard to task analysis of security officers in terms of service vs. security vs. safety.
 (2) What the study showed concerning the visitor reaction to guard presence, appearance, etc.

B. Security responsibilities/functions that most directly affect the visitor:
 (1) Crowd Control issues
 (a) Ticket procedures for popular exhibits
 (b) Queuing strategy
 (c) Flow
 (d) Emergency requirements
 (2) Check Rooms
 (a) Defining what needs to be checked
 (b) Legal liability
 (c) Risk to terrorist or other threats
 (3) General Access Issues
 (a) Policy regarding strollers, wheel chairs
 (b) Building regulations that may conflict with ADA requirements
 (c) Right to inspect packages, brief cases, purses, etc..
 (4) Lost and Found procedures
 (5) Response to Visitor problems — illness, accident, etc.

C. Training for Performance — Maintaining a Positive Image and Courtesy
 (1) Customer Service Begins at home.
 (a) Visitors are not the security staff's only customer
 (b) Top-down endorsement of the customer service principle

(c) Customer service a significant part of the security mission

(2) Security Officer Image

(a) Verbal and Nonverbal Impressions

(3) Tactful enforcement

(a) How to say "you cannot" or "no" in a pleasant manner

(b) Dealing with the difficult patron

(c) Hand-off to a supervisor

D. The Team Concept — Security is Everybody's business!

BASIC SKILLS COURSE

MAINTAINING A POSITIVE IMAGE AND COURTESY

First Impressions

We don't get a second chance to make a first impression. Review these impressions that we give, some of which we don't even realize:

Nonverbal Impressions

Look professional Alert posture Smile Eye contact	"We take pride in our work." "We're on our toes." "You're in good hands." "We are interested in you." "We know you are here."

Verbal Impressions

Greet visitors Pleasant answers to questions Firm, but fair reminder of rules Explain the "why" behind the rules	"Welcome!" "We are available if you need our help." "We care about protecting you and our national collection." "We respect you."

A Good Approach:

Approach	When to Use	What to Do
Watch	As visitor enter and leave museum	Smile, eye contact, friendly welcome "Good morning" (afternoon) "Welcome to the Museum" "I hope you enjoy it."
Serve	Verbals or nonverbals say, "HELP!"	Offer help right away Make eye contact; reassure Direct them to someone who can help if you can't "You look like you need some directions. How can I help?"
Protect	Visitor breaks museum rules	Address visitor with respect Explain rules in a pleasant tone, and the why behind it. "Excuse me, Sir. Smoking isn't allowed in the museum. The smoke damages the exhibits"

Give words a positive power:

Don't cop out:	Show that you care:
You should have . . .	I understand what you mean.
You have to . . .	I'm sorry you had that problem
Our policy is . . .	I apologize for the inconvenience.
It's not my job.	Thanks for letting me know.
Lots of visitors make that mistake.	It sure looks/sounds like you've had a tough time of it:
I'm not allowed to . . .	How can I help?
You have to understand . . .	I can see that you're upset.
There's nothing I can do.	I'll be happy to get someone who can help.

To make the best impression
- Make eye contact and smile
- Show your interest in the visitor's issues
- Give the visitor your attention
- Treat each question like it's the first time you've heard it
- Don't take it personally if the visitor is upset
- Let the visitor finish his or her story

- Repeat what you heard to show you understand
- Politely interrupt to get the facts you need
- Thank the visitor for his or her patience and cooperation
- Keep an eye on security, too

Listen and think before you act . . .

Tom Bresson is the former Deputy Director, Office of Protection Services, Smithsonian Institution.

DEALING WITH AN INJURY TESTS GUEST RELATIONS

Dave Scharlach

Reprinted From *WestMuse* (Summer 2000), "the newsletter of the Western Museums Association." Dave Scharlach

One of the most stressful aspects of guest relations involves approaching and assisting an injured visitor. The expert advice on this topic runs the gamut from never touch them (unless they need a pen to sign the release form)' to "send them to the hospital in a limousine with flowers and a free lifetime membership in hand."

In most cases, a balanced and flexible approach based on common sense may be the best way to go. Understanding the nature of guest accidents, a little bit of law, and something about human behavior should help you put together a sensitive and effective response to visitor injuries.

As much as any other factor, the guest's perception of the initial contact of the museum staff will determine the ultimatedisposition of the incident.

NATURE OF ACCIDENTS

Most injuries to guests at museums are the result of slips, trips and falls. Of these, two-thirds involve stairs; the remainder are falls from the same level. Prevention involves engineering (proper design, railings, barricades and lighting) and administrative controls (posting warning signs, supervision of risk areas).

THE LAW

In most states, an injured person seeking redress must prove that an accident was caused by the negligence of another. A judge or jury in a civil court trial eventually decides this. Once this is proven, the injured person may receive money as compensation for his or her losses. Losses can include out-of-pocket expenses, including court costs; past, and, future, estimated medical fees and hospital bills; and lost wages. Money can also be awarded for pain and suffering, inconvenience, disfigurement, and loss of companionship.

HUMAN NATURE

The actions of security and guest relations staff within the first few minutes of an incident have an impact on both the psychological and physiological injury to the guest. You have undoubtedly established procedures for attending to the physical injury, but may not fully address the emotional or psychological component.

When under severe stress it is human nature to go into a "fight or flight" mode. Whether through pain and shock or simple embarrassment, an injured guest may make a scene over a minor scrape or, on the other hand, hobble off with a broken bone just to "save face."

INITIAL CONTACT

In their book, *Contact: the First Four Minutes*, Leonard and Natalie Zunin state " . . . what people communicate during their first four minutes of contact is so crucial that it will determine whether strangers will remain strangers or become acquaintances, friends, lovers or lifetime mates." As much as any other factor, the guest's perception of the initial contact of the museum staff will determine the ultimate disposition of the incident. When a visitor is injured in the presence of friends, associates or family, the ego may be bruised as much as the body, so he or she is especially sensitive to the conduct of your staff. Of course if the injury is serious, immediate action must be taken, but here are some things to keep in mind when approaching an injured guest and determining his needs:

- **Introduce yourself by name and identify your association with the museum:** Using your name and theirs personalizes the encounter. By identifying your affiliation with the museum the guest will be reassured that someone of authority is tending to him.

- **Listen carefully to the injured guest** is the main indication that you care. Make eye contact, and avoid distractions and clinical jargon.

- **Consider and be sensitive to the guest's fears and embarrassment.** Again you may not be able to perceive the extent of injury if the guest is embarrassed or anxious. Be sensitive to gender issues (a woman may feel more comfortable discussing her condition with another woman), language barriers (perhaps a companion can translate), and crowds of people around the scene, all of which may increase the stress level.

- **Answer questions as quickly and completely as possible. (If you are not sure of the answer it is better not to give out information.)** Here is a brief example: small children often put objects in their mouth to discover more about their world. In a museum setting, that might include a flower, berry or a painted item. Alarmed parents will ask if the object is poisonous. You really do need to have a good answer. (For example at a museum/botanical garden with which I work, botanical curators are called upon to identify the berry and show the parents in reference books proof that there is no chance of serious injury.)

- **Present the options available to the guest:** Unless the guest is unconscious (in which case there is implied consent to treat and transport in most jurisdictions), the decision to treat any first-aid type of injury or to call paramedics should be agreeable to the injured party.

- **Establish a plan of action with the injured guest and his or her companions:** This collaborative approach is reassuring.

- **Some Don'ts:** Be too authoritarian, ignore questions, admit liability, say you knew something like this was going to happen, touch the guest unnecessarily, raise your voice or insult the guest — even when provoked.

SAYING GOOD-BYE & FOLLOW-UP CONTACT

Just as the first few minutes of contact are critical to the museum's relationship with the guest, so are the parting words. Addressing the guest's needs after the incident may involve arranging for transportation, offering a free pass to compensate for a shortened visit, providing authorization for medical care, or simply presenting a business card of someone to call with further concerns. The appropriate courtesies should leave a positive impression on the guest and help ensure his return to the museum.

With the advice of legal and insurance representatives, you may consider calling or writing the visitor to check in. Sending gifts or flowers though, may be going too far and may be perceived as an attempt to buy-off the guest from filing a lawsuit.

These simple suggestions for interacting with a visitor who has had an accident both support your goals for visitor services and help to mitigate liability and public relations for your institution.

Dave Scharlach is the Vice President, Integrated Management Services, for Willis Insurance Services of Los Angeles, California.

CHAPTER 5

Evaluating your services

WHAT VISITORS THINK ABOUT VISITOR SERVICES

Randi Korn

Reprinted from *WestMuse* (Summer 2000), the newsletter of the Western Museums Association. © Randi Korn, Randi Korn and Associates, Inc.

The new Tech Museum of Innovation opened its doors in downtown San Jose, California in October 1998. In May 1999, Randi Korn & Associates, Inc. (RK&A), was hired to conduct a comprehensive evaluation of the four permanent galleries and the overall visitor experience, based on staff members' concerns. Phase I of the evaluation documented the scope of the galleries' impact and effectiveness; Phase II documented information about the whole museum experience. The following data samples were collected: 400 visitor observations; 200 post-gallery visit open-ended interviews; 100 focused visitor observations and interviews; 1102 post-museum visit questionnaires to assess whole museum experiences; 50 post-museum visit open-ended interviews; and 50 post-visit open-ended telephone interviews with visitors who had visited The Tech three or more months earlier.

Four issues were strongly associated with visitors' overall rating of their experience at The Tech: staff availability, staff courtesy, exhibit maintenance, and exhibit availability.

STAFFING ISSUES

Survey results indicated that almost half the visitors had between one and two interactions with staff in the galleries, and one-quarter said they had three or more. The survey also asked visitors to rate two staff-related issues, "Courtesy of staff in galleries" and "Availability of staff to help me in the galleries" on a "Poor" (1) / "Excellent" (7) rating scale. Staff courtesy received a very high rating overall, with a mean of 6.09. "Availability of staff to help me in the galleries" received a less favorable score, with a mean rating of 5.05. Visitors with more education rated the item lower than did those with less education, indicating that those with more education may have higher expectations regarding presence of staff in the galleries.

The survey also asked visitors to read eight statements and select the ones that described what they experienced in the galleries. The statement associated with staffing read, "I would like some staff to be available to help me use the exhibits." Females indicated a stronger preference for staff help, perhaps because they believe staff presence might help build confidence with the content. Female visitors may also assume a staff member comfortable with the content would be better able to foster enriching experiences for their children.

The conclusions we draw from these findings are that staffing the floor is absolutely necessary, particularly for first-time, female, and well-educated visitors. Hiring more floor staff is costly, but will increase visitor satisfaction. Staff courtesy was rated very high, so The Tech should continue customer service training, and if staff are being trained to interpret content, continue that as well. If staff are not trained in interpretation, begin such training.

EXHIBIT MAINTENANCE

Several questions focused on maintenance issues, specifically broken exhibits. In the museum exit interview, visitors were asked "What, if anything, was particularly annoying about your visit?" If visitors did not mention the crowds or broken exhibits, specific probes were used to encourage visitors to feel comfortable about expressing negative experiences. Overall, about one-half of interviewees found nothing annoying about their visit. A few noted the broken exhibits they had encountered; when

specifically asked about them, two-thirds said that they had seen signs indicating broken exhibits. Interestingly, many of those interviewees said they were unaffected by those exhibits.

Survey results present similar feedback. Two-thirds of visitors who encountered broken exhibits selected a statement that read, "The number of broken exhibits I encountered didn't bother me." One-quarter of visitors selected, "I was disappointed because there were broken exhibits" to describe what they felt in the galleries. Visitors were also asked to rate the maintenance of exhibits on the 7-point "Poor" "Excellent" scale, and they gave it a mean rating of 5.23. First-time visitors and those with a high level of education were more likely to choose these options, perhaps indicating these types of visitors are more difficult to satisfy. They currently make up the vast majority of visitors to The Tech.

Our conclusion, then, is that exhibit maintenance is an important factor in overall enjoyment of the museum experience, especially among first-time and well-educated visitors. The Tech should consider creating an exhibit or visitor experience around the problem, in the way that other museums have created "behind-the-scene" exhibits around objects that are being conserved. For example, the National Museum of American History removed Old Glory from its display for a large conservation project. Rather than taking the flag to an off-site laboratory, staff built a state-of-the-art conservation area in a public area. Visitors now stand behind glass watching conservators clean and repair the flag. Some visitors may be disappointed when they realize Old Glory is not on display in its regular place. But when they see it lying on a massive worktable, they are mesmerized by its enormous size and the informational exhibit that tells the story of the conservation effort.

EXHIBIT AVAILABILITY

Exhibit availability and crowding is the fourth issue closely associated with a visitor's overall rating. Some museum exit interviewees commented that they had been forewarned about crowding, and therefore expected crowds; others did not feel crowded. The written survey included six statements associated with crowding; only three were selected by a noteworthy percentage of visitors.

Almost two-thirds of visitors selected, "I enjoyed watching other guests use some of the exhibits." Clearly, this helps alleviate the discomfort of waiting in line. However, about one-third selected, "The lines at certain exhibits were too long and I chose not to wait in some of them." This suggests that The Tech has other exhibits that interest these individuals. One-quarter said they "didn't mind waiting in line because the exhibits are unique," although more visitors with a high school diploma selected this statement than did visitors with four or more years of college. Overall, only 3% of survey respondents said, "I was disappointed because I came to the Museum to use a specific exhibit and it was always in use." A few telephone interviewees, too, recalled having to wait in line to use some exhibits, and unfortunately, their memory of waiting overpowered other memories of their experience at The Tech.

We suggested to The Tech that when the Museum is especially crowded, they ask visitors to be courteous of others who may be waiting to use an exhibit. Place five-minute timers adjacent to each problem exhibit and encourage visitors to set them when they begin.

One further suggestion focused on first-time visitors. They need to have an exceptional experience at The Tech so they will return. Consider giving first-time visitors a unique sticker to wear so floor staff can recognize them and give them special attention-similar to the way some restaurants introduce new patrons to the unique selections on their menu.

COMMENTS FROM THE TECH ON THE VISITOR SURVEYS

The comprehensive evaluation of The Tech's galleries and museum experience conducted by Randi Korn & Associates has had a significant impact on the museum's operations. The process of engaging staff in considering the scope of work and interpreting the results has strengthened communications and cross-departmental collaborations and is already improving the visitor experience.

Visitors' impressions of staffing in the galleries have always been of concern. The Tech believes that personal interactions are most likely to create memorable experiences. To make staff more visible in the galleries, uniforms have been changed from blue denim logo-shirts to purple

polo shirts (logo on the front and "The Tech" on the back in 3-inch mango letters), with an optional mango-colored vest. Customer service training is provided to both staff and volunteers. This June, with support from the David and Lucile Packard Foundation, The Tech invested in full-day customer service workshops for all staff.

This winter, gallery staff were reorganized and job descriptions revised to attract new staff with strong dramatic and interpretive abilities. More programs are scheduled in the galleries, and new programs are being created to align with revised gallery goals and objectives that staff developed based on Phase I results. Extra programs on crowded days in open spaces can engage more visitors, so the exhibit areas seem somewhat less crowded.

New information about visitors' perceptions of broken exhibits is informing marketing tactics. Interpretation is now provided of those exhibits that cannot be removed while being fixed. In addition, staff and volunteers are being trained to redirect visitors interested in broken or busy exhibits to find other satisfying experiences in the museum.

Currently, The Tech is in the process of analyzing the results and assessing the recommendations in the Phase II report. The issues of staff presence, courtesy, broken exhibits and crowding are all high priorities and work will continue. The strategic plan adopted on June 14, 2000 calls for another comprehensive evaluation of gallery experiences in 2002. Expectations are that tactics and strategies adopted in response to these reports will result in a more positive visitor experience overall.

For additional information about this project, please contact Susan B.F. Wageman, Evaluation Manager, The Tech Museum of Innovation at suewageman@thetech.org or (408) 795-6303.

Randi Korn & Associates are in Arlington, Virginia and can be reached through their web site at randikorn.com.

Note: The material in this article is based upon work supported by the National Science Foundation under Grants No. 9705633, 9627196, and 9552566. Any opinions, findings, and conclusions or recommendations expressed in this material are those of the authors and do not necessarily reflect the views of the National Science Foundation.

MUSEUM VISITORS' ATTITUDES TOWARD EXHIBITS, STAFFING, AND AMENITIES

William J. Boone and Ruth S. Britt

From *Curator* 37 (1994): 208-21. © 1994 by American Museum of Natural History. Reprinted by permission of AltaMira Press, a division of Rowman & Littlefield Publishers, Inc.

INTRODUCTION

In 1990, the Cincinnati Museum of Natural History (CMNH) moved from its original building of under 20,000 square feet of exhibit space to a new location in the city's massive Union Terminal railroad station. This move provided a potential of 90,000 square feet for exhibits (including a 10,000-square foot gallery for traveling exhibits) and facilitated a great expansion of the museum. Attendance on an average weekend day is now approximately four times what it was in the former location.

Prior to the move, the CMNH was housed in its own structure. In its new setting, a museum associated with the Cincinnati Historical Society is also located on site, as is as an Omnimax theater. Visitors to the complex have a variety of choices and pay separate fees to enter each museum and the theater.

There were a number of reasons for conducting the attitudinal survey presented in this article. In addition to now being housed with other entities, the CMNH itself had undergone many changes both in its physical layout and in the type of exhibits it presents. Additionally, the public perception of one institution as separate from another was known to be a point of some confusion. Because of all these things, the museum staff wished to (1) establish a

baseline of visitor satisfaction regarding specific factors affecting the quality of a visit to the museum and (2) use these data, coupled with other research data, to maintain and increase attendance by providing the best possible visitor experience.

THE SURVEY INSTRUMENT

To begin identifying the key factors influencing a museum visit, two instrument-development steps were carried out. First, 17 CMNH staff members — curators, administrators, and personnel interacting regularly with the public — filled out an open-ended questionnaire about factors that they felt were important in affecting the quality of a typical visitor's museum experience. Second, an open-ended questionnaire probing these same issues was distributed to 73 adult visitors. From these "pre-surveys," a final 18-item survey about potential "museum improvements" was constructed. (Three drafts were developed by an off-site psychometrician. Each was critiqued by the museum evaluator, and the final version was evaluated by others on the staff.) Since the survey focused on one issue (improvements), a wide range of questions could be presented, and attitudes could easily be statistically distinguished. Table 1 shows the 18-item survey. Topics ranged from exhibits (computer-aided, dinosaur), to staffing (admission-booth workers, live demonstrations) to amenities (food, seating).

The scale with end points of "important" and "very important" was selected for a number of reasons. First, the survey was constructed from items that the pre-survey had already suggested were important. Thus, those using the final survey would probably rate these topics as important to some degree. By using a scale that stressed the "important" end of the scale, we hoped to more accurately distinguish differences in visitors' attitudes. Second, by utilizing a scale with a greater number of selections (1-10), individual attitudes of visitors can often be separated with decreased error. Although individuals are most familiar with scales that offer four or five selections, a 10-step numerical scale is not unheard of. There are strengths and weaknesses in the use of this scale.

The survey was administered on five weekends and weekdays during February and March, 1993. One hundred and fourteen participants (18 years of age and older) were selected at random as they entered a "spotting zone" near the museum's exit. During each data collection, the first person to enter the zone (while exiting) was approached, offered the survey, and told that, upon completing it, he or she would receive a coupon for a 10% discount in the museum's shop. After the participant had begun filling out the survey, the next person entering the area was approached. The on-site evaluator stood by, available to answer questions and explain the scale.

Although random sampling techniques were utilized, statistical checks were carried out to further determine whether these data were representative. Data collected from the first three sampling periods were comparable to those collected during the last two periods. The comparison indicated no statistical differences in the average ratings of items. Simple means and standard deviations were calculated.

RESULTS

The results of the data collection are shown in Figure 1. The survey items are ordered as if one were reading a thermometer of visitors' average views. The item at the base (Improve the cleanliness of the Museum of Natural History) ranked as the least important improvement. The item at the top (Make sure that exhibits change frequently, so that visitors returning after a few months can see something new) is ranked as the most important. As one looks up the "thermometer," one sees items that were ranked at greater and greater importance.

IMPLICATIONS

Amenities — First, from the nonexhibit side of things, visitors do not seem overly concerned with the need to improve the cleanliness of the museum (Item 10), the quality of the food (Item 12), or the number of seats in the food area (Item 6). Surveyed visitors do feel that increasing the number of seats for resting in the museum is important (Item 5); they rate this concern almost exactly in the middle of the scale between "important" and "very important."

Staffing — Visitors rated Item 15 (Individuals working in the admissions booth supplying correct information) and Item 8 (Having staff available to explain about exhibits), similarly. In contrast to these two staffing items, however,

visitors felt that Item 16 (Increase the number of "live" demonstrations by the CMNH staff) was distinctly more important.

Exhibits — Item 1 (Improve directional signs to exhibits) was rated, overall, as of low importance. This could relate to both the floor layout of the museum (traffic flow is primarily linear) and the design and location of museum signage.

Although concerns about "signs directing visitors to exhibits" and "making sure that exhibits are working" are considered of higher importance than "written information," the relatively low ratings of all these items suggest that the signage must be working well enough to be viewed as a low priority and that when these data were collected, visitors were satisfied about exhibits being in working order.

Table 1. Survey administed to 115 visitors of the Cincinnnati Museum of Natural History. Respondents were asked to rate the components of the museum which needed improvement. Visitors were given unlimited time to complete the survey.

Visitors, we would like to know your opinions! Some improvements to the Museum of Natural History have been suggested by other visitors. Please tell us your views on what parts of the museum need improvement. Below are a number of possible changes. Would you please play "olympic judge" and provide a rating between 1 and 10. Thanks! Just circle your choice! All questions involve ONLY the Natural History Museum NOT the Omnimax theater, NOT the Historical Society Museum.

1) Improve signs directing visitors to exhibits.
 Important 1 2 3 4 5 6 7 8 9 1 0 Very Important

2) Increase the number of exhibits.
 Important 1 2 3 4 5 6 7 8 9 1 0 Very Important

3) Increase the number of exhibits that can be touched.
 Important 1 2 3 4 5 6 7 8 9 1 0 Very Important

4) Make sure that exhibits change frequently, so that visitors returning after a few months can see something new.
 Important 1 2 3 4 5 6 7 8 9 1 0 Very Important

5) Increase the number of seats for resting in the Natural History Museum.
 Important 1 2 3 4 5 6 7 8 9 1 0 Very Important

6) Increase the amount of seating in the food area.
 Important 1 2 3 4 5 6 7 8 9 1 0 Very Important

7) Increase the number of exhibits for adults.
 Important 1 2 3 4 5 6 7 8 9 1 0 Very Important

8) Have more Natural History Museum staff available to explain about exhibits.
 Important 1 2 3 4 5 6 7 8 9 1 0 Very Important

9) Improve the explanation about what is included in admission to the Museum of Natural History.
 Important 1 2 3 4 5 6 7 8 9 1 0 Very Important

10) Improve the cleanliness of the Museum of Natural History.
 Important 1 2 3 4 5 6 7 8 9 1 0 Very Important

11) The Museum of Natural History needs to do a better job of making sure that all exhibits are working
 Important 1 2 3 4 5 6 7 8 9 1 0 Very Important

12) Improve the food.
 Important 1 2 3 4 5 6 7 8 9 1 0 Very Important

13) Design a permanent Dinosaur exhibit.
 Important 1 2 3 4 5 6 7 8 9 1 0 Very Important

14) Decrease the amount of written information at each exhibit.
 Important 1 2 3 4 5 6 7 8 9 1 0 Very Important

15) Make sure individuals working in the admission ticket booth supply correct information.
 Important 1 2 3 4 5 6 7 8 9 1 0 Very Important

16) Increase the number of "live" demonstrations run by the Museum of Natural History staff.
 Important 1 2 3 4 5 6 7 8 9 1 0 Very Important

17) Increase the use of computers in exhibits.
 Important 1 2 3 4 5 6 7 8 9 1 0 Very Important

18) Do a better job explaining how exhibits relate to the Cincinnati area.
 Important 1 2 3 4 5 6 7 8 9 1 0 Very Important

Figure 1. Results of the visitors' attitudinal responses to the 18-item survey. The three categories of items are distinguished in type: Amenities, italic; Staffing, bold face; and Exhibits, regular.

Very Important	Raw Averages		Items (Standard Deviation)
	7.0	Q4	Change exhibits frequently (2.7)
	6.9	Q13	Design permanent dinosaur exhibit (3.1)
	6.6	Q3	Increase number of touchable exhibits (2.8)
	6.2	Q16	**Increase number of live demonstrations** (2.9)
	5.6	Q2	Increase number of exhibits (2.8)
	5.5	Q17	Increase use of computers in exhibits (2.8)
	5.2	Q7	Increase number of exhibits for adults (2.8)
	4.8	Q5	*Increase number of seats for resting* (3.2)
	4.6	Q9	*Explain what is included in admission* (3.0)
	4.5	Q8	**Have more staff to explain about exhibits** (2.7)
	4.3	Q18	Explain how exhibits relate to Cincinnati area (3.0)
		Q15	**Make sure admission workers supply correct information** (3.5)
	3.9	Q11	Make sure exhibits are working (3.2)
	3.8	Q1	Improve way-finding signs to exhibits (3.0)
	3.4	Q6	*Increase seating in food area* (2.4)
	3.3	Q14	Decrease written information at each exhibit (2.7)
	2.9	Q12	*Improve food* (2.3)
	2.0	Q10	*Improve cleanliness* (2.0)

Important

Four types of exhibits were discussed in the survey: those that would be targeted for adults, those that would use computers, those that would be hands-on, and those that would involve a permanent dinosaur installation. Of these exhibit types, the "adult" exhibits were viewed as least important, the computers were viewed as slightly more important, while the dinosaur and hands-on exhibits were viewed as being the most important.

This group of visitors' highest ratings were given to the item about the need to frequently change exhibits. This response may suggest that these individuals have a new expectation for this museum (and probably other museums as well). These visitors seem to no longer expect museums to be static places of unchanging collections and exhibits. They appear to want museums such as the CMNH to be alive and ever changing. (Therefore, this item suggests that if visitors of years past expected a museum to be nonchanging, these surveyed visitors may hold a much different expectation.) The small number of museum members who were part of the survey sample (15%) did not differ in their overall ratings to the survey items when a separate analysis was conducted; thus, museum members did not skew the ratings on this item. One might expect that members, as the most likely repeat visitors, would be more interested in exhibits changing; however, this does not appear to be the case. These data are also consistent with other CMNH research that shows "frequently changing exhibits" to be an extremely high motivation for a repeat visit.

CONCLUSIONS

These data show a wide range of ratings for items involving issues of exhibits, staffing, and amenities. Within each of these categories, a wide range of average ratings is present; however, in general, visitors felt least strongly about improvements involving seating and food, while they felt most strongly about increasing "live" demonstrations, hands-on exhibits, changing exhibits, and perhaps designing a permanent dinosaur exhibit. It could be hypothesized that those topics that were ranked low on the priority list are either issues that the museum has done a good job of confronting or are issues that are considered low in priority regardless of whether or not the museum has done an adequate job. Likewise, the most highly rated items (those suggesting visitor interest in improvement) could be issues that the museum either has not fully tackled or those issues that visitors would view as important regardless of the museum's success. Since the museum has an extensive number of hands-on displays and live demonstrations, the high priority rating by visitors probably indicates that the museum has successfully whetted the appetite of visitors and that more of these exhibits are needed.

The specific scale for data collection was selected in an effort to utilize a measurement device that would more accurately differentiate the views of visitors. Rather than selecting a four-step scale (Strongly Agree, Agree, Disagree, and Strongly Disagree), a scale with a larger number of rating categories was first piloted on a small set of data and then utilized for the collection and evaluation of the data set reported in this paper. Probably the type of rating scale described here is most useful when one has previous information that helps one confidently target a scale toward a particular population. Although this scale and instrument provide important data, it must be pointed out that such data should probably be collected in tandem with qualitative data. Individuals utilizing this scale could have selected their ratings as a function of two key factors.

Perhaps a visitor rated an item as a "2" because he or she felt this issue should be a low priority since the museum had done a good job of keeping everything running. But another person could have given this same item a rating of "2," feeling that even if the museum had not done a good job, there were other more important priorities. In any rating scale (or open-ended questionnaire, for that matter), there can be a multitude of reasons for a particular response. Although this can make the analysis of any data set difficult, some useful information always results. In this case, a new scale was devised, quantitative data collected, new questions raised, and a number of issues from earlier research efforts were further investigated.

William J. Boone is Professor of Science Education, School of Education, Indiana University, Bloomington, IN 47401. Ruth S. Britt is Exhibits Evaluator, Cincinnati Museum of Natural History, Museum Center at Union Terminal, l301 Western Avenue. Cincinnati, OH 45203.

QUALITY VISITOR SERVICES

Joseph Aubert

From *NemaNews* (Summer 1998), the newsletter of the New England Museum Association. Reprinted with permission of Joseph Aubert.

CUSTOMER SERVICE AT MUSEUMS?

Today museums face stiff competition from other cultural organizations for tourist/visitor/customer leisure-time attendance, participation and dollars. Movies, sports events, theatre, dance and other museums, not to mention shopping outlets, may attract potential visitors away from museums. These other options vying for consumer's limited leisure time are increasingly placing an emphasis on quality customer/visitor service.

How do museums measure up in the area of visitor service? You may have heard more talk about quality visitor service in recent years, yet when you become a visitor at another cultural institution do you find the quality of visitor service to be poor? Many museums do not like to use the word "customer." They feel that there is something too commercial or tacky implied in the word. However, from another perspective the advantage of at least recognizing the word is that it moves museums toward the understanding of including all their constituents. Museum "customers" include visitors, store shoppers, members, volunteers, schools, tour companies, the community, and those internal customers — the staff and the board.

The larger question of what is and how to express quality visitor services comes into play. How do we as museums meet visitor expectations, needs and desires? Are there means to gather more information from visitors so that the museum's approach is constantly adjusted to provide better service/value? Knee-jerk reactions by some organizations to raise or lower admissions fees as a response to increasing competition from other leisure activities may be misguided. While visitors are looking for both quality and quantity in exhibits, programming, and products, a focus on value-added visitor services can make a big impact on the quality of the visitor's experience.

We've probably all heard of those studies which show that a satisfied customer tells 2, 4 or 6 people, whereas a dissatisfied customer may complain to 8, 10, or as many as 20 people. Investments in brochures and advertising only really pay off in the long run if the visitor has a great experience. Close attention to visitors is vital to maintaining and expanding museum activities. Museums need to spend money on the staff, the tools and the equipment that will provide the level of service that will meet, if not exceed, their visitors' expectations. Museums must consider their visitors' satisfaction from a number of points of view — convenience, courteousness, timeliness, minimal mistakes, resolution of customer problems, etc.

MUSEUM GUIDELINES/SUGGESTIONS MOVING TOWARD AN INSTITUTIONAL POLICY AND STYLE OF VISITOR SERVICE

Training your staff in a couple of specific customer service skills is a good start, but nurturing a museum-wide focus on quality customer service is better. Many organizations, not just museums, become too focused on the institution's day-to-day operations — budget deadlines, internal meetings, etc. — rather than being focused on the customer. The following are beginning steps for creating a museum-wide customer service policy and program.

- Prepare by learning all you can about quality customer service.
- Next, secure the commitment of senior management. If the board, director and others do not support a strong emphasis on customer service, you really have work to do in terms of changing your museum's culture.
- Create a team to oversee the process. If you are in a small institution the team may be you and one other person. If you are in a larger museum, try to have members of the team represent all departments and different levels of the museum staff.

- Write an overarching strategy to move the ideas and inspiration to everyday activities.
- Survey both visitors and staff to find out what they want and expect from the museum.
- Prepare a plan for the improvement of customer service.
- Make sure that staff training is continuous over time. Use the model of ongoing, incremental improvements.

Make a commitment to improve your and your museum's quality of visitor service. There are many individuals and resources just waiting to give you a helping hand. Books: *A Complaint is a Gift* by Jamelle Barlow & Claus Moller, *Customer Service for Dummies* by Karen Leland & Keith Bailey, *Delivering Knock Your Socks Off Service* by Kristin Anderson & Ron Zemke.

Winston Churchill was once asked to give a speech. At the appointed time he stood up to give his address and slowly looked over the audience. Then he is supposed to have very slowly said, "Never, ever, ever, ever, give up." And he sat down. Take this approach to improving visitor service over time, and always keep your sense of humor for sanity's sake.

Joseph Aubert is the Manager of Visitor Services at the Normal Rockwell Museum at Stockbridge. MA. He leads training on complaint handling and quality visitor service.

MUSEUM CUSTOMER SERVICE QUESTIONNAIRE

From *NemaNews* (Summer 1998), the newsletter of the New England Museum Association. Reprinted with permission of the New England Museum Association.

SELF EVALUATION:

Use the following numbers to evaluate each question.

 0 = Rarely
 1 = Sometimes
 2 = Often
 3 = Almost Always

___ When having a conversation with someone, do I give her or him my complete attention and avoid doing other activities?

___ Do I make eye contact when speaking with a visitor to show that I am paying attention?

___ When speaking over the phone, do I make an effort to use inflection in my voice to convey interest and concern?

___ Do I pick up the telephone by the third ring?

___ Do I avoid technical museum jargon and use language that everyone can understand?

___ When I cannot provide someone with exactly what he or she wants, do I suggest options and alternatives?

___ Do I sincerely apologize to someone when a mistake has been made by me or my museum?

___ When someone is voicing a complaint, do I remain calm and understanding - even if I think he or she is wrong?

___ Do I view complaints as an opportunity to improve service rather than as a problem that is taking up valuable time? Museum Evaluation: Use same scoring system. Do we do surveys to find out how satisfied visitors are with our exhibits/service/products and ask for their suggestions and improvements?

___ Do we survey our staff to find Out how satisfied they are with the working environment and ask for their suggestions for improvements?

____ Do we have a written mission statement or specific long range goals that focus on our commitment to providing our visitors/customers with quality services and products?

____ Do we collect information on what poor quality service costs our museum in terms of lost visitors, wasted time and reduced morale?

____ Do we train our front-line staff in telephone and face-to-face visitor relations and communications skills?

____ Do we train our managers in the skills they need to support staff in providing excellent service (team-building, delegation, coaching, conflict negotiation and so on)?

____ Do we put newly hired staff through an orientation process that stresses the importance of customer service .in their specific job?

____ Is customer service part of your job description?

____ Do we have a process in place that allows us to make specific changes in our policies based on visitor feedback?

____ Do we go out of our way to reward and recognize staff for their efforts on behalf of the visitor/customer?

____ Does supervisory staff listen to the suggestions and complaints of other staff and volunteers? Thank you.

Adapted from Customer Service for Dummies

APPENDIX A

Museum Staff and Visitor Safety: A Selected Bibliography

Robert F. McGiffin, Chief Museum Conservator/Administrator and Health and Safety Coordinator,
Kansas Museum of History, Topeka, Kansas

This article was reprinted with permission and was originally published as Technical Leaflet Number 3, "For Your Information," by the Mountain-Plains Museums Association.

PREFACE

Within the museum profession, there is an increasing awareness of the issues surrounding health and safety, for both personnel and visitors. Unfortunately, many administrators and staff members have limited knowledge of possible hazards and know of few places to turn if questions arise.

In the near future, you may hear more about museum health and safety in professional publications and at seminars and conferences. Many of the issues are complex ones, with difficult and expensive solutions. Current areas of concern include: proper safety equipment and supplies; storage and disposal of flammable and toxic materials; ventilation of hazardous fumes from conservation and exhibit work areas; safety liabilities of museums; untrained and apathetic staff; compliance with federal, state and local regulations; hazardous original materials in collections; fumigations; pesticides; and the presence of lead paint and asbestos in historic structures.

Where can one look for help? The local office of the U.S. Department of Labor, Occupational Safety and Health Administration (OSHA) or the state Office of Health and Environment (title may vary from state to state) are good places to start. Check with these offices before purchasing safety equipment such as exhaust fans. The chemistry department at a local college or university may provide information on toxic waste disposal.

The following two national agencies will provide lists of health and safety publications:

Center for Occupational Hazards (COM)
5 Beekman St.
New York, NY 10038 (212/227-6620)

American Conference of Governmental Industrial
 Hygienists (ACGIH)
Publications Section
6500 Glenway Ave., Bldg. D-7
Cincinnati, OH 45211 (513/661-7881)

In addition, COH will provide consultant services, with a report pointing out ways in which to upgrade equipment and procedures.

Do not rely solely on architects, equipment catalogues, salespersons, purchasing agents and contractors or on those who say, "I've worked with it for years and it hasn't hurt me." The advice of an engineer specializing in health and safety is needed to resolve potentially hazardous situations.

PUBLICATIONS

BOOKS AND MANUALS

Alliance of American Insurers, *Organic Industrial Solvents,* 5th ed. Chicago: Alliance of American Insurers, 1980.

A.M. Best Company, *Best's Safety Directory,* 2 vols. Oldwick, New York: A.M. Best Company, 1982. Updated regularly.

American Conference of Governmental Industrial Hygienists, *Threshold Limit Values for Chemical Substances and Physical Agents in the Work Environment.* Cincinnati: American Conference of Governmental Industrial Hygienists, 1984. Updated regularly.

——————, *Documentation of the Threshold Limit Values,* 4th ed. Cincinnati: American Conference of Governmental Industrial Hygienists. 1980.

American Mutual Assurance Alliance, *Handbook of Organic Industrial Solvents.* 5th ed. Chicago: American Mutual Assurance Alliance. 1980.

American National Standards Institute, *Practice for Occupational and Educational Eye and Face Protection.* New York. American

National Standards Institute. 1980. ANSI Z87.1-1979.

_____, *Safety in Welding and Cutting*. New York: American National Standards Institute. 1973. ANSI Z49.1-1973.

American Society for Testing and Materials. *Standard Practice for Labeling Art Supplies for Chronic Health Hazards*. Philadelphia: American Society for Testing and Materials. 1983. ASTM D4236.

Barazani, Gail, and McCann, Michael, ed. *Health Hazards in the Arts and Crafts*. Washington, D.C.: Society for Occupational and Environmental Health, 1980.

Bell, Bruce M.; Edwards, Stephen R.; and King, Mary Elizabeth, *Pest Control in Museums*. Lawrence, Kansas: Association of Systematics Collections, 1980.

Clark, H.; Cutter, T.; and McGrane, J., *Ventilation: A Practical Guide*. New York City: Center for Occupational Hazards, 1984.

Committee on Industrial Ventilation, *Industrial Ventilation*. Lansing, Michigan: American Conference of Governmental Industrial Hygienists. 1982.

Eastman Kodak Company, *Safe Handling of Photographic Chemicals*. Rochester, New York: Eastman Kodak Company, 1979.

Gosselin, Robert; Smith Roger; and Hodge, Harold. *Clinical Toxicology of Commercial Products*. 5th ed. Baltimore: Williams and Wilkins. 1984.

Hamilton, Alice, and Hardy, Harriet. *Industrial Toxicology*. 3rd ed. Action, Massachusetts: Publishing Sciences Group, 1974.

Hawley, Gessner, ed. *The Condensed Chemical Dictionary*. 10th ed. New York: Van Nostrand-Reinhold, 1981.

International Labor Office, *Encyclopedia of Occupational Safety and Health*. 2 vols. 3rd ed. Geneva, Switzerland: International Labor Office, 1983.

McCann, Michael, *Artist Beware*. New York: Watson-Guptil, 1979.

_____, *Health Hazards Manual for Artists*. New York: Foundation for the Community of Artists, 1979.

McGiffin, Robert F., *A Current Status Report on Fumigation in Museums and Historical Agencies*. Nashville, Tennessee: American Association for State and Local History, 1985. Tech Rept. #4.

Munro, H.R.U., *Manual of Fumigation for Insect Control*, New York: United Nations Agriculture Studies, 1961.

National Fire Protection Association, *Flammable and Combustible Liquids Code*. Boston: National Fire Protection Association, 1981. NFPA #30.

National Institute for Occupational Safety and Health, *19809 Registry of Toxic Effects of Chemical Substances*. Washington, D.C.: Government Printing Office, 1981. DHEW (NIOSH) #81-116.

_____, *Supplement to the NIOSH Certified Equipment List*. Washington, D.C., Government Printing Office, 1981. DHEW -(NIOSH) #82-106.

_____, *NIOSH Certified Equipment List as of a June 1, 1980*. Washington, D.C., Government Printing Office, 1980. DHEW (NIOSH) #80-144. Updated regularly.

_____, *Occupational Diseases: A Guide to Their Recognition*. Rev. ed. Washington, D.C., Government Printing Office, 1977. #1097.

_____, *A Guide to Industrial Respiratory Protection*. Washington, D.C., Government Printing Office, 1977. DHEW (NIOSH) #76-189.

_____, *The Industrial Environment: Its Evaluation and Control*. Washington, D.C., Government Printing Office, 1973.

National Safety Council, *Accident Prevention Manual for Industrial Operations*. 8th ed. Chicago: National Safety Council, 1981.

Patty, Frank, ed. *Industrial Hygiene and Toxicology*, Vol. II. 3rd ed. New York: Interscience Publishers, 1982.

Sax, N. Irving, *Dangerous Properties of Industrial Materials*. 5th ed. New York: Van Nostrand-Reinhold. 1979. Updated regularly.

Seeger, Nancy, *Alternatives for the Artist*. Rev. ed. Chicago: School of the Art Institute of Chicago, 1984.

Shaw, Susan, *Overexposure: Health Hazards in Photography*. Carmel, California: Friends of Photography, 1983.

Stellman, Jeanne, and Daum, Susan, *Work is Dangerous to Your Health*, New York: Vintage, 1973.

Story, Keith, *Approaches to Pest Management in Museums*. Washington, D.C.: Smithsonian Institution, 1985.

U.S. Consumer Products Safety Commission, *Federal Hazardous Substances Act Regulations*. Washington, D.C.: Federal Register, Sept. 27, 1973.

U.S. Department of Labor, *General Industry Occupational Safety and Health Standards*. Washington, D.C.: Federal Register, June, 1981. 29CFR 1910. Updated regularly.

ARTICLES AND DATA SHEETS

Agoston, George, "Health and Safety Hazards of Art Materials," *Leonardo 2* (1969): 373.

Alexander, William. "Ceramic Toxicology." *Studio Potter* (Winter 1973/74): 35.

Barazani, Gail, "Glassblowing Hazards." *Glass Studio*, no. 11 (1980): 34.

_____, "Hazards of Stained Glass." *Glass Studio*, no. 10 (1980): 33.

Bond, Judith, "Occupational Hazards of Stained Glass Workers," *Glass Art*, vol. 4, no. 1 (1976): 45.

Carnow, Bertram, "Health Hazards in the Arts." *American Lung Association Bulletin* (January/February 1976): 2.

Center for Occupational Hazards. *Art Hazards News*. Monthly Newsletter. First issue 1997.

_____, *Data Sheets*. As listed.
Art Hazards Course Syllabus (12 pp.); Art Painting (3 pp.); Asbestos Substitutes (2 pp.); Bibliography (5 pp.); Ceramics (2 pp.); Children's Art Supplies Can be Toxic (7 pp.); Commercial Art Hazards (1 pp.); Common Solvents and their Hazards (4 pp.); Dye Hazards and Precautions (4 pp.); Electric Kiln Emissions and Ventilation (4 pp.); Face and Eye Protection (2 pp.); Flammable and Combustible Liquids (1 pp.); Formaldehyde (4 pp.); Gloves (1 pp.); Health and Safety in Schools (6 pp.); Lead and Lead Compounds (2 pp.); Lead Glazes and Foods (2 pp.); Material Safety (2 pp.); Medical Surveillance Program for Art Schools (1 pp.); Organic Pigments (2 pp.); Paint Removers (2 pp.); Papier Mache (3 pp.); Photography (2 pp.); Plastics (2 pp.); Respirators (3 pp.); Reproductive Hazards in the Arts and Crafts (4 pp.); Safety Rules for Power Tool Operation (2 pp.); Silica Hazards (3 pp.); Silk Screen Printing Hazards (1 pp.); Stained Glass (2 pp.); Teaching Art to High Risk Groups (6 pp.); Traditional Sculpture and Casting (1 pp.); Welding, Soldering and Brazing (1 pp.); Workers' Compensation for Artists (1 pp.).

Dregsson, Alan, *"Lead Poisoning," Glass*, vol. 5 no. 2 (1977): 13.

Foote, Richard, *"Health Hazards to Commercial Artists," Job Safety and Health* (November 1977): 7.

Graham, J.; Maxton, D.; and Twort, C. *"Painter's Palsy: A Difficult Case of Lead Poisoning," Lacet* (November 21, 1981): 1159.

Halpern, Fay and McCann, Michael. *"Health Hazards Report: Cautions with Dyes."* Craft Horizons (August 1976): 46.

Jenksin, Catherine, *"Textile Dyes are Potential Hazards," Journal of Environmental Health* (March/April 1978): 18.

Mallary, Robert, *"The Air of Art is Poisoned." Art News* (October 1963): 34.

McCann, Michael, *"The Impact of Hazards in Art on Female Workers," Preventative Medicine* (September 1978).

_____, *"Health Hazards in Painting," American Artist* (February 1976): 73.

_____, *"Health Hazards in Printmaking," Print Review*, no. 4 (1975): 20.

_____, and Rossol, Monona. *"Health Hazards in the Arts and Crafts."* Presented at American Chemical Society Annual Meeting, New York (August 15, 1981).

Mortality and Morbidity Weekly Reports. "Chromium Sensitization in Artist's Workshop." Vol. 31 (March 12, 1982): 111.

Nixon, W., *"Safe Handling of Frosting and Etching Solutions," Stained Glass* (Fall 1970): 215.

Prockup, Leon, *"Neuropathy in an Artist." Hospital Practice* (November 1978): 89.

Seeger, Nancy, *Pamphlet Series*. Chicago: Art Institute of Chicago. As listed.
An Introductory Guide to the Safe Use of Materials.
A Printmaker's Guide to the Safe Use of Materials.
A Photographer's Guide to the Safe Use of Materials.
A Painter's Guide to the Safe Use of Materials.A ceramist's Guide to the Safe Use of Materials.

Siedlicki, Jerome. *"Occupational Health Hazards of Painters and Sculptors." Journal of American Medical Association* 204 (1968): 176.

_____, *"Potential Hazards of Plastic Used in Sculpture." Art Education* (February 1972).

Stewart, Richard, and Hake, Carl. *"Paint-Remover Hazard." Journal of American Medical Association* 235 (1976): 398.

Waller, Julian, *"Another Aspect of Health Issues in Ceramics," Studio Potter.* Vol. 2., no 2 (1980): 60.

_____, and Whitehead, Lawrence. *"Health Issues."* Craft Horizons. (1979-1980): regular column.

Wellborn, Stanley, *"Health Hazards in Woodworking." Fine Woodworking* (Winter 1977)

Willis, J.H., *"Nasal Carcinoma in Woodworkers: A Review," Journal of Occupational Medicine*, vol. 24, no. 4 (1982): 315.

For your information, a technical leaflet is published on an occasional basis under the auspices of the Mountain-Plains Museums Association. Copies may be ordered from the MPMA coordinator, P.O. Box 335, Manitou Sprints, CO 80829.

APPENDIX B

Professional Standards for the Practice of Visitor Research and Evaluation in Museums

Committee on Audience Research and Evaluation, a Standing Professional Committee of the American Association of Museums.

For membership information in this committee, contact AAM at 202/289-9130 or membership@aam-us.org.

Museums are by definition institutions designed to serve the public. While they collect, research, and preserve a wide variety of materials and objects, it is their presentations to the general public about these objects through the media of exhibitions and public programs that give museums their distinct and unique character. Such presentations vary widely in their content and style, from paintings in a gallery to an interactive computer game on the importance of rain forests, to a docent-led tour of school children visiting a zoo or aquarium. Nevertheless, they all share a common purpose: to facilitate visitor experiences that are both enjoyable and informative. However, the heterogeneous and voluntary nature of the visitor population presents unique challenges to those that conceive of, design, and implement museum exhibits and programs. A knowledge and understanding of that population is a necessary prerequisite to the realization of the educational goals of museums.

It is in this context that the field of visitor studies has evolved over the years. Starting in the late 1920s and gaining momentum since the mid-'60s, there is now a considerable body of knowledge (much of it published and available) that clearly demonstrates the value of utilizing information obtained from and about visitors to improve exhibits and programs in communicating with their intended audiences.

In preparing these standards it is the goal of the Committee on Audience Research and Evaluation (formerly the MM Visitor Research and Evaluation Committee) to promote professionalism and quality in all visitor research and evaluation activities and to increase the institutional commitment of museums to utilize this knowledge in their day-to-day activities. We also recognize that creativity and diversity are needed to keep the field of visitor studies responsive and viable, and so we expect that these standards will evolve as the field itself evolves and as museums continue to respond to the forces of change in our dynamic and pluralistic society.

The committee sincerely thanks all those who helped In the preparation of these standards, but especially the subcommittee on professional standards for taking the lead in their creation - Lois Silverman, Chair, with Harris Shettel, Stephen Bitgood, Minda Borun, George Hein, Ross Loomis, and Mary Ellen Munley.

Adopted May 1991

Committee on Audience Research and Evaluation: A Standing Professional Committee of the American Association of Museums

(The word "museum" as used throughout this document refers to all public interpretive facilities and institutions, such as zoos, botanical gardens, aquariums, science centers, historic houses, heritage sites, natural parks, and nature centers.)

INTRODUCTION

The missions of museums intimately involve and depend upon visitors. Accordingly, museums bear the vital responsibility to understand the needs, interests, and concerns of audiences, actual and potential, and to incorporate this understanding into their policies, practices, and products. Studies of visitors carried out to date amply document the fact that assumptions and speculations about visitors can be both inaccurate and unknowingly biased. For example, visitor experiences and interest often differ in important ways from the expectations and intentions of those who prepare exhibits and other public access programs. In light of repeated findings such as these, the need to support and engage in visitor evaluation, research, and other audience

advocacy efforts becomes paramount. Only in this way can museums respectfully and accurately respond to the needs, perspectives, and diversity of audiences, even as they change over time. While the design and conduct of visitor studies should be undertaken by those who possess the appropriate skills and knowledge, the entire community of museums shares this broad responsibility.

This document defines general guidelines for the competent and responsible support and practice of visitor studies, defined as the process of systematically obtaining knowledge from and about museum visitors, actual and potential, for the purpose of increasing and utilizing such knowledge in the planning and execution of those activities that relate to the public.

Over time, the practice of visitor studies has evolved into a rich, interdisciplinary field, characterized by a variety of methodologies and theories. Those who engage in such studies include social scientists from disciplines such as psychology and sociology, educators, exhibit designers/developers, professional consultants, as well as others. While the needs and skills of these individuals may vary, and while their locus of operation may be within or without the institutions they serve, this document is intended to provide standards of practice that have applicability to all of them. These standards are also intended to serve as useful guidelines to museum studies programs in developing curriculum materials related to visitor research and evaluation as well as to those governmental agencies and private foundations that may support visitor studies.

These standards are divided into three major sections. The first presents the responsibilities of those who engage in and support visitor studies. The second addresses the competencies required to carry out visitor studies. The third section deals with the responsibilities of the museum community at large to support efforts to improve our understanding of the museum visitor.

I. RESPONSIBILITIES

While two groups are identified below as having special responsibilities connected with the conduct of visitor studies, (A) those who design and implement them, and (B) those who sponsor and facilitate them, it should be emphasized that anyone connected with such studies shares in these responsibilities.

A. Those Who Design and Implement Visitor Studies Have the Responsibility to:

1. **Decide** — whether or not a study is feasible and appropriate, based on a careful consideration of the needs and concerns of the sponsor and the resources available to carry out the study.

2. **Design** — methods and procedures that are sensitive to and appropriate for the needs of the study and supporting institution, the questions and issues raised, the audience(s) selected, and the constraints imposed.

3. **Document** — prior to the initiation of the study and agreement among relevant parties regarding the rationale and objectives of the study, the work to be done, the role of all individuals involved, the time and funds estimated as required to complete the work, and the rights, restrictions, and conditions regarding the publication and dissemination of study findings.

4. **Communicate** — to project and support personnel the progress of the work being done as well as any problems that may interfere with its successful completion.

5. **Adhere** — to existing ethics and standards documents that may apply to a particular study and/or methodology, such as those published by the American Association of Museums, the American Psychological Association, and the Joint Committee on Standards for Educational Evaluation.

6. **Respect** — the rights and privacy of all individuals who may be involved in a study. For example, visitors who are asked to participate in a study should be fully informed of the purpose of their participation and given the right of refusal.

7. **Report** — recommendations that are based on study findings and that are in keeping with the original objectives of the study. Distinguish between those findings that meet the criteria of significance, relevance, and practical importance, and those that do not.

8. **Disseminate** — to the extent possible and allowed, the study design, procedures, and findings to other practitioners, and to museum professionals in general, through presentations, publications, and other appropriate forums. Include both the strengths and the limitations of the study and the extent to which findings can be generalized to other settings.

B. Those Who Sponsor or Facilitate Visitor Studies Have the Responsibility to:

1. **Provide** — the necessary financial, staff, logistical, and other forms of support, as previously specified and agreed upon.

2. **Utililze** — study findings appropriately, accurately, and in keeping with the original objectives of the study.

3. **Assess** — the original plan, its execution, and the outcomes of the study based upon its original objectives, the time and funds required, the recommendations made, and the extent to which the results provide information that leads to improved understanding of, and communication with, visitors.

II. COMPETENCIES

While visitor studies are conducted by individuals representing a variety of backgrounds and training, the following areas describe the basic competencies required for professional practice:

1. **Relevant Literature** — All professionals involved in the practice of visitor research and evaluation should be familiar with the history, methodologies, past and current developments, and major findings of the field. In addition, there exists a large body of work in areas that have relevance to visitor studies, including educational theory, environmental design, developmental psychology, communication theory, leisure studies, and marketing research. While it is not possible for any one person to keep abreast of all these fields, professionals share a collective obligation to monitor major directions and findings and to be open to opportunities for the enrichment of the visitor studies field by other relevant areas of inquiry.

2. **Museum Policies and Practices** — All individuals who engage in visitor research and evaluation must understand the practices and procedures of museum operations in general, as well as those of the particular institution for which such work is being conducted. In order to make intelligent study interpretations and recommendations, it is especially important to acquire an understanding of the principles and practices of museum education, the exhibit development process and marketing-public relations activities.

3. **Methodological and Analytical Skills** — Those who design and/or conduct visitor studies must possess a working knowledge of social science research design and the related methodological and analytical skills necessary for responsible decision-making and study execution. While some may specialize in a particular methodological or theoretical approach, they must also possess sufficient familiarity with alternative methods and approaches so that they can properly assess and represent the "best fit" for any given study issue or problem.

4. **Communication Skills** — Visitor study practitioners must be skilled in effective communication and information-gathering techniques with museum staff at all levels, as well as with visitors. This includes the ability to clearly articulate what is being done, why it is being done, and how it is being done, as well as how the findings will be of use to the Institution.

5. **Field Advancement** — Those involved in visitor research and evaluation have a commitment to the pursuit, dissemination, and critical assessment of theories, studies, activities, and approaches utilized in and relevant to visitor studies. Through conference attendance and presentations, journals and publications, and other formal and informal forums of communication, visitor study practitioners should support the continued evolution of visitor research and evaluation.

III. INSTITUTIONAL COMMITMENT AND SUPPORT

The practice of visitor studies can make its most important contribution to the museum community when it is considered to be an integral part of professional museum responsibilities. To realize this, every museum should:

1. **Advocate** — efforts to increase knowledge and understanding of their audiences, both actual and potential.

2. **Incorporate** — the needs, interests, and perspectives of people of different ages, backgrounds, and walks of life, in the planning, execution, and revision of exhibits, programs, and other presentations that relate to the general public.

3. **Support** — the practice of visitor research, evaluation, and other audience advocacy efforts within their own institution by providing the necessary staff and funding.

APPENDIX C

Standards and Best Practices for Historic Site Administration

From *Standards and Practices for Historic Site Administration* ($12), a publication of the Tri-State Coalition of Historic Places. To order, contact the Coalition at 100 South Broad Street, Suite 1341, Philadelphia, PA 19110, telephone 215-569-2896; or at hparmenter@juno.com.

VISITOR SERVICES

The organization that administers a historic site serves its visitors by providing:

GOOD	BETTER	BEST
• Regular access for visitors, staff and services • All the visitor services it promises	• Visitor information	• Network of visitor services and tour arrangements with other sites
• Basic amenities	• Access to restrooms, parking, shops and food services	• Adequate amenities for large groups • Appropriate foreign language materials
• An understanding of the needs of the disabled and the impaired	• Efforts to accommodate persons with physical disabilities	• Accommodations for all types of disabilities and impairments

APPENDIX D

Science Museum of Minnesota Front-Line Handbook

Reprinted with permission of the Science Museum of Minnesota

INTRODUCTION

The Front-Line Handbook outlines the general policies, rules, regulations, and benefits specifically pertaining to front-line employment at the Science Museum of Minnesota. This handbook is an extension of the Science Museum of Minnesota Employee Handbook but should not be considered a substitute. Please familiarize yourself with the Science Museum of Minnesota Employee Handbook. A copy is available to you in your work area or you may request your own copy from the human resources department.

The policies and procedures in this handbook pertain to all front-line employees. However, there are usually additional policies and procedures for each front-line department. Your immediate supervisor is responsible for ensuring that you receive an orientation to these particular procedures and policies.

This handbook is not intended to be a contract or a guarantee of employment for any particular period. Employment at the museum is considered an "at will" arrangement. This means that the employer and/or the employee are free to terminate the employment at any time for any reason. The Science Museum of Minnesota may change the benefits and policies set forth in this handbook at any time without prior consent or notice to its employees.

Hereafter in this handbook, the Science Museum of Minnesota will be referred to by the abbreviation

(See Employee Handbook, page i.)

SCIENCE MUSEUM OF MINNESOTA'S MISSION STATEMENT

Inviting learners of all ages to experience their changing world through science.

Welcome to the Science Museum of Minnesota! You have joined a world-renowned museum with exhibits addressing subjects such as anthropology, biology geography, paleontology, technology, cultural history, and natural history. Additionally, the museum houses a collection of more than 1.75 million scientific objects and an Omnitheater that produces films shown all over the world.

The Science Museum of Minnesota is a private, nonprofit, education and research institution, organized to collect, study, and preserve objects of scientific significance for future generations and to interpret the objects, discoveries, and insights of science for the general public through exhibits and education programs.

As a front-line staff member, your mission will be to add value to our visitors' experience by providing exceptional service and to safely accommodate our visitors. You were selected as a Science Museum employee in large part because you enjoy working with the public. Ensuring a successful visitor experience is a team effort, requiring the skills of many trades, the knowledge of many professions, and the work and cooperation of every employee. When we all work together as a team, it adds up to a maximum amount of enjoyment and a minimum amount of frustration, both for our visitors and ourselves. Once again, welcome to SMM. We hope that you will enjoy your employment here.

(See Employee Handbook, page iv.)

AN INSTITUTIONAL FRAMEWORK FOR DIVERSITY AT THE SCIENCE MUSEUM OF MINNESOTA
February 8, 1996

The mission of the Science Museum is to invite learners of all ages to experience their changing world through science. Our vision statement declares that we will achieve strength within our mission by seeking diversity in these areas:

- the audiences we serve;
- the learning styles we support;
- the communities from which we draw our support;
- and the staff and board whom we employ.

Our principal reasons for valuing diversity are that we will be:

- a stronger Science Museum in carrying out our mission;
- a more effective entity in broadening the base for decision-making and in building leadership skills across the organization;
- and a broader and deeper community resource.

With this framework, we begin to create a context for seeking diversity. The staff and board of the Science Museum commit ourselves to these beliefs:

- Diversity is an institutional value which recognizes that this organization can thrive on the richness of differences, especially (but not limited to) those of cultural, racial, ethnic, or religious heritage; gender; age; sexual orientation; socioeconomic class; and physical ability. When we, the museum staff and board, pursue diversity, we create a climate of inclusiveness, equity, and acceptance--a strong organization.
- Diversity also is a process. It is an evolving concept, one that we embrace even without knowing its complete implications for the individual, for society, and for the museum. We are eager to participate in this process. We will lead and manage it in a spirit of openness to the differing perspectives we engage along the way.
- Diversity is an integrating principle linking all levels: institutional, interdepartmental, and interpersonal. Our programs, policies, and practices will be responsive and welcoming to a wide range of people, their insights, values, and cultures. We expect our staff and board to be respectful of this principle; diversity cannot exist on an institutional level without such a personal commitment.

SMM SERVICE MISSION AND STANDARDS

SERVICE MISSION

To add value to our visitors' experience by providing exceptional service.

SERVICE COMMITMENT

We will:

1. Actively seek feedback from our visitor and each other.
2. Maintain constructive and cooperative relationships with the visitors and each other.
3. Work together to meet and exceed visitors' expectations.
4. Give our service freely and respectfully.
5. Each take the initiative to make things better.
6. Lead by our example.

THE THREE STANDARDS FOR SERVICE

All museum staff and volunteers are expected to:

1. Represent the museum. To be aware and understand the impact each of us has on the visitor.
 How: Be responsive, listen to visitors, be courteous and patient, maintain a clean and neat appearance, and be punctual.
2. Be informed. Have a basic knowledge of museum operations and programs.
 How: Listen, read, and ask.
3. Make every visitor feel welcome. Make each visitor feel welcome and important. Every visitor needs to know that their presence and the quality of their experience is important to the museum.
 How: Acknowledge every visitor. Make eye contact and/or smile, say hello. Be prompt with assistance and follow through.

VISITOR SAFETY
(SEE EMPLOYEE HANDBOOK 6.07.00)

It is important to remember that one of your main responsibilities is to safely promote SMM and all of its programs in a positive and informative manner.

SMM EMPLOYEE BENEFITS

Employee name _____

Job title _____

Supervisor _____

Supervisor's phone number _____

Date hired _____

As a front-line hourly employee, you are entitled to a number of benefits: premium pay for holiday work (see Employee Handbook 4.01.03); the opportunity to join SRA and GRA retirement savings plans with TIAA CREF (see below); complimentary exhibit and Omnitheater passes (see below); complimentary or discounted continuing education/computer education classes and lectures (see Employee Handbook 3.04.00); and discounts in the Explore Stores and at museum restaurants (see Employee Handbook 3.05.00 and 3.06.00)

In addition to these benefits, you will be eligible for consideration for an hourly rate increase after three months. Each increase thereafter will coincide with your date of hire. These increases are not automatic: they are based on satisfactory performance.

Your level of performance will be determined by your supervisor during your three-month performance review. To prepare for this review, we suggest that you read and understand the responsibilities in your job description and the procedures outlined in this manual.

RETIREMENT SAVINGS PLANS

- Supplemental Retirement Annuity (SRA) This program provides an excellent opportunity for employees to set aside pre-tax dollars for retirement savings. All hourly (and salaried) employees, even new hires, are eligible to participate in the SRA program by agreeing to contribute a minimum of two percent of their salary, up to a maximum of 19 percent.
- Group Retirement Annuity (GRA) All hourly (and salaried) employees are eligible to participate in this program either January 1 or July 1, if they meet the following eligibility requirements: are actively employed; are 21 years old; and have completed two years of 1,000 hours each, based on their original hire date.

If an employee elects to not participate in the museum's retirement plan when s/he first becomes eligible, s/he cannot enroll at a later date.

If you would like to learn more about these two benefit programs, please contact human resources.

OMNITHEATER AND EXHIBITS — COMPLIMENTARY TICKETS (SEE EMPLOYEE HANDBOOK 3.03.00)

The museum provides each staff member 30 Omnitheater admissions per year per household or 60 per year per household if two or more are employed at SMM. Exhibit hall admission is unlimited per year per museum household. SMM asks employees to limit the number of guests to 10 per visit when visiting the Omnitheater or exhibits. Remaining Omnitheater admissions are forfeited at the last day of employment.

At the box office, Omnitheater and exhibit hall tickets are available to employees presenting their museum identification. Employees are expected to wait their turn in line (with visitors) at the box office. Reservations are not required, but are recommended during the museum's busiest times, such as weekends and holidays. During these peak hours, restrictions may be placed on staff admissions. Some films or exhibits may require an additional charge. Additional tickets and memberships may be purchased at a 10-percent discount by employees.

EMPLOYEE CHECK CASHING
(SEE EMPLOYEE HANDBOOK 3.10.00)

Employees may generally cash checks up to $50 at the box office between noon and 2 p.m. on an available basis. No second or third-party checks can be cashed, and SMM retains the right to refuse check-cashing privileges. A service charge will be assessed for any bank-returned items. Museum identification must be presented when cashing checks. Employees are expected to wait their turn in line (with visitors) at the box office.

SMM HOURS
(SEE EMPLOYEE HANDBOOK 2.00.00)

Hours are subject to change, so check the most current visitor guide for correct times.

WEST BUILDING

Monday - Saturday	9:30 a.m.-9 p.m.
Sunday	10 a.m.-9 p.m.

Closed Mondays after Labor Day through mid-December; see visitor guide for exact dates.

EAST BUILDING

Monday - Friday	7 a.m.-9 p.m.
Saturday	8 a.m.-9 p.m.
Sunday	9 a.m.-9 p.m.

EXHIBIT HALLS

Monday - Saturday 9:30 a.m.-9 p.m.
Sunday 10 a.m.-9 p.m.

Closed Mondays after Labor Day through mid-December; see Visitor Guide for exact dates.

LOADING DOCK DOOR (EAST BUILDING)

Monday - Sunday 7 a.m.-9:30 p.m.

SKYWAY DOOR (WEST BUILDING)

Monday - Friday 7 a.m.-9 p.m.
Saturday 8 a.m.-9 p.m.
Sunday 9 a.m.-9 p.m.

PARKING RAMP (BELOW WEST BUILDING)

Monday - Thursday 6:30 a.m.-11 p.m.
Friday 6:30 a.m.-1:30 a.m.
Saturday 7 a.m.-1:30 a.m.
Sunday 8 a.m.-10:30 p.m.

ADMINISTRATIVE OFFICES

Monday - Friday 8 a.m.-5 p.m.

For adverse weather information, call 221-9488.

SMM DRESS CODE POLICY FOR FRONT-LINE STAFF

(revised July 1995)

FIRST IMPRESSIONS

Visitors from all over the state, nation, and the world are attracted to the Science Museum of Minnesota-and every visitor is important. Visitors entrust the staff and volunteers of the museum to provide them with a safe, comfortable, and completely enjoyable experience. We want visitors to know that we value that trust, and that we are fully committed to our responsibilities to them.

First impressions are crucial in any relationship, and so we are committed as the museum's public representatives to make ourselves visible and easily identifiable by wearing clothing that is consistent amongst the museum's representatives to the public. We recognize that being visible, easily identifiable, and prepared to help is what is important to the public. A consistent look identifying us as representatives of the museum also shows that we have both the authority and responsibility for their welfare and that of the museum.

However, a uniform alone cannot substitute for courteous behavior. We will maintain an attitude of consistent courtesy and willingness to help, making each visitor feel welcome.

OVERALL DRESS CODE POLICY
(SEE EMPLOYEE HANDBOOK 5.09.00)

The Science Museum of Minnesota has established a dress code policy for staff and volunteers working with the public. A reasonable standard of neatness and cleanliness will be expected. Uniforms will be worn and will be provided by the museum for each front-line staff position. Wearing the appropriate uniform is a condition of employment for people working with the public. Understatement of other clothing and jewelry is the best choice, given the variety of people these staff and volunteers will encounter.

The museum provides standard uniform items; however, each staff member is responsible for maintaining those articles in good and clean condition. As items wear out, they will be exchanged for new ones at no cost to the employee. Articles lost or damaged through abuse will be replaced and charged to the employee at full replacement cost. All staff are expected to notify supervisors of problems with uniforms.

Questions regarding dress, grooming, or uniforms should be addressed to supervisors, who will suggest appropriate solutions.

SPECIFIC DRESS CODE GUIDELINES

GROOMING

Cleanliness and a reasonable standard of neatness is expected.

Hair, including facial hair, may need to be trimmed or tied back if safety or neatness issues are identified.

Jewelry and other items of personal decoration should remain understated and also may be dictated by safety concerns.

Make-up or perfume use may be adapted at the request of the supervisor.

UNIFORMS

These guidelines are to be followed in all work areas requiring uniforms. There may be additional uniform requirements from area to area. Supervisors will inform their staff of any additional uniform requirements.

STANDARD UNIFORM

Uniform tops will be provided by SMM and will have the SMM insignia. Staff tops will be red short-sleeved polo shirts, vests, or aprons. Staff will provide their own solid color shirts or blouses to be worn under vests or aprons. Shirts or blouses with slogans or offensive language are not acceptable.

Uniform bottoms will be provided by individual staff and will be long pants or skirts in a solid color.

Shoes should not present a safety hazard; i.e., very high heels, sandals, or open-toed and/or unlaced shoes.

Identification badges are issued by SMM and must be worn by all staff while on duty. Badges must be worn so that they are easily visible to the visitor.

BUILDING MAINTENANCE UNIFORMS

Building maintenance staff will wear pants and shirts provided by the museum.

Information regarding changes to and enforcement of dress code policy and guidelines may be obtained from the director of visitor services.

GENERAL INFORMATION

ABSENTEEISM

It is very important that you are present and in uniform at the beginning of your scheduled shift. Your position is important to the smooth operation of SMM. When you are not ready and in uniform, an extra burden is placed upon the rest of the front-line staff team. Check with your supervisor about what to do if you are ill.

ACCIDENTS-WORK RELATED

If you have a work-related accident, notify your supervisor immediately, so that he or she may fill out the appropriate report of injury forms.

ADVERSE WEATHER
(SEE EMPLOYEE HANDBOOK 6.08.00)

If the museum is to open late or not open at all due to adverse weather, staff will be informed by:
- calling SMMs general number (221-9488).
- listening to WCCO Radio (830 AM).
- receiving a call from their supervisor.

ARTIFACTS AND SCOPE
(SEE EMPLOYEE HANDBOOK 6.09.03)

Artifacts is SMM's weekly interoffice newsletter. It is distributed every Thursday morning. *Scope* is SMMs monthly membership newsletter. These publications keep our employees and members informed and updated as to exhibit openings, new Omnitheater films, special events, job postings, and any other pertinent SMM information. As a front-line employee, it is particularly important that you keep current by reading *Artifacts* and *Scope*. Ask your supervisor where copies are posted in your area.

BREAKS (SEE EMPLOYEE HANDBOOK 2.02.00)

Everyone needs a break to relax and rejuvenate their enthusiasm. Your supervisor will work with you to schedule your break times. For each four hour shift worked, you are entitled to one 15-minute paid break. If you are scheduled for eight hours, you also are entitled to a 30-minute unpaid break. Please remember to clock in and out during unpaid breaks.

DAILY BRIEFINGS

A briefing is held each morning 20 minutes before opening. At the briefing you will find out about any special events, classes, or programs scheduled for that day. All front-line staff working an opening shift are expected to attend the daily briefing.

DAILY PROGRAM SCHEDULE

A list of the day's public programs is posted in the west building lobby. A handout of this list also is available at the box office or the information booth.

DONATIONS

If someone wishes to make a gift of money to the museum, contact the development department (2515). If they are not available, direct the person wishing to make the donation to the head cashier at the box office. If a visitor wishes to donate an object or have an object identified, they must contact the science division (Monday-Friday 9 a.m.-4:30 p.m., 9424). Never accept an object (for donation or identification) from a visitor.

EQUAL OPPORTUNITY STATEMENT
(SEE EMPLOYEE HANDBOOK 1.01.00)

SMM's policy and practice is to recruit, hire, and promote well-qualified people and to administer all compensation and other terms and conditions of employment without discrimination because of race, creed, color, sex, age, religion, disability, marital status, status with regard to public assistance, national origin, sexual or affectional orientation, or other protected-class status.

If an employee believes he or she has been discriminated against in violation of this policy, he or she is asked to contact the director of human resources.

EMPLOYEE COMPLAINTS/CONCERNS
(SEE EMPLOYEE HANDBOOK 5.06.00)

Complaints or concerns of an employee about working relationships or working conditions shall be considered promptly and fairly. Such concerns should be brought to the department or division head or to that person's supervisor if such concerns cannot otherwise be resolved. The director of human resources also should be consulted. If reasonable resolution cannot be achieved, the matter of concern should be relayed in writing to the president for resolution. The executive committee of the board of trustees represents the final stage of appeal.

EMPLOYMENT RECOMMENDATIONS
(SEE EMPLOYEE HANDBOOK 1.06.00)

Your relatives and friends are welcome to apply for employment at SMM. If you have qualified relatives and friends interested in our job openings, please direct them to our human resources department.

EXHIBIT MAINTENANCE

If an exhibit needs repair, inform your supervisor. Do not allow visitors to use the exhibit until maintenance arrives. If exhibit maintenance is unavailable, and the broken exhibit is a safety hazard, inform the visitor relations manager.

FIRST AID ROOM

There is a first aid room located on the skyway level of the museum's west building. Ask your supervisor for the code to unlock the door. The first aid room has a toilet, sink, cot, and supplies of bandages and cold packs. For more information, see the emergency procedures manual (available from the visitor relations manager).

INCIDENT REPORTS
(SEE EMPLOYEE HANDBOOK 6.0 7.00)

Incident reports are to be filled out for medical emergencies, shoplifting, vandalism and other problems. Generally, these reports are completed by the visitor relations manager, however, there may be occasions when other staff will need to fill one out. These reports are kept at the box office and should be turned in to the visitor relations manager as soon as possible for insurance and general recordkeeping reasons.

INFORMATION BOOTH

There is an information booth located in the west building lobby Visitor guides, daily program schedules, maps, bus schedules, and information about other area attractions are available there.

LATE SEATING IN THE OMNITHEATER

There is no late seating in the Omnitheater. If someone is locked out, direct them to the box office.

LOST AND FOUND
(SEE EMPLOYEE HANDBOOK 6.16.00)

Lost and found items should be turned in to the box office. At the end of the day, items are taken to the reservations office. If you are unable to leave your area, let the visitor relations manager know that you have a lost and found item. If an item has not been turned in to the box office, visitors can fill out a lost and found form, and they will be contacted if their lost item is found.

MULTIPLE MUSEUM JOBS

Museum staff often piece together several jobs in the museum in order to best use their time. Following are some reminders for those of you who are considering working in more than one place at SMM:

1. It is your responsibility to communicate with all of your supervisors to ensure that you do not work more than 40 hours per week. If you are close to 40 hours, inform your supervisor. They may choose to cut your hours rather than pay you overtime.
2. If you give up shifts in one area to work on a project or take a temporary/seasonal position, you may not get those shifts back when the project is finished. It is best to be prepared ahead of time and have plans made with different supervisors long before projects or temporary jobs are finished.

3. When using the electronic time clock, make sure you put in each work area's code individually.

4. No more than three museum jobs may be held by an individual employee at one time.

PERSONAL VISITORS AND PHONE CALLS
(SEE EMPLOYEE HANDBOOK 6.03.00 AND 6.04.00)

Personal visitors and phone calls keep you from your job of assisting museum visitors. Please keep them to a minimum, preferably during your break time.

PHONE LIST

A phone list containing phone extensions for all museum employees is regularly updated and published in Artifacts. A copy of this list also is kept in the information booth and at the box office.

PUBLIC ADDRESS ANNOUNCEMENTS

P.A. announcements are controlled by the box office. Announcements are made for Omnitheater show times and museum closing. Due to ongoing programs and demonstrations, announcements are made only in the case of extreme emergencies, such as fires, bad weather, or lost children. All announcements should be kept as clear and concise as possible.

SCHEDULES

You are responsible for working all of your scheduled shifts. Check with your supervisor about where to find your schedule, procedures for requesting time off, etc.

SPECIAL-NEEDS VISITORS

SMM is equipped to accommodate the visitor with a disability. Entrances, exits, restrooms and the third-floor entrance to the Omnitheater are all accessible to our visitors in wheelchairs. Additionally, SMM has several wheelchairs for visitor use. Omnitheater scripts in both regular and large-print are available (at the box office) for our hearing- and sight-impaired visitors. Sign language interpreters are available with 72 hours notice. To make it easier for you to deal respectfully with visitors with disabilities, remember to:

1. Offer help, but wait until the offer has been accepted before giving it.

2. Accept the fact that the disability exists. Personal questions regarding the disability are inappropriate.

3. Speak directly to the visitor with a disability, not to the person accompanying him or her.

4. Speak clearly, distinctly, and at a normal speed to a visitor with a hearing impairment. Do not exaggerate or shout. Provide a clear view of your mouth to make lip-reading possible. If they still do not understand you, write down your message.

5. Speak clearly and concisely to a visitor with a mental disability and try not to use complex sentences. Do not change the tone of your voice or talk down to them.

6. If you cannot understand what a visitor with a disability says, ask that the statement be repeated or written down.

7. When calling on the radio to alert Omnitheater staff of a wheelchair entrance, say, "third floor entry," not "handicap" or "wheelchair" entry.

THEFT/VANDALISM

You are not expected to confront anyone suspected of shoplifting or vandalism. Instead, report any thefts or vandalism to your supervisor or the visitor relations manager.

TIME CLOCKS
(SEE EMPLOYEE HANDBOOK 2.00.00)

Your supervisor will let you know which time clock to use. Be sure you clock in and out each working day and also during unpaid breaks. When clocking in at the beginning of your shift, be sure to enter the correct code for the area or job in which you will be working.

TRAINING

All new front-line staff are expected to attend a new employee orientation. Contact the human resources department for a schedule of these sessions. Front-line staff also are required to attend annual emergency procedures training and service training. Individual areas will require additional training for staff.

UNACCEPTABLE BEHAVIORS
(SEE EMPLOYEE HANDBOOK 5.00.00)

The following is a list of behaviors that are considered unacceptable at SMM. The following list does not include all the causes for discipline, nor does it in any way restrict SMM's right to discharge employees with or without cause at any time.

1. Arguing, being disrespectful, using profane language, or telling ethnic or sexual jokes in the presence of SMM visitors or employees.

2. Insubordination or refusing to perform assigned work.

3. Continued violation of museum policies, such as dress code.

4. Extensive tardiness or absence.

5. Inadequate work performance.

6. Violations of operating rules and procedures, especially violations that could result in bodily injury or damage to visitors, staff, or SMM property

7. Falsification of documents, such as employment applications or time cards.

8. Unauthorized release of confidential information.

9. Using, possessing, or being under the influence of alcohol or drugs during working hours, or reporting to work under such conditions.

10. Theft or misappropriation of property belonging to SMM.

11. Misusing, destroying, defacing, or damaging SMM property.

VISITOR GUIDE

The museum visitor guide includes current information about museum hours, Omnitheater show times, prices, and special exhibits. It is updated seasonally. Copies of the visitor guide are available at the box office or the information booth.

GENERAL EMERGENCY PROCEDURES

BASIC GUIDELINES:

1. Stay off the radio and listen for instructions.

2. Stay calm-visitors will look to you for assurance.

3. During a fire alarm or tornado warning, do not allow anyone to use the elevators.

4. During a fire alarm or tornado warning, take your radio with you.

5. Never move anyone who is injured-call the visitor relations manager (VRM).

6. Never administer first aid-call the VRM (unless you are CPR/First Aid certified and have told the VRM in advance).

7. Never call 911-call the VRM.

8. If you're away from the radio, the VRM can be reached at 4772 (outside SMM: 221-4772).

FIRE ALARMS

When the fire alarm sounds, you should clear visitors from your area as quickly and calmly as possible, directing them to the nearest fire exit.

EMERGENCY EVACUATION (OTHER THAN FIRE)

The VRM will notify you that the building must be evacuated. At that time you should clear visitors from your area as quickly and calmly as possible, directing them to the nearest exit.

TORNADO WARNINGS

When a tornado warning is sounded (over the radio or PA system), you should direct all visitors to the nearest shelter area. The shelter area for the east building is located in the canteen and, if necessary, the exhibit office corridor. The west building tornado shelter area is located in the back of the first and second floor exhibit halls. Visitors who wish to leave the museum during a tornado warning are free to do so. Visitors remaining in the museum must follow Science Museum tornado procedures.

Most areas of the museum have additional procedures for fire alarms, evacuation, and tornado warnings. These are outlined in the Emergency Procedures Manual (contact the visitor relations manager for a copy). You should familiarize yourself with any additional emergency procedures or duties for your area.

LOST CHILDREN

When a visitor is looking for a lost child, the following information needs to be obtained: the name, age, clothing, hair color, and last known location of the child. After this information has been gathered, it should be broadcast over the radio and all floors will be searched for the child (if you do not have a radio, contact the VRM, and they will broadcast the information).

Finding the child will become the priority of all SMM staff on the floor until the VRM calls off the search! When a call about a lost child goes out, search your area. If the child is not found in your area, notify the VRM and continue the search. If the child is found, notify the VRM and follow his/her instructions.

LOST PARENTS/GUARDIANS

When a child has become separated from his/her parent or guardian, escort them to the box office so that a PA announcement can be made for the lost parent. If you are unable to leave your area, contact the VRM to come for the child.

MEDICAL EMERGENCIES

The VRM is responsible for all first aid within SMM. When a medical emergency occurs, notify the VRM and inform them of the type of emergency, as can best be determined, and the location of the emergency within the museum. Also, let the VRM know if the emergency involves bleeding. Stay near the situation until the VRM arrives and assist the VRM as directed.

If you are involved in any incident that involves blood, your own or another's, let the VRM know immediately. These incidents must be reported to the SMM safety officer.

VANDALISM

If vandals are observed destroying SMM property, notify the VRM and keep track of the vandals until the VRM arrives so that they can be identified. If vandalism is discovered after the fact, notify your supervisor or the VRM and write an incident report.

BOMB THREATS

If you receive a bomb threat phone call, try to remain as calm as possible. Signal another staff member to contact the VRM immediately. Keep the person on the line and extract as much information as possible. Note the background noise, accent, sex, etc. If you receive a written threat, contact the VRM immediately

SUSPICIOUS PACKAGES

If you receive or find a suspicious parcel or object, you should immediately turn off your radio and instruct others in the area to turn off their radios. You should then contact the VRM using a land line (not a cellular phone) at 4772.

UNRULY GROUP/VISITOR

If you feel a group(s) or visitor(s) is a possible problem, contact the VRM immediately (using STAND BACK code, if necessary; see Radio Protocol) and request that Unit 12 be alerted. Remain with the situation until the VRM arrives and assist the VRM as directed.

POWER OUTAGE

When there is a power outage at SMM, the emergency generator will come on in one to two minutes, and the emergency lights will come on. Calm the visitors and advise them that the emergency lights will be on shortly. After the emergency lights are on, direct visitors to a lighted area and have them remain there until power is restored. If power is to be out for an extended period, the VRM will broadcast instructions on what to do.

OTHER EMERGENCY SITUATIONS

Notify the VRM immediately (by calling 4772 or by radio, using STAND BACK code, if necessary; see Radio Protocol) and describe the situation and the type of assistance required.

BLOODBORNE PATHOGENS/ UNIVERSAL PRECAUTIONS

UNIVERSAL PRECAUTIONS

At SMM, we practice "Universal Precautions." We treat all human blood and body fluids as if they are known to be infectious for HBV and HIV and other bloodborne pathogens. In circumstances where it is difficult or impossible to differentiate between body fluid types, we assume all body fluids to be potentially infectious.

WORK PRACTICE CONTROLS

Our facilities have adopted the following work practice controls as part of our bloodborne pathogens compliance program:

- Employees wash their hands immediately, or as soon as feasible, after removal of potentially contaminated gloves or other personal protective equipment.
- Following any contact of body areas with blood or any other infectious materials, employees wash their hands and any other exposed skin with soap and water as soon as possible. They also flush exposed mucous membrane with water. Employees then immediately contact the visitor relations manager to fill out a Blood Exposure Incident Form.
- Eating, drinking, smoking, applying cosmetics or lip balm, and handling contacted lenses is prohibited in work areas where there is potential for exposure to bloodborne pathogens (first aid room).

HOUSEKEEPING

If there is a blood and/or body fluid spill, contact the VRM immediately.

RADIO PROCEDURES

HOW TO USE THE RADIO

1. Make sure the radio is turned on and the volume is up.
2. Make sure the radio is on channel 1.
3. To call:
 a. Depress long button on the side. Hold it for two seconds before speaking, otherwise your message will be cut off.
 b. Depress button while speaking.
 c. Identify yourself and who you are calling ("Paleo to VRM").
 d. Release button and wait for a response.
 e. Depress button again and ask brief, direct questions.
 f. Release button and wait for a response.
 g. When the conversation is finished, sign off by identifying yourself and saying "clear" or "out."
4. If you are unsure whether your radio is working, call the VRM and ask if they can hear you. If you get no response, phone the VRM and ask if they can find you another radio while yours is charging. Report other radio problems to the VRM.
5. At closing time, turn off the radio and place it in the charger. Make sure the charger is plugged in.
6. Do not disassemble the radio. Wear the radio on your belt while it is in your charge. Do not leave your radio in the break room (west building) while you are on break, take it with you.
7. Leave the radio turned on at all times, except when putting it on the charger.

RADIO PROTOCOL

Two-way radios are used by more than 30 individuals at any given time. All conversation can be heard by all of these individuals, as well as anyone within earshot of them (including visitors). For this reason, the following guidelines must be observed:

1. Always speak professionally. Do not say anything which might offend an employee or visitor.

2. Do not conduct personal conversations over the radio.
3. If you are unable to reach a staff member by other means (i.e., the phone) and need to carry on a long conversation, ask them to switch to channel 2. The two of you can talk at length without disturbing others. However, be warned that others may still hear you even though you are on another channel. Be professional in your conversation.
4. All requests for maintenance staff must go through the VRMs. Give the VRM all the information possible, and they will send the appropriate person and equipment.
5. All emergencies must go through the VRMs. Do not call 911 or call for Unit 12 (the off-duty police officer) yourself. Call the VRM and provide them with enough information to act.
6. During emergencies and lost child searches, cease all other radio conversation unless it relates to the emergency.
7. If there is a problem in the museum that you need to inform others of but do not want visitors to hear, use the STAND BACK code:
 a. After identifying yourself say, "All staff please STAND BACK. All staff please STAND BACK."
 b. Wait for a minute to allow staff to turn down the volume of their radios and hold them to their ears, then proceed to broadcast your message.

Use the STAND BACK code in an emergency situation in which you do not want to alarm others in the museum. If you hear a STAND BACK call, quickly remove yourself from visitor earshot and turn down your radio. Listen carefully for details and request a repeat if you miss something important.

VISITOR INFORMATION

This is a list of the most common topics about which visitors have questions. All front-line staff are expected to be able to answer these questions when asked.

CASH MACHINE

There is a cash machine located in the west building, in the lobby, near the information booth. The next closest machine is located in the World Trade Center at 7th and Wabasha streets.

CHANGE

Quarters are available at the box office. There are also change machines located near the vending machines in the east and west buildings. If a visitor needs change smaller than a quarter, direct them to the Explore Store.

CHECK/CREDIT CARD

The museum does accept checks. Visa, Mastercard, and Discover also are accepted as payment.

DINOSAURS

The museum's dinosaur collection is located in Paleontology Hall on the first floor of the east building.

ELEVATORS

There are three sets of elevators in the museum. There is a set in Museum Square (out the doors between the stores by the box office) that goes down to the parking ramp and up to the skyway level of the museum. There is another elevator in the west building, behind the box office area, by the special exhibit hall. This elevator services all three floors of the west building. In the east building, the elevator is located across the skyway and down the hallway, next to the tree cross-section. This elevator gives access to all the floors in the east building, including the penthouse, the concourse, Paleontology Hall, Our Minnesota and the canteen area, where the vending machines and restrooms are located.

FOOD

The museum's restaurants, The Periodic Table CaFe and Pizza Pi Shop, are open daily. Check for hours and menu. There also are vending machines located in both buildings. A guide for places to eat near the museum is available at the box office or the information booth.

JOB OPENINGS AT THE MUSEUM

The human resources department is located is located in the east building, on street level, across from the elevator. They have a list of current job openings as well as employment applications. Their hours are Monday through Friday 9 a.m. to 5 p.m. Leaving and returning to the museum

Visitors with exhibit hall tags can come and go as they please for the day that the ticket was purchased. Visitors going to the Omnitheater also must purchase tickets to the exhibits, if they wish to see them.

LOCKERS/COAT CHECK

There are lockers available, for a small fee, in the west building lobby and on the east building concourse. If a visitor has a problem with a locker, contact the visitor relations manager.

LOST AND FOUND

Lost and found items should be turned in to the box office. At the end of the day items are taken to the reservations office. If you are unable to leave your area, let the visitor relations manager know that you have a lost and found item. If an item has not been turned in to the box office, visitors can fill out a lost and found form, and they will be contacted if their lost item is found.

MAPS

Maps of the museum can be found on the back of the exhibit hall tags and in the visitor guide. Visitor guides are available at the box office or the information booth. Maps of downtown St. Paul and the skyway system also are available from the information booth.

MUMMY

The museum's mummy is located in Anthropology Hall on the second floor of the west building. It is in the rear of the hall, by the fire exits and behind a wall that says "Ancient Egypt."

OMNITHEATER

The Omnitheater is in the west building. The main entrance is on the second floor above the lobby. This can be reached by using either set of stairs, or the elevators. The exit from the Omnitheater is on the third floor. This also is the wheelchair entrance to the Omnitheater. Information about show time availability and prices is available at the box office.

PAY PHONES

There are five pay phone stations available in the museum. In the west building one is near the elevators (skyway level) in Museum Square, another near the elevators (street level) in Museum Square, and a third near the information booth in the lobby. In the east building, one is at the end of the skyway, across from Our Minnesota and one is on the lower level by the restroom.

PARKING

Parking is available in the ramp under the west building (enter on Exchange Street between Wabasha and St. Peter streets). Ramp hours are: Monday-Thursday, 6:30 a.m.-11:30 p.m.; Friday, 6:30 a.m.-1:30 a.m.; Saturday, 7 a.m.-1:30 a.m.; Sunday, 8 a.m.-10:30 p.m. Check at the box office for current parking rates. The parking ramp does accept checks. There also are meters available on the streets around the museum. Visitors should pay the meters Monday-Saturday from 8 a.m. to 4:30 p.m.; all other times are free.

RESTROOMS

There are public restrooms in both museum buildings. In the west building, restrooms are on the second floor outside of Anthropology Hall. In the east building, restrooms are located on the lower level, downstairs from Paleontology Hall.

STROLLERS

Stroller rental is not available at the Science Museum.

TIME NEEDED TO SEE THE MUSEUM

This depends on your interests, however, there are some simple guidelines. The Omnitheater takes about an hour, not counting the time you spend in line. Each exhibit hall takes about 30 minutes to an hour to visit. Special public programs, should you choose to see them, range from 10 to 30 minutes.

WHEELCHAIRS

The museum has several wheelchairs for public use on a first-come, first-served basis. The visitor relations manager or the commons area visitor assistant will provide the wheelchairs.

FRONT-LINE STAFF AND SUPERVISORS

VISITOR SERVICES

- Director of Visitor Services oversees the coordination and delivery of service for visitors to the museum.
- Visitor Relations Manager (VRM) supervises visitor service staff and volunteers. Also responsible for any safety or security concerns Involving visitors, staff and volunteers, or museum property.

- Visitor Assistant (VA)-Commons Area greets and assists visitors. Provides security for common museum areas (lobby, stores, skyway, concourse, etc.).
- Police Officers (Unit 12) are supervised by the VRMs. Assists in any emergency situation. Heightens the security presence in the museum. Have a general knowledge of the museum.
- Ticketing Manager supervises all box office and reservations staff and oversees all ticket sales and reservations.
- Box Office Head Cashier oversees the operation of the box office. Responsible for assisting visitors with any concerns regarding tickets or reservations.
- Ticketing Staff sell tickets and take reservations for exhibits, Omnitheater, special events, CE classes, etc.

MUSEUM PROGRAMS

- Head of Museum Programs Division oversees the coordination and delivery of museum programs for visitors to the museum.
- Science Hall Manager oversees the operation of each individual science hall. Hires and trains staff and volunteers and coordinates programming in each hall.
- Science Hall Supervisor assists hall manager in the supervision of staff and volunteers in each science hall. Titles vary from floor supervisor to lab manager to assistant hall manager.
- Visitor Assistant (VA)-Science Halls performs the same tasks as the VA-Commons Area for each of the science halls (Our Minnesota, Paleontology, Experiment Gallery, Anthropology, and special exhibits) and helps to interpret exhibits for visitors.
- Public Programs Staff perform theater and demonstration programs for museum visitors.

OMNITHEATER

- Projectionist supervises Omni staff, runs projector, and makes any executive decisions regarding the running of the Omnitheater.
- Console Operator controls lights and sound for Omnitheater presentations.
- Omni Host manages and assists visitors inside the Omni. Works with visitor assistants to manage visitor entry and exit from the Omni.

EXPLORE STORES

- Store Manager runs the overall store operation, including layout, display, and staffing.
- Store Supervisor supervises store clerks and serves as manager during weekends and holidays.
- Store Clerk sells science-related merchandise to visitors and the public. Has a general knowledge of museum operations.

FOOD SERVICE

- Food Service Manager oversees the operation of the museum's food services. Also manages catering for museum events and space rentals.
- Food Service Staff prepare and sell food to museum visitors and the public.

MAINTENANCE

- Engineers repair and maintain non-exhibit areas and systems of the museum.
- Exhibit Maintenance keep museum exhibits in working order.
- Custodians keep the museum clean for visitors and staff.

Your supervisor can provide information on how to reach these and any other museum staff member when necessary.

APPENDIX E

This Appendix contains a variety of position descriptions for visitor services staff. Unless otherwise indicated, the position description was previously published in the book *Museum Job Descriptions and Organizational Charts*, American Association of Museums, 1999.

ATLANTA HISTORY CENTER COMMUNICATIONS DIVISION POSITION DESCRIPTION

From *Museum Job Descriptions and Organizational Charts*, American Association of Museums, 1999.

Title: Visitor Services Manager
Reports To: Director of Communications
Department: Visitor Services
Location: McElreath Hall
Date: November 1997

POSITION PURPOSE:

This position is responsible for group sales, including planning and implementing effective marketing strategies to promote sales to tour companies and community groups, booking these groups, coordinating their activities on site, and invoicing. This position is also responsible for managing customer service for both individual visitors and groups, including entry orientation, ticket sales, customer satisfaction; this involves hiring, training, and supervising telephone and admissions desk reception personnel.

PRINCIPAL ACCOUNTABILITIES:

1. Plan and implement effective group sales strategies, including packaging tours, direct mail, advertising and trade shows.
2. Provide information by phone, fax or mall to groups about offerings and activities at AHC and about group rates and special programs, coordinate with mailings of information on facilities rentals as appropriate.
3. Make sales/information presentations to SMERF and tour groups.
4. Book, schedule, and confirm tourist and SMERF groups; provide information to and ongoing supervision of daily tour companies; coordinate group schedules as needed with education department for school groups and with the museum houses.
5. Implement follow-up as needed, including invoicing, thank you letters, etc.
6. Act as AHC representative at networking functions to promote AHC to tourism market, including acting as primary group sales contact with ACVB, GA Dept. of Tourism, tour companies, hotels, and Chamber of Commerce.
7. Provide FAM tours and other special and VIP tours as needed.
8. Work with education and public programs staff to ensure that visitor expectations and needs are met.
9. Provide monthly reports with statistics on group visitation, use of discount coupons, brochure distribution, etc. as needed.
10. Assist in the development and implementation of group tour evaluations, visitor evaluation systems and result analysis.
11. Hire, train and manage admissions desk staff and telephone receptionist to ensure full coverage of front line positions and consistent quality service.
12. Provide customer service training to staff outside department as needed.
13. Maintain and distribute weekly schedule to staff as needed.
14. Coordinate and implement use of specialized scheduling software; oversee the maintenance of all equipment needed for the software; act as AHC liaison to the software support company.
15. Prepare annual budget, group sales goals and department plans, including marketing strategies, for approval by director of communications.
16. Assist director of communications as necessary to ensure fulfillment of department and division goals, including special events, hosting VIPs, and other special projects, as needed.

BELMONT: THE GARI MELCHERS ESTATE AND MEMORIAL GALLERY

From *Museum Job Descriptions and Organizational Charts*, American Association of Museums, 1999.

JOB DESCRIPTION:
VISITOR CENTER MANAGER

(State Classification: Visitor Services Supervisor)

GENERAL FUNCTION AND SCOPE

The Visitor Center Manager is responsible for the daily operations of the Visitor Center facility, including, but not limited to, visitor admissions, the museum store and the orientation theater. The Visitor Center Manager reports to the Director of Belmont.

CHARACTERISTIC RESPONSIBILITIES

BUILDING:

Open Visitor Center each day, oversee daily maintenance and upkeep, monitor and report needed repairs and services.

STAFF:

Hire and train admissions/sales desk staff. Schedule working hours.

ADMISSIONS:

Oversee sale of tour tickets to the general public and help coordinate group-tours. Work closely with docents in maintaining daily tour schedule. Keep admission records and reconcile and deposit daily admission receipts.

MUSEUM STORE:

- Act as store manager, responsible for
- selecting and purchasing existing merchandise
- developing new products
- inventory control and pricing
- display and promotion
- maintaining shop records including daily receipts and deposits, monthly reports and annual budget
- training sales staff in store procedures

ORIENTATION THEATER:

Oversee operation and visitor use of AV program, reporting malfunctions or necessary maintenance.

CONFERENCE ROOM:

Schedule and oversee use of Visitor Center Conference Room by public groups and private businesses and organizations.

STAFFORD COUNTY INFORMATION SERVICES:

Oversee the distribution of information about Stafford County, its historic sites and visitor amenities via the sales desk, printed materials and other means determined in consultation with county representatives.

The above duties are to be performed in cooperation with the Belmont administrative office and with the approval of the Director. — February 1999

A Virginia and National Historic Landmark Administered by Mary Washington College

224 Washington Street, Fredericksburg, VA 22405

Telephone: (540) 654-1015
Fax: (540)654-1785

Accredited by the American Association of Museums

OREGON HISTORICAL SOCIETY

From *Museum Job Descriptions and Organizational Charts*, American Association of Museums, 1999.

JOB DESCRIPTION

Title: Manager, Visitor Access / Hospitality
Exempt
Pay Grade: E-8
Department: Facilities
Reports to: Director / Facilities
Effective Date:

GENERAL POSITION SUMMARY:

Manages Visitor Access / Hospitality component of OHS's Facilities program. The position is responsible for developing and implementing policies and procedures to facilitate visitor access and promote positive visitor experiences at OHS facilities and programs, including admissions, fee-based and internal facilities use, public information (printed and recorded), orientation programs & materials, visitor comments & complaints, coat check, and internal communication of OHS programs/exhibits/events. Develop and implement institution-wide customer service program, including policies, procedures, and a year-round training program featuring customer service, public relations, safety, and security components.

Position is responsible for day-to-day management of Visitor Access/ Hospitality program, including customer service, scheduling, coordinating support services & dissemination of information concerning facilities use, and related financial management tasks, i.e., purchasing, invoicing, program reports, and budget preparation & monitoring. Position provides support to Marketing & Development Department with the planning & execution of OHS events.

PRIMARY FUNCTIONS / MAJOR RESPONSIBILITIES:

I. VISITOR ACCESS (75%).

a. Creates and administers policies and procedures relative to daily visitor access-related operations at OHS facilities. Specific areas of oversight are: admissions, entry reception, telephone & administrative reception, access-related public information (recorded phone messages, signage, orientation materials), visitor comment & complaint response, compliance with security arrangements (photography restrictions, ID tags, logs, fire/ life safety response), visitor property check-in & lost & found.

b. Supervises Visitor Access staff, including admissions staff, receptionists, and volunteers. Supervision consists of coordinating recruitment with Personnel, training, scheduling, and periodic performance reviews & evaluations.

c. Develops and administers year round training for all Visitor Access / Hospitality staff, including volunteers, in such topics as customer service, fire / life safety, security arrangements, providing general and specific public information & orientation, responding to complaints, knowledge of OHS organizational history & structure, phone reception, and events-related procedures & management.

d. Develops and administers agency-wide customer service program for all staff, including such topics as phone reception, correspondence, and interaction with the public.

e. Supports the Marketing & Development Department with institution-wide evaluation program, including visitor experience, exhibits, public programs, and research services. Serve as member of Program Marketing Team in order to participate in the marketing, promotion, and collaborative planning of OHS programming and public image.

II. HOSPITALITY (25%)

a. Coordinate use of OHS facilities for internal program-related public programs, events, and day-to-day staff use. Schedule space use and publish accurate internal space use calendars. Enforce established facilities use polices with regard to scheduling, equipment, food service, and security considerations, and recommend changes to these policies to Director / Facilities. Assist with design of events set up requests and coordinate implementation of set ups / tear downs with maintenance staff to ensure customer satisfaction. Coordinate

with Security to ensure events are safe and executed according to risk management and fire / life safety codes. Work closely with OHS departments and outside groups to plan public programs and events held at and/or cosponsored by OHS. Maintain inventory of OHS Hospitality-related equipment & supplies, coordinate with Maintenance for equipment repairs & refurbishing, and recommend new and replacement equipment as needed.

b. Assist Marketing & Development Department with the planning and implementation of OHS sponsored events as requested, including the three annual signature events, Wintering In, Annual Meeting, and Holiday Cheer.

c. Manage the external rental of OHS facilities at the History Center in concert with external rental policies & procedures. Respond to rental inquiries, show rental facilities, work with rental clients to plan and implement events in accordance with established facilities use policies & procedures. Maintain correspondence, contracts, and confidential client information related to external rentals. Determine rental fees according to established fee schedules and coordinate billing & collections with Accounts Receivable. Coordinate with OHS Security and Maintenance to ensure external rentals are secure and provided with custodial service in set up, tear down, and close out. Act as the liaison between rental customers and other OHS departments.

JOB SCOPE:

Position is responsible for developing and implementing policies that govern the work of all OHS personnel as it relates to customer service and effects every visitor to OHS facilities. These policies are central to providing public access to OHS collections and services and are essential to ensuring public satisfaction with the Society's programs and services.

Position is responsible for setting and meeting annual admissions revenue projects, currently running at approximately $100,000 (FY98-99) and for preparing and administering the Visitor Access & Hospitality budget.

Position is responsible for ensuring that visitor access needs are considered in the management and planning of OHS facilities space use, including safety, signage, admissions and information desk configurations & locations, orientation materials preparation and distribution, and disabled access.

Position is responsible for management of internal and external hospitality services: explaining OHS facilities use policies, procedures, fees, equipment use & restrictions, contract provisions & obligations of all parties, facilities use scheduling & information dissemination, coordination of facilities use support services with other Facilities services, code & legal compliance (fire code restrictions on room occupancies, OLCC licensing requirements re serving alcohol), preparing draft invoices, assisting with collections of overdue accounts, securing appropriate permits where applicable, and timely preparation & submission of purchase orders, invoices, reports and other documentation related to internal or external hospitality services.

Position is responsible for supporting Marketing & Development Department in the coordination and production of OHS events with special emphasis on customer service and satisfaction, including attention to detail (aesthetics, quality of production), punctuality, and thoroughness of planning in areas of Facilities support services (Security, Maintenance & Custodial).

SUPERVISORY RESPONSIBILITIES:

Position supervises Admissions and Reception staff (2 full time, 5 part time positions), Hospitality staff (1 part time position, and Facilities maintenance staff as assigned for support services) and a number of volunteers in support of all aspects of Visitor Access / Hospitality services. Supervision includes preparation of job descriptions, recruitment, orientation & training, scheduling, performance review, evaluation, and recommending disciplinary action.

INTERPERSONAL CONTACTS:

Internal contacts are made at all levels of the Society including the Board of Directors. Internal contacts relate to the implementation of visitor access policies and related evaluation, and procedures regarding internal communications in the interest of visitor access. Close working relationships with Administration, Marketing & Development, Research & Reference, Interpretive Programs, and other Facilities program components (Maintenance & Security) are necessary. Position may also have periodic

contact with board committees in the areas of facilities, exhibits, and programming.

External contacts include significant community contacts made as a high profile representative of OHS. Contacts by correspondence, telecommunications, and in person are made daily with visitors, and hospitality-related clients & their service vendors. Mature, professional presentation, appearance and conduct and clear, concise, business-like communications skills are critical to the success of the Visitor Access/Hospitality program. Contacts involve information presentation and exchange, problem anticipation and resolution, and negotiation of contested issues.

SPECIFIC JOB SKILLS:

Ability to manage complex programs and projects, and to plan and implement new programs. Ability to manage visitor services-oriented programs and build staff teams to accomplish program goals. Ability to manage program financial elements including bookkeeping, information analysis & report writing and budget preparation &

administration. Demonstrated excellence in oral and written communications skills. Demonstrated administrative level experience with word processing, spreadsheet, and data base PC-based applications, WordPerfect or MS Word, Excel, MS Access preferred.

EDUCATION & EXPERIENCE:

BA in Business Management, Public Administration, or Non-Profit Management and three years of managerial level experience in customer service & hospitality services required. Superior public service skills, including planning, public information, admissions & orientation, events management, coordination of support services. Experience in non-profit agency is a plus.

JOB CONDITIONS:

Position will require early morning, evening, and weekend hours from time to time. Physical ability to lift and carry up to 40 lbs.

SCIENCE MUSEUM OF MINNESOTA

30 East 10th Street, Saint Paul, MN 55101
phone: (612) 221-9488 fax: (612) 221-4777

Reprinted with the permission of the Science Museum of Minnesota

JOB DESCRIPTION

Title: Visitor Relations Manager

Operating Group: Museum Programs & Internal Support

Primary Team: Member of Visitor Relations Manager Team

Other Teams: Member of the Visiteam (coordinates the visitor stream and daily operations of the public museum). Works closely with the Collections, Exhibit Maintenance, Omni, Stores, Ticketing and Hall Management Teams to deliver and enhance visitors' experiences in the museum.

Reports To: Team leaders for Visitor Services and Maintenance

PRIMARY OBJECTIVES OF THE POSITION

Each member of the Visitor Relations Management Team is equally accountable for:

Upholding the Science Museum of Minnesota's philosophy, vision and core standards for visitor service. Their primary focus is to ensure that the visitors' "first and last impression" of their experience at the museum is a positive one.

Developing and implementing the initial orientation for 200,000 visitors who attend the museum in groups (i.e. students, seniors, tourists, etc.).

Maintaining a safe environment for the 750,000 visitors who annually visit the museum as well as for 500 museum staff and an equal number of museum volunteers. In addition, the visitor relations manager is accountable for the security of the facility itself, the exhibits and artifacts (non-curatorial security).

Team members between them, cover all open museum hours.

SPECIFIC RESPONSIBILITIES

1. VISITOR SERVICE & SATISFACTION

- Has primary responsibility AND AUTHORITY for ensuring visitors' satisfaction.
- Has authority and responsibility to interpret museum policies and procedures for the visitor.
- Act as a service advocate to resolve visitor concerns to their satisfaction and the museum's.
- Handle any and all visitor on site complaints which other staff cannot or will not handle.
- Ensure all visitors receive an initial and basic orientation to the museum. Conduct orientations using narrative, inquiry, discussion, discovery and other interactive techniques.
- Provide further orientation to the museum to prescheduled visitor groups, including schools and community groups.
- Conduct tours for prescheduled groups at group request.
- Communicate with a variety of visitors with diverse interests and abilities in a manner that enhances their understanding of science in general and the museum in particular.
- Supervise volunteers and visitor assistants, giving initial orientation and/or tours.
- Ensure sufficient and appropriate seating is available in commons areas.
- Ensure all commons spaces including bathrooms and elevators are maintained as agreed with maintenance group.

2. SAFETY AND SECURITY

- Manage and coordinate the museum's response to any emergency.
- Maintain up to date emergency procedures; conduct regular security audit.
- Maintain current systems and procedures for safety and security, including the management of all incident reports and recommend necessary changes to team leaders.
- Ensure that staff and volunteers are appropriately trained to act effectively and appropriately in emergencies.
- Ensure that visitors and staff are aware of and follow identification requirements (badges and/or tags).
- Supervise police officers hired by the museum.
- Develop and implement in consultation with Collections and Science Halls, a regular security check of artifacts.
- Manage and coordinate the daily opening and closing of the museum.
- Set and monitor all alarms as assigned by SMM Maintenance.
- Supervise the safe loading and unloading of student and other visitor groups.
- Establish procedure to ensure safety of staff/volunteers leaving late in the evening.
- Responsible for coordinating the regular patrol of perimeter areas, grounds, delivery dock/parking facilities.

3. COMMUNICATION AND INFORMATION

- Ensure that the information visitors receive is accurate.
- Serve as primary contact and coordinator for daily intercommunication in the public museum.
- Coordinate all radio communication, protocol, training and maintenance.
- Conduct daily shift briefings for ALL floor staff.
- Coordinate and maintain the daily flow of up to date program/event information to all floor staff and visitors through the distribution of the daily program guide and various schedules for Education classes and lectures, group visits, special events, internal and external bookings of the common spaces, and History Theater schedules.
- Supervise information booth staff and volunteers.
- Maintain communications with all other key visitor areas; Science Halls, Public Programs, Omni, Education, and Public Relations.

4. LOGISTICS

- Coordinate the on-site logistics of events/programs held in the commons areas.
- Ensure museum standards for directional and informational signs in the commons areas are maintained.
- Act as back-up to Visitor Support and Information to conduct scheduled showings of rental spaces.

5. OPERATIONS

- Manage the visitor activity and daily operations in the Commons Areas.
- Ensure that visitor assistants in the commons areas provide the appropriate level of service to our visitors.
- Hire, train and supervise Commons Area floor staff including visitor assistants for Commons Areas and volunteer greeters and information booth volunteers.
- Manage the budget for scheduling Visitor Assistants and the appropriate line items for operating the Commons Areas.
- Monitor and plan for the daily management of group visitor traffic, including the storage of visitor lunches and coats.
- Maintain necessary reports, records and files.
- Maintain lost and found.
- Maintain first aid room.

6. RESEARCH & DEVELOPMENT

- Support the marketing department in actively seeking and monitoring regular feedback from visitors regarding their experience.
- Implement quarterly visitor satisfaction surveys as directed by marketing.
- Implement visitor topic tests as directed by marketing.
- Maintain and manage visitor comment box.
- Continue to develop ways to improve service to visitors.

7. TRAINING

- Plan, prepare and participate in the training of all Visitor Assistant staff working in the Commons Areas and the Special Exhibit Hall.

- Plan, prepare and participate in training all appropriate museum staff and volunteers in security and emergency procedures.
- Work in cooperation with the Volunteer Department to train all volunteers working in the Commons Areas.
- Receive training on the Explore System in order to manage group visits, and to serve as a back-up to SMM Ticketing staff.
- Participate in other appropriate training as requested by supervisors.

8. SPECIAL SUPPORT

- Provide support as directed by supervisors for the History Theatre and any museum or theatre rentals.

REQUIREMENTS:

- At least a four year college degree or equivalent with minimum of 4 years experience in customer service field; superior communication and judgment skills.
- Must be able to interpret museum policy and procedure for the visitor. Is required to exercise sound judgment often independent of any other museum authority.
- Ability to listen actively to visitors, and be responsive to their needs and expectations.

KNOWLEDGE OF:

- SMM policies, procedures, programs, services, personnel, history and operations is desirable.
- Behaviors and attitudes of a variety of visitor groups (age, education, economics and cultural).
- Principles of good customer service.

SKILLS IN:

- Oral and written communications.
- Presentation
- CPR
- First Aid/First Response
- Organizational (of self and others)
- Planning; Anticipate and avoid crises where possible.
- Computers; must be willing to learn SMM Explore System.

ABILITIES
- Make quick and sound judgments.
- Remain calm and level headed in all types of situations.
- Motivate others. Ability to work effectively on a variety of teams; must motivate a variety of people (visitors, staff and volunteers) from a variety of education, economic and cultural backgrounds) over whom they have no authority to cooperate to ensure the best experience for the most people.

- Conflict resolution skills: Ability to effectively and constructively resolve conflicts with and between visitors.
- Juggle multiple priorities from multiple constituents. Must constantly evaluate and synthesize a variety of challenges ranging from the mundane to life threatening.
- Creative problem solving experience a must.
- A sense of humor.

SCIENCE MUSEUM OF MINNESOTA

Reprinted with the permission of the Science Museum of Minnesota

POSITION DESCRIPTION
Title: Director of Visitor Services
Operating Group: Museum Programs
Reports To: Head of Museum Programs.

PURPOSE
- To oversee/direct the implementation of a coordinated, museum-wide strategic plan for visitor service and operations; to direct annual service and operations planning for the museum visitor place.
- To supervise the management of Omni operations, museum retail stores, food service, ticketing services, visitor orientation, security and information services.
- To direct, coordinate and monitor the smooth integration of the day to day operations of the public museum. Ensure that these operations effectively support both the programs and the needs of the visitors.
- To build and maintain a commitment to consistent excellent customer service in all areas of the public museum.
- Working with director of marketing to maintain a strong integrated visual identity within the public museum.

OUTCOMES
- Maintain and increase overall visitor satisfaction rating, focusing specifically on building the satisfaction ratings in areas of workforce helpfulness, quality of visitor amenities and services, control costs "per visitor" of operations and support. Manage visitor flow and access to ensure optimum usage while maintaining high visitor satisfaction ratings. Maintain and increase net profits in retail and food.

SPECIFIC TASKS AND RESPONSIBILITIES
- Develop the public museum's strategic service and operations plan and oversee its ongoing implementation; this plan will include general recommendations for institutional standards, staffing, structure and skills necessary to effectively serve visitors, manage visitor flow and access. Ultimately improve visitor satisfaction with specific recommendations for the expansion and improvement in service and profitability in the areas of retail, food, ticketing, orientation (greeting, way finding) and support services. Develop and contribute to projections and plans with regard to strategic program mix, visitor flow, attendance patterns, audience diversification and other issues.
- Serve as the senior staff member to the Head of Museum Programs; establish the goals, structure and functions of the Visitor Service and Operations Division which includes the areas of the Omni operations, food service, museum stores, ticketing services. visitor relations (orientation and support)

- Guide and lead areas in Visitor Services and Operations to achieve annual gross revenue goals of $1.5 million-plus (32% of total earned revenue for the Visitor Place).
- Oversee and control expenses of Visitor Services and Operations with a combined operating budget of nearly $3 million (63% of total operating costs of the Visitor Place).
- In collaboration with museum marketing and program directors and managers, guide and lead all departments in the Visitor Place to collectively achieve a high level (9+ out of 10) of overall visitor satisfaction through the effective management of service delivery, visitor flow and access.
- Provide coaching, direction, professional development support and performance appraisals to the key staff of the 5 Visitor Service and Operations areas: Food, Stores, Ticketing, Visitor Relations and Omni. Provide individual supervision as necessary and conduct regular meetings to maintain smooth, effective operations and internal communications. In addition, through the VISITeam, provide leadership and direct support to other departments in the Visitor Place regarding the integration of daily operations in order to deliver excellent service and support to all of our visitors.
- Participate in the SMM board committee for New Ventures whose charge is to guide the profitable expansion of museum enterprises including retail sales, facility rentals, telemarketing/phone center, and food service.
- Direct the service and operations planning for the new facility including providing strategic direction for "Science City" which includes: managing visitor flow and access, food service, retail sales, facility rentals (in collaboration with the marketing division) ticketing, and orientation and support services.
- Establish policies and procedures which support service standards, visitor safety and security; and enhance visitor flow, access and satisfaction.
- Participate in the review and selection of key program or product offerings at the public museum including selection of incoming special exhibits. (Exhibit Review Committee).
- At the request of either the President or the Head of Museum Programs, represent the museum externally and/or lead or participate in teams involving issues of strategic and or museum-wide importance. (e.g. Coordination of SMM's participation in 96 AAM conference, the New Facility Planning, SMM's strategic plan review group, SMM Job Evaluation Committee, Diversity Change Team.)

SKILLS AND EXPERIENCE

EDUCATION:

- Bachelor's degree in marketing, retail marketing, public relations or a related field.

WORK EXPERIENCE:

- 5 years minimum experience in customer service and/or retail area; a passion for customer service. Experience should include general management of a large public facility, ticket management and food and/or retail sales management. Experience in management of a not for-profit organization is a plus.
- 5 years minimum experience in organizational planning and development. Experience in volunteer management a plus.

SKILLS: THE ABILITY TO:

- Develop and manage budgets of significant size.
- Build and manage cohesive teams from a variety of functions.
- Perform strategic analysis and long range planning.
- Direct planning and implementation activities across the organization.
- Organize, communicate and plan effectively.
- Function effectively and comfortably in a complex and culturally diverse environment.
- Operate effectively in an environment of constant change.
- Manage, motivate and support staff with broad range of responsibilities and ability.
- Analyze a service workforce and make structural and assignment changes necessary to improve service and maximize efficiencies.
- A proactive approach to problem solving.
- Public relations and service oriented leadership and communication skills.
- A working knowledge of accounting, budgeting processes, basic computer skills.

POSITION DESCRIPTION

Source Undisclosed

I. POSITION TITLE: DIRECTOR, VISITOR SERVICES

Department: Visitor Services

Title: VP Science Center

II. POSITION SUMMARY:

One or two sentences summarizing why job exists. Responsible for managing all aspects of front-line service including membership sales & service, ticket and admission sales, reservations, visitor orientation, safety and comfort. Ensures that membership sales and renewal revenues meet projections and customer service standards of excellence are met

III. QUALIFICATIONS:

Excellent interpersonal skills, knowledge of business practices, good writing skills, willingness to work irregular hours.

IV. ESSENTIAL JOB FUNCTIONS:

List sentences stating the essential job functions performed, in order of importance, from the most important to least important. A job function is essential if it is a primary responsibility of the position; if it requires that only the person in this position perform the function; and if there is no other person in your department to perform the function.

1. Ensures each visitor has a courteous, pleasant and efficient initial contact with Museum. Accomplishes this by overseeing floor staff and managers and box office staff.

2. Working with other departments which impact the floor, through floor staff; ensures each visitor receives excellent customer service throughout their visit.

3. Projects and meets sales and revenue goals for membership sales based on paid individuals attendance numbers. Ensures that visitors are made aware of membership opportunities while on site.

4. Ensures members receive fulfillment services while on site as well as via mail and telephone.

5. On an on-going basis, oversees the Institute's effort for improving customer service. Responsible for ensuring that managers and floor staff are given the proper training and skills so they can represent the Institute and provide the highest quality of service possible

6. Hire, train, mentor, supervise and evaluate managerial staff. Recommends separations, raises and promotions.

7. Administers department budget. Develops revenue projections and sees that they are met.

8. Participates in creating division-wide policies and procedures.

9. Organizes and oversees creation and follow through of department systems, policies and procedures.

10. Researches and disseminates useful approaches to membership sales, service and benefits and front-line service from other organizations.

V. NON-ESSENTIAL JOB FUNCTION:

List job duties that could be performed by someone else in your department if the incumbent were unable to perform these functions (i.e. answering phones, copying, opening mail, etc.)

1. Oversee data processing for billing, account maintenance and service for members.

2. Create written and on-site sales and renewal devices on an on-going consistent basis. Monitor success rates of these efforts.

3. On a day-to-day basis, oversee successful floor operations — such as group check-in, visitor complaints, and overall procedures.

4. Serve on museum committees — such as Marketing, Programs, and Customer Service to maintain and enhance the overall museum experience for the visitor.

VI. POSITION DIMENSIONS:

A. Titles and number of people in each title reporting to this position, if any.

Manager- 3

Assistant Manager- 6

B. Pertinent financial, personnel, or other data that describes the position (i.e. size of contract, size of budget, value of materials and equipment responsible for, etc.)

Membership budget in excess of 1 million dollars. Admission expense budget and Visitor Services budget maintained by two managers.

C. Frequency and purpose of contacts outside the department or company and level of persons normally contacted.

High frequency of contact with Vice President of External Affairs, VP of Human Resources, VP of Operations. All other museum directors. Moderate contact with Director of Visitor services/Members.

D. Exposure to confidential material:

Minimal Average Extensive

E. Amount of decision making required:

Minimal Average Extensive

F. Describe working conditions in which job is performed (i.e., aspects of environment that are unpleasant, temperature extremes, noise, dust, amount of workspace) On a frequent basis will be required to work irregular hours including nights and holidays. Long periods of standing on floor.

VII. OTHER JOB SPECIFICATIONS

A. Minimum formal education required to be considered qualified to perform the essential job functions. Bachelor's Degree

B. Certifications, licenses or other additional training relevant to the essential job functions. High level of experience in dealing with the public and strong customer service skills.

C. Specific prior work experience required. Five years customer service experience Three years management experience.

D. How long should it take to perform this job at an acceptable level.

Six months

E. Indicate if there are any physical demands required to perform the essential functions of the job (i.e., lifting, climbing, standing for long periods of time, etc.) Standing for very long periods of time.

VIII. COMMENTS:

Include any other pertinent information that will provide additional insight into this position.

Person must possess unique combination of sales, customer services and creative writing / event skills.

IX. POSITION DESCRIPTION PREPARED BY:

(name/title) VP Science Center

Approved by: _____

Department VP or Director

Date: _____

THE TECH MUSEUM OF INNOVATION

Reprinted with the permission of the Tech Museum of Innovation

VISITOR EXPERIENCE MANAGER

The mission of The Tech Museum of Innovation is to serve as an educational resource that engages people of all ages and backgrounds in exploring and experiencing technologies affecting their lives, and to inspire young people to become innovators in developing technologies of the future.

The Visitor Experience Manager oversees and coordinates the exhibit and floor program experiences in the museum. This creative, people-oriented individual will work with Volunteer Services, Exhibit Engineering, Public Programs and Education staff to ensure that our visitors enjoy and learn more about science and technology through engaging, educational experiences.

RESPONSIBILITIES:

- Implement and manage floor programs and demonstrations with the assistance of volunteers and other staff.
- Create and develop informal and formal visitor programs in science and technology with Education and Public Programs staff.
- Train and support volunteers in their work with visitors.
- Develop long-term training plan with the Volunteer Services Manager.
- Work with Engineering staff to assure that all exhibits, sound, signage and lighting support the visitor experience.
- Work with Exhibits, Engineering and other departments to test and assess new exhibits.
- Keep up to date about The Tech's education and public programs, membership, special events and related visitor information. Work with other staff to maintain attractive, accessible brochures and other materials.
- Coordinate regular training and drills for staff and volunteers for the Injury and Illness Prevention Program of The Tech Museum. The Visitor Experience Manager is the designated Incident Commander for emergencies and coordinates the evacuation of the museum.
- Assist with evaluations of the visitor experience and work with staff to use the feedback to inform program and exhibit development and to improve customer service.
- Responsibilities include working one day each weekend based on a five day work week

REQUIREMENTS:

- Degree in science, education or related field and/or equivalent experience in a museum, making public presentations and/or working with volunteers.
- Experience with training or educating adults and/or children.
- High interest in science and technology and passion for life-long learning and working with people.
- Commitment to The Tech's mission.
- Ability to set priorities and work on projects simultaneously.
- Energetic, dynamic and creative individual who welcomes challenges with a willingness to problem solve.
- Excellent public speaking, communications and presentation skills.
- Fluency in a second language is valued.
- Willingness to work on weekends and holidays.

APPLICATION PROCEDURE:

The Tech offers excellent benefits including paid health, dental, vision and life insurance. Please send cover letter and resume with salary history to The Tech Museum of Innovation, 145 W. San Carlos Street, San Jose, CA 95113, Attn: Human Resources. Or, e-mail ASCII text file resume to xuan@thetech.org (do not send attachments.) FAX: (408) 279-7149. No phone calls please. The Tech Museum of Innovation is an Equal Opportunity Employer with a strong commitment to diversity. (http://www.thetech.org) 02/22/97

MCFADDIN-WARD HOUSE

Reprinted with the permission of McFaddin-Ward House

POSITION DESCRIPTION:

Visitor Center Manager / Volunteer Coordinator

Reports To: Director

Current Incumbent:

Date of Last Revision:

SUMMARY DESCRIPTION

Responsible for management and operation of the Visitor Center, scheduling of regular and group tours, gift shop sales and supervision of the activities of docents, host/hostesses, and desk receptionists. Serves as liaison with the Volunteer Service Council, acting as their adviser, and coordinating their meetings, trips, and other educational activities.

REPRESENTATIVE RESPONSIBILITIES

VISITOR CENTER

Manages the Visitor Center building on a day-to-day basis including opening and closing, reporting maintenance problems, and general upkeep.

Oversees the scheduling of individual and group tours and the maintenance of the reservation book.

Prepares contracts, tour policy sheets, and deposits for large group tours. Assists such tours with logistic planning for their visit.

Responsible for all retail associated activities of the Visitor Center. This includes routine reports, bank deposits, merchandise inventories, and visitor statistics.

Works with other staff in procuring various items of merchandise for sale in the gift shop. Tracks sales of these items and insures timely ordering to re-stock.

Obtains promotional and instructional materials that may be of benefit to the traveling public. Stocks such items and sees to their distribution.

This sample document is made available through AAM's Technical Information Service. The contents shall not be substituted for, nor substantially used as the basis for, a document produced by the recipient. Museums are encouraged to compose original materials based on their unique circumstances

VOLUNTEERS

Schedules volunteers for assignments according to the needs of the museum. To do this a monthly scheduling letter is produced and distributed to the volunteers.

Collects statistics on volunteer hours. Maintains volunteer files.

Museum Liaison to the Volunteer Service Council, attending their meetings and representing the museum's interests to them. Assists the executive committee in its recruitment and programming efforts.

Assists with the training and development of docents, host/hostesses, and desk receptionist.

Serves as a member of the museum newsletter editorial team. Writes articles and features for inclusion. Prepares critical calendar information for this publication.

APPENDIX F

Ticketing Systems in Museums

From Technical Information Service's Fast Fax series for AAM Institutional Members.

There is no single set of predetermined factors available to decide if your museum is ready for an automated ticketing system, or which one you should choose if you are ready. To aid in planning and decision-making, however, the TIS has assembled the following list of questions you should ask of your institution:

- Do you sell enough tickets to warrant the expense of an automated ticket system?
- Do you accept advance reservations for tours, special events, or theater show times?
- Do you offer more than one type of ticket, or tickets for more than one event or location?
- Would you like to be able to sell tickets by phone or over the internet?
- Do you accept credit cards as payment for ticket sales? Do you need to verify or authorize credit before accepting the payment?
- Do you want to send letters confirming reservations and print invoices?
- Would it be helpful for a system to search for available times based upon specific criteria?
- Is there a need to print tickets? Or is a receipt acceptable in lieu of a ticket?
- Is it important to allow multiple sale areas (box offices, visitor centers, or education departments, for example) access to the same ticket inventory?
- Are there multiple departments requiring access to the admissions/reservations system (for example, the education, special events, and marketing departments)? Is it important for these other departments to access information from the admissions/reservations system?
- Would you like to distribute daily/weekly/monthly schedules or calendars to other departments? Would you like to automate these reports?
- Do you want to generate financial reports from the ticketing system? Would you like to access statistical reports generated by a computer?
- Can you afford the expense of the software, hardware (including a server and networking capabilities), and on-going maintenance and support for a ticketing system?
- Do you have the time and financial resources to train other staff members to use the software, as well as initially setting up and daily operation of the system?
- Is there a technology/system administrator on staff who could handle day-to-day operations? Are you prepared to hire one?

If you answered YES to most of these questions, you may consider purchasing an automated ticketing system.

Thanks to 2b Technology, OmniTicket Network, and Paciolan Systems, Inc. for assisting in this project.

APPENDIX G

American Association of Museums Museum Assessment Program Public Dimension Assessment

The Museum Assessment Program (MAP), funded in part by the Institute of Museum and Library Services and developed and managed by the American Association of Museums, offers four assessments; Institutional, Collections Management, Public Dimension, and Governance* (to be released in late 2001). Of particular interest to readers of this manual is the Public Dimension Assessment. This assessment addresses how a museum is communicating with its audience and community. It focuses on programs, exhibits, visitor service, public relations, and marketing. Benefits reported by participants include

> Clearer understanding of the museum's image in the community
> Insight into developing/improving marketing
> Increased ability to broaden the museum's audience
> Improvement in public programs

ALL MUSEUM ASSESSMENTS INCLUDE THREE PHASES:

SELF-STUDY

Guided by a MAP Self-Study Workbook, staff and governing authority members answer questions and complete activities that stimulate a review of the museum's policies, procedures, and records

PEER REVIEW

Each museum is matched with a peer reviewer (or two in the case of the Public Dimension Assessment) with experience and expertise relevant to the challenges facing the participating museum. The peer reviewer examines the museum's self-study, consults with staff and board during a one or two day site visit, and prepares a report that identifies the strengths and weaknesses of the museum and makes recommendations for change.

IMPLEMENTATION

Using the information accumulated through self-study, the peer-review visit, and the assessment report, the staff and board formulate goals and strategies for improving the museum. This planning can carry the museum through several years of development.

MAP application deadlines are March 15 and November 1 of each year.

For more information about the Museum Assessment Program, contact the MAP staff at 202-289-9118, e-mail at map@aam-us.org, or go to the AAM's web site at www.aam-us.org/map.htm.

This new assessment helps the museum leadership and governing authority examine their structure, roles and responsibilities, enhancing their ability to advance the museum's mission and engage in effective planning.

APPENDIX H

Glossary of Public Dimension Assessment Terms

Reprinted from the *Public Dimension Assessment Self-Study Workbook,* Museum Assessment Program. © 2000, American Association of Museums. All rights reserved.

Audience: Groups of people who use the museum's services. Audiences can be defined by the types of services they use and how they use them (e.g., visitors, subscribers, researchers, program participants, Web site users), or by their demographic characteristics (e.g., families, school groups, seniors, culturally specific groups).

> **Current audience:** The groups or individuals who actually use the museum services.

> **Potential audience:** Groups of people who could, but are not yet, using the museum's services.

> **Target audience:** Groups of people whom the museum want to be their primary users and for whom they design programs and services

Audience survey/study: Collecting data from the museum's actual and potential audiences to determine their composition. Used to assess the effectiveness of the museum's activities and services.

Collaborative effort: A formal arrangement to work with other organizations on the planning, development, or implementation of exhibitions and public programming.

Community: The geographic area and its associated population in which the museum exists.

Docent: A person who teaches in a museum and is usually a volunteer.

Financial resources: The income and expenses of the museum.

Focus group: Interview studies involving a carefully selected sample of 8-10 individuals whose demographic and psycho-graphic characteristics are of special interest to the museum. A planned but informal discussion carried out with the small group of visitors or community members to discuss a pre-determined topic in their own terms.

Formative evaluation: Testing carried out during development, including prototype building, testing comprehension of label copy, etc.

Friend/Auxiliary: An organization whose purpose is to work solely on behalf of the museum.

Front-end evaluation: Collecting data from potential visitors to determine their level of interest and knowledge about a subject before an exhibition or program is developed.

Full-time staff: Employees who work 35 hours or more per week.

Governing Authority: The entity that has legal and fiduciary responsibility for the museum (this body may not necessarily own the collection or the physical facility) and may include not-for-profit boards, appointed commissions, governmental bodies, and university regents.

> **Names of governing authority include:** Advisory Council, Board of Commissioners, Board of Directors, Board of Managers, Board of Regents, Board of Trustees, City Council, Commission.

Head of governing authority: The elected or appointed head of the executive body to which the director reports. For institutions that are part of a larger non-museum parent organization, the head of the governing authority is considered to be the individual within the institution's larger parent organization to whom the director reports/is responsible (e.g., dean or provost of a university, director of parks and recreation for a city government, military post commander, etc.).

Human resources: All of the people, paid and unpaid, who regularly work at the museum.

Interpretation: The media/activities through which a museum carries out its mission and educational role:

Interpretation is a dynamic process of communication between the museum and the audience.

Interpretation is the means by which the museum delivers its content.

Interpretation media/activities include, but are not limited to: exhibits, tours, web sites, classes, school programs, publications, outreach.

Mission: The mission statement defines the purpose of the museum and the means by which the museum achieves its purpose. The statement must be in accord with the purposes of the museum as enumerated in the basic legal documents.

Parent organization: The overseeing organization (such as an historical society or university) which is responsible for the fiduciary control of the museum.

Part-time staff: Staff who work fewer than 35 hours per week.

Planning: The creation of policy and written plans. Thomas Wolf (Managing a Nonprofit Organization, 1990) lists two essential prerequisites of planning: 1) an evaluation/assessment of the organization's current position, and 2) a clear vision of the organization's future expressed through a statement of mission and goals. These prerequisites apply to all types of planning, whether it is long-range, disaster, exhibition, marketing or program.

Public experience: What happens physically, intellectually and emotionally to the public when it comes in contact with the museum either by word-of-mouth, through media references, or directly (visiting the museum).

Public involvement: When the public actively participates with and supports the museum financially and/or with physical presence, for example, as corporate sponsors, donors, trustees, advisors, visitors, volunteers, members, friends, or collaborators.

Public perception: The public's impression, knowledge of and feelings about the museum. These create your museum's image and establish the role your museum has in the community.

Purpose: The museum's broad guiding principle as stated in its governing documents.

Research: Includes two types: applied -- for the purpose of identification, reference, or solving a particular problem, or for acquiring information for the development of a program or publication; and pure — for the purpose of acquiring new knowledge or adding to knowledge. All museums are expected to engage in applied research; some museums may engage in pure research.

Special events: Concerts, festivals or special seasonal programs.

Special exhibitions: Usually short-term, temporary exhibitions.

Summative evaluation: Determining the effectiveness of an exhibition or program after its installation.

Tours: Any type of tour of the exhibitions, includes school, self, audio and guided.

Visitors: Groups and individuals who go to the museum's physical facilities to use the museum services.

Visitor evaluation: Obtaining valid and reliable information from visitors that helps in the planning of exhibitions and programs and in determining the extent to which the activities are meeting their intended objectives. Can include observation (tracking) studies, questionnaire, interviews, community meetings, and focus groups. Visitor evaluation can be carried out before (front end), during (formative), and after (summative) exhibition or program development.

Visitor services: Facilities or services that provide comfort to visitors, including the checkrooms, dining area, first aid stations, information desk, restrooms, seating, signage, telephone booths, and water fountains.

Volunteer: An individual who offers time and service to the museum for no salary or wage.

MAP 2000

APPENDIX I

Visitor Services Professional Interest Committee of the American Association of Museums

Dedicated to Enhancing the Visitors' Museum Experience

WHAT IS VS-PIC?

The Visitor Services Professional Interest Committee (VS-PIC) of AAM is a group of museum professionals who are visitor advocates, concerned with providing museum visitors with the best overall experience possible.

THE MISSION OF THE VS-PIC IS TO ENHANCE THE VISITORS' MUSEUM EXPERIENCE.

The goals are:

a. Establish services as a fundamental value of our respective institutions

b. Incorporate service into the institutional strategic plans for creating the visitor experience.

c. Integrate the delivery of service with the delivery of programs to create an effective learning environment.

d. Understand and effectively meet the needs of a variety of visitors.

e. Enhance our skills and those of our staff to better meet the needs of visitors.

BENEFITS OF MEMBERSHIP

Membership in VS-PIC is open to anyone interested in elevating visitor service in their museum, regardless of job duties. Membership is valid for a full year from the date of joining. VS-PIC members enjoy the following benefits:

- Invitation to the annual business meeting at the AAM annual conference.
- Networking with museum professionals in visitor services.
- Regular communication on issues relating to visitor services in museums.
- Opportunities to enhance your skills to better meet the needs of museum visitors.

VISION

Become a member of the Visitor Services Professional Interest Committee of the American Association of Museums and join your colleagues in this national network dedicated to promoting visitors services in your museum. To join, send your $10 annual membership fee (payable to AAM) to VS-PIC Membership, American Association of Museums, 1575 Eye Street, NW, Suite 400, Washington DC 20005. Please put "VS-PIC dues" in the memo section of the check.

For more information, Please contact Sarah Christian, VS-PIC Chair, Denver Museum of Natural History, 2001 Colorado Blvd., Denver, CO 80205-5798, phone 303-370-6363.

VSMUS LISTSERV

The Visitor Services in Museums Listserv (VSMUS) is a forum that brings together museum professionals and others concerned about the quality of the visitor experience in museums. VSMUS serves as an avenue to relate experiences, ideas, and questions as well as provide an efficient method for sharing advice and resources with others in museum environments.

To subscribe to VSMUS send a mail message to:
majordomo@trfn.clpgh.org

The first line (not the subject line or the CC:) of the message should read:
subscribe vsmus

You will receive a reply that explains how the Listserv works, what the list contains, and Listserv rules and regulations. Read these carefully and then save them. Listserv etiquette is important.

To post a message on the VSMUS Listserv send to:
vsmus@trfn.clpgh.org

If you have problems subscribing, contact Greg Burchard at burchardg@warhol.org